THE
NIKON
RANGEFINDER CAMERA

*An Illustrated History of the Nikon Rangefinder
Cameras, Lenses and Accessories.*

by

Robert Rotoloni

Hove Foto Books

Dedicated to my wife Kathleen
and my daughters Rachel and Cara

First edition 1981 (cameras only)

Second edition August 1983 (cameras, lenses and accessories)

ISBN 0 906447 25 9

Published by Hove Foto Books
34 Church Road, Hove, East Sussex BN3 2GJ
United Kingdom

US Distributors HP Books
PO BOX 5367 Tucson AZ 85703

UK Trade Distribution Patrick Stephens Ltd,
Bar Hill, Cambridge CB3 2EL

Printed in Great Britain

Acknowledgements
Robert Rotoloni and Hove Foto Books wish to thank Nippon Kogaku K.K.
for their considerable assistance and confirm that they are the trade mark
holders of 'NIKON' and 'NIKKOR'.

Notes on photography
When compiling a book so well illustrated as this one, and covering so many items
some of which are exceptionally rare, some photos have been taken under difficult
conditions and do not come up to the author's or publisher's standards but by the
necessity of their rarity they are included.

CONTENTS

PART III

INTRODUCTION TO PART I

The author has been collecting the Nikon 'S' Series of rangefinder cameras since 1967. When I first started out I immediately discovered how difficult it was going to be to obtain such items as original literature and definitive information about this fine series of cameras. Being a product of the reflex age I had no first-hand experience to go by. After exhausting the public library I began searching the tables at the many trade shows I've been to. Over the years I've been able to obtain some original literature on the subject but nothing that really gives an exact listing of models and variations. I next tried to obtain information from both the importer and the factory, but to no avail. Therefore, what you will read in the following pages of this book represents the culmination of years of accumulating, absorbing and deciphering small bits of information that have come my way through magazines, newspapers, literature, advertisements and the exchange of information with other Nikon collectors worldwide. It must be noted at this point that without the help of two of my friends, who happen to possess two of the largest Nikon collections in North America, this book would not be possible. Therefore, I would like to acknowledge both the help and inspiration of a dear friend from Michigan, who wishes to remain anonymous, and Mr. William Kraus from New Jersey. These gentlemen were gracious enough to submit photographs of items lacking in my collection.

In the following pages I have shown, in chronological order, as many of the variations in the Nikon 'S' series as possible. Each camera is shown in two positions to allow as much visual information to be presented as possible. Along with each model are a few paragraphs of information such as production quantities, serial numbers and dates of manufacture.

Information new to this edition include two tables one of which shows the batch numbers and quantities produced for the various models. The second is a detailed listing of the actual month, quantity and serial numbers for the Nikon I and M cameras. Also included are photos of an additional Nikon I, which is very special, and a black Nikon S, both contributed by Mr. T. Konno of Japan. More photos of the Nikon S3M have been added plus an entire new chapter has been included that discusses the Nikon S2 'Dummy' cameras that are of great interest to any Nikon collector. I hope that these additions have improved the content of the first book that is now complemented by a second part that discusses all the lenses and accessories made for this fine camera system. Therefore, at this point I present to you the most definitive book on the Nikon rangefinder series in the English language.

ROBERT ROTOLONI

March 31, 1983

HISTORY

Nippon Kogaku, K.K., or Japan Optical Co., was formed on July 25, 1917, by the merger of three small optical firms, one of which dated back to 1881. They began with some 200 employees and eight German technicians who were invited in July of 1919 and arrived in January of 1921. They were actually an optical firm and not a camera manufacturer, therefore, their beginnings parallel those of Leitz and Zeiss, who also began as optical manufacturers. They began to produce a vast array of optical products such as microscopes, telescopes, transits, surveying equipment and optical measuring devices for industry and science. Because of the types of products they made they became well known in the scientific and industrial communities but not to the general consumer. By the 'thirties they were producing a series of photographic lenses from 50mm to 700mm, mostly for plate back cameras, and the word 'Nikkor' was first used, having derived it from 'Nikko' which was used on their early microscopes. By July and August of 1937 they had completed the design of 50mm f4.5, 3.5 and 2.0 Nikkors which came as original equipment on the famous Hansa Canon of the same year. Nippon Kogaku actually produced all of Canon's lenses up to mid-1947; therefore all prewar and early postwar Canons came with Nikkor lenses. Of course the first were in Canon's own bayonet mount, but later ones were equipped with the Leica thread mount. So we see that by the late 'thirties Nippon Kogaku was producing lenses for miniature cameras, but had yet to produce a camera of its own. With the advent of World War II they were chosen by the government to be the largest supplier of optical ordnance for the Japanese military machine and grew to nineteen factories and 23,000 employees. It should be noted that many of the items they made during the war, such as binoculars, aerial lenses, bomb sights and periscopes, are prized by military collectors.

With the end of World War II they were reorganized under the occupation for civilian production only and were reduced to just one factory and approximately 1400 employees. They immediately began to produce many of the fine optical products from before the war, for which they were justly famous in Japan. However, at this point, they were virtually unknown to the outside world.

Sometime in late 1945 or early 1946 it was decided that they should produce a camera of their own and research began on both a $2\frac{1}{4} \times 2\frac{1}{4}$ TLR and a 35mm., interchangeable lens, coupled rangefinder camera. The TLR was dropped and design of the '35' continued. On April 15, 1946, a production order for twenty miniature cameras, to be used in experiments, was issued. Their camera went through many name changes during this gestation period, but in September of 1946 the design of the camera was completed and the name 'NIKON' was decided upon, which is the first time that this word is ever seen. A lens programme was also going on at this time, but actual production of the camera did not begin until early 1948, which brings us to the first Nikon, the model I.

6

THE NIKON I

Although it was not marketed until March of 1948, the original Nikon's design was completed in September of 1946. Please keep this date in mind for it is important when we come to serial numbers. The basic design of the first Nikon was a combination of features from both the Leica and Contax cameras of the day, even though over the years many collectors have assumed that it was simply a copy of the Contax. The Japanese camera industry in 1946 was not known for innovation. They had a reputation for being copiers, especially the designs of German cameras. However, the engineers at Nippon Kogaku decided that neither the Leica nor Contax possessed a perfect design. After looking at both models they decided what features they thought were strong points in each and combined them to produce their camera. From the Contax they took the basic body shape with angled corners and removable back, front mounted focusing wheel for normal and wide angle lenses, top mounted shutter controls, bayonet lens mount, back focus and the front decorator plate. All of these features gave the camera a definite 'Contax' look, which probably led most people to consider it a copy. However, after closer examination one will find that they took two important features from the Leica. They decided to use both the Leica's rangefinder mechanism and its cloth, horizontal travel focal plane shutter. A lot can be said for the Contax's rangefinder and shutter, but both were extremely complicated and expensive to manufacture. It is hard to believe that *any* Japanese manufacturer was capable of effectively producing those two systems at that time. Besides, Nippon Kogaku's emphasis was on simplicity, and therefore strength, in the design of their camera. In retrospect the decision was sound, for the vast majority of early Nikons that I own or have examined still have functioning rangefinders and shutters.

While on the drawing board the camera went through a series of name changes. Many names were considered and some will sound familiar to you. In possible chronological order they considered: BENTAX, PENTAX, PANNET, NICCA, NIKKA, NIKORET, NIKO and NIKKORETTE. It is thought that NIKKORETTE was the last name to be considered before the final configuration was decided upon. It appears that just before the final design was completed the name was changed to NIKON, which is the first time that this word is ever seen.

On April 15 1946, production order 6FT-1 was issued to construct twenty miniature cameras as an experiment. As stated the completion date was September 1946. In the West this date could be written as 9/46, 09/46 or, as some would do, 09/6. In Japan they write their dates just the opposite way, therefore it would be 46/9, 46/09 or 6/09. It is this last method that is important. Nippon Kogaku decided to use this date in their serial numbering scheme and chose '609' as a sort of prefix. The twenty cameras that were constructed for test purposes were numbered consecutively from 6091 to 60920. These twenty cameras were used in late 1947 for three experiments to determine the feasibility of marketing the camera. It is also thought that an additional camera, 60921, was also used in these tests, therefore, the first production camera bears the serial number 60922. It is not known at this time what those 20 or 21 cameras looked like, for they have not been accounted for, but it is safe to say that they looked very much like the model I shown on these pages, which is a very early example.

Nippon Kogaku maintained the 609 prefix and continued to add numbers. It is

hard to determine just how many Nikon Is were made but, depending on your source, the last unit was numbered either 609758 or 609759, for a total production of 758 or 759 cameras including the prototypes. Please refer to the last chapter for a more detailed discussion of early Nikon production.

The Nikon I was produced from March of 1948 to August of 1949, or a little over one year. The basic configuration is evident from the photographs in this chapter. Shown is a very early Nikon I, 60939, which is a fine example of what early Nikons looked like, the Nikon I as issued by the factory, had no flash synch of any kind, 'Made in Occupied Japan (MIOJ)' engraved on the baseplate and either a 50mm F3.5 or 2.0 Nikkor in a collapsible mount. This model did not prove to be very popular, for the GHQ of the Occupation forces, under General MacArthur, would not allow the camera to be exported to the US because the 24 × 32 format was not compatible with Kodachrome slide mounts. Therefore, very few Nikon Is made their way to the US even though they were sold to the Occupation troops. It is rumoured that the first fifty production cameras were exported to Hong Kong but it appears that the majority were sold in Japan. It was this restriction on export, because of the film size, that prompted Nippon Kogaku to introduce a second model which corrected this. In August of 1949, the Nikon I was discontinued and replaced by a second model known as the Nikon M.

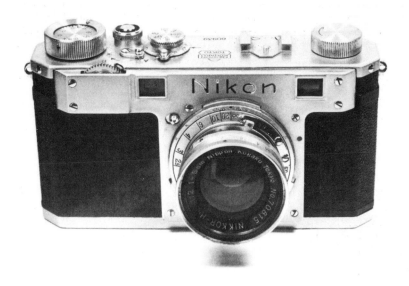

Fig. 1 and 2 *Two views of Nikon I No. 60939 which is amongst the first twenty
production cameras. Mounted is a proper 50mm f2.0 Nikkor No. 70815 in a
collapsible barrel (1948).*

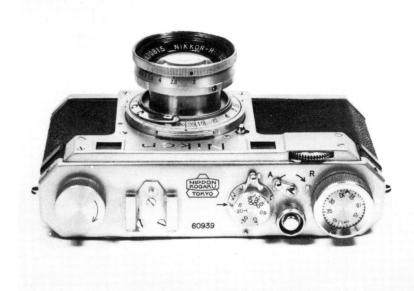

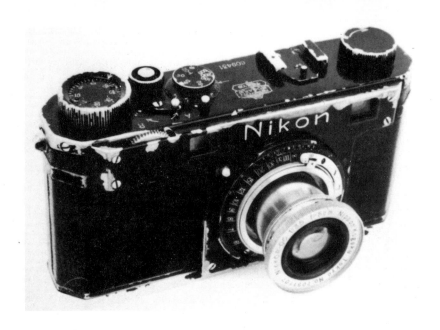

Fig. 3 and 4 *Two views of what is probably the rarest of all Nikons. This is black Nikon I No. 609431 with 50mm f3.5 Nikkor No. 7051107. This camera was reportedly specially made for an American photo-journalist and is the only known example of a black Nikon I (1948). (S. Abe)*

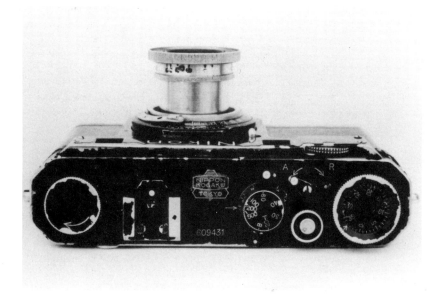

THE NIKON M

The 24 × 32 format of the Nikon I proved to be unpopular for various reasons and in August of 1949 was replaced by a second model, the Nikon M. The Model M has proved to be an interesting camera for me because of the abundance of variations that exist. There are a few problems incurred when writing about the Nikon M, because of discrepancies in numbering and a disagreement amongst collectors as to what constitutes a Nikon M, but one aspect is easy. The Nikon M is the only Nikon rangefinder ever made to be so identified on the camera itself. The letter 'M' precedes the serial number engraved on the camera top plate. No other Nikon has such an identification.

At this point you may ask why this second Nikon was called the 'M' and not the Nikon II. The 'M' is derived from the fact that this model had a format of 24 × 34, which is half way between the 24 × 36, or Leica (L) size, and the 24 × 32, or Nippon (N) size. Both numerically and alphabetically this model is a Medium (M) format, and therefore the 'M' designation. A rather unique way to name a camera.

The two major differences between the Nikon I and the Nikon M are the format size and the letter designation in the serial number. The two cameras side by side appear to be identical and for all intents and purposes they are. The only other change of any significance is that the 'M' possesses a fixed, factory aligned take-up spool, which simplifies loading immensely.

Depending on your source, it appears that the first Nikon M would be camera 609759 or 609760. For a more detailed discussion about this discrepancy refer to the last chapter. We now come to a major difference amongst collectors, and that is – where does the 'M' model end and the 'S' model, which followed, begin? We have to go back to the beginning of production when it appears that Nippon Kogaku followed the practice of manufacturing the top plates at one time, or at least in very large batches. These plates were engraved with consecutive serial numbers from 6091 and up. Since the top plates did not change much it is easy to understand why it would be more economical to produce these en masse at one time and number them up to what appeared to be a reasonable estimate as to how many would be sold. As an example, let's say that back in 1948 they would produce 4000 top plates in one batch with consecutive serial numbers, believing this number to be a reasonable estimate of sales. However, when the decision was made to produce the Nikon M they had only reached 759 or so cameras. Since there was to be no change in the top plate from one model to the next, and there isn't, it would be rather easy to engrave an 'M' in front of the serial numbers on the remaining plates. It appears that this is what was done, for the 'M' often seems to be spaced slightly too far to the left in relation to the digits in the number, and a bit larger. Again, as an example, let's say that they engrave all of the remaining 3200-plus plates in this manner. The production of the Nikon M continues for about a year and reaches approximately camera 6092350 at which point the factory decides to add one important feature to their camera, and this is flash synch, but continues to use those same top plates with the 'M' in the serial number. As far as Nippon Kogaku is concerned, any Nikon M without flash synch is an 'M', but any camera manufactured with factory synch is recorded as a Nikon S, even though the first 1600 or so still have an 'M' in the serial number. This is what causes disagreement amongst collectors as to what constitutes a Nikon M. Japanese collectors seem to favour the factory's method and consider only 1643 Ms as having

been produced, while American collectors consider any Nikon with an 'M' in the serial number to be a Nikon M. It appears that the 'M' was dropped from the serial number at around 6094000, therefore, as far as the author is concerned, approximately 3240 Nikon M models were made. Therefore, the serial number range of the Nikon M is from 609759 or 760 up to about 6094000.

As mentioned earlier, there are a great number of variations seen in the Nikon M. So many in fact, that it would get a little tedious to list them all. A good example is that, of the first six Ms acquired by the author, no two were identical. I've included photographs of more Ms than any other model to give the reader an idea of some of the many variations available, and must mention that I have at least ten other cameras recorded that are also different in some way. Granted, some of the variations are small, and only a few really changed the camera, but it is fascinating tracking them all down. A small listing would be: many changes in external hardware such as wind and rewind knobs; accessory shoes and shutter release guards; the position of the 'F' and 'S' engravings for the flash synch and the colour of the sockets; the shape of the ridge on the camera back; types of pressure plates; the finish of the interior and the film guide rails; the method of routing the synch wires. Major variations include: position of the MIOJ logo which was moved from the baseplate to the back leather at around 6091900; and the type of finish on the body panels. It appears that at about camera 6093544 the characteristic dull gray chrome seen on all preceding Nikons was changed to the more familiar satin chrome.

In January of 1951 Nippon Kogaku replaced the model M with what most collectors are familiar with as the Nikon S, which brings us to the first really successful Nikon.

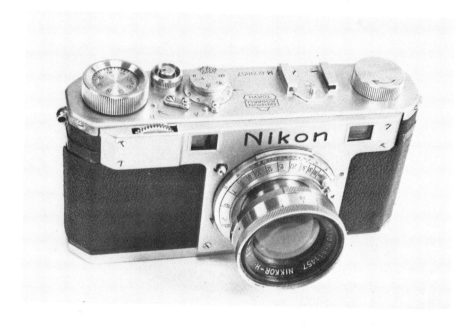

Fig. 5 and 6 *Nikon M No. 609857 with collapsible 50mm f2.0 Nikkor No. 811457. This camera is amongst the first 100 Nikon Ms manufactured and is one of the earliest examples of this model in an American collection (1949).*

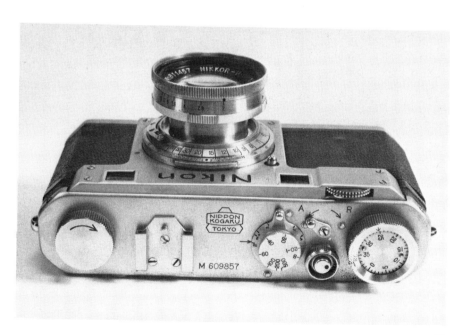

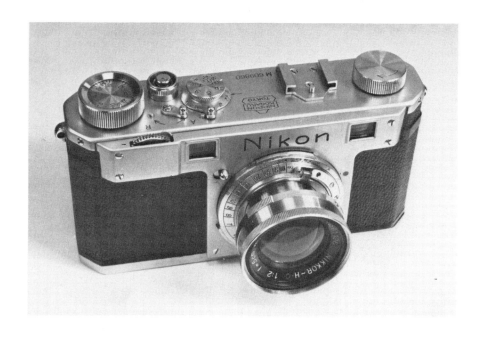

Fig. 7 and 8 *Shown is Nikon M No. 609860 with 50mm f2.0 Nikkor No. 81198. Note that it is only two serial numbers removed from the preceding example. Both cameras are in the author's collection and were acquired eight years apart (1949).*

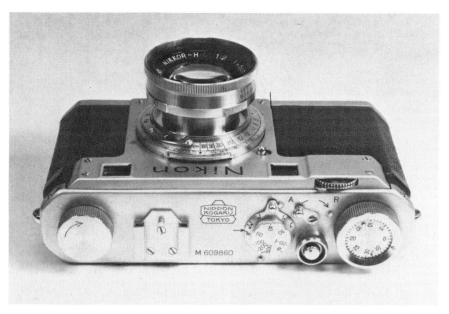

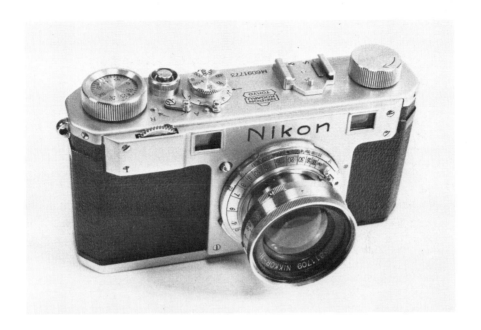

Fig. 9 and 10 *Another early production Nikon M No. 6091773 with 50mm f2.0 Nikkor No. 811709 still in a collapsible mount. No flash synch has been added yet but pressure rails are now present in the accessory shoe (1950).*

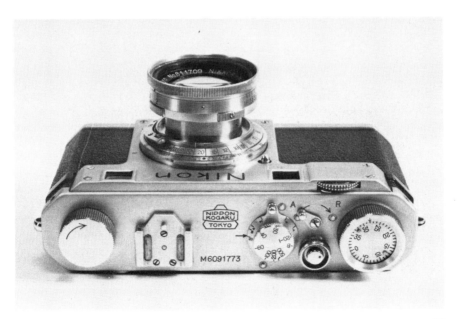

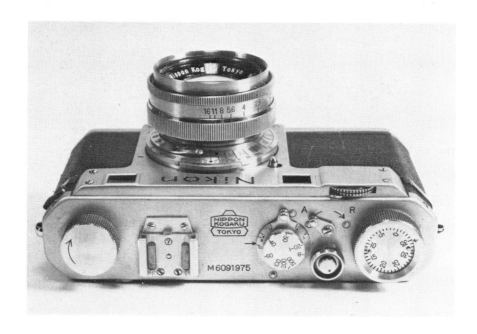

Fig. 11 and 12 *Nikon M No. 6091975 with an early example of the rigid 50mm f2.0 Nikkor No. 617634. This is the earliest example of a Nikon M with factory synch known to the author. Since more follow without synch it could have been assembled out of numerical order (1950?).*

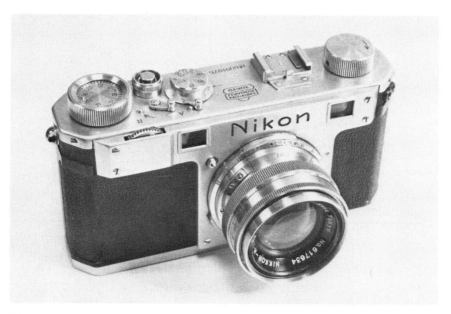

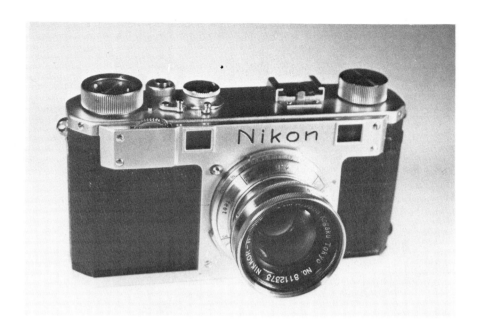

Fig. 13 and 14 *Two views of Nikon M No. 6092051 with a unique 50mm f2.0 Nikkor No. 8112373. This lens is a 'hybrid' having features of the earlier collapsible lens yet it is rigid. Compare this with No. 617634 shown in Fig. 11 and 12 which is a standard rigid lens (1950).*

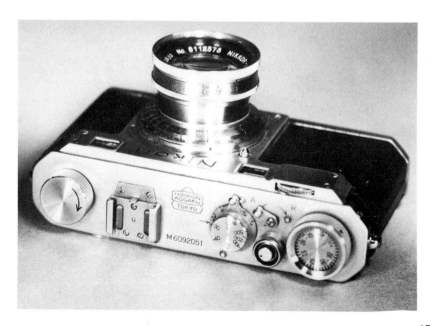

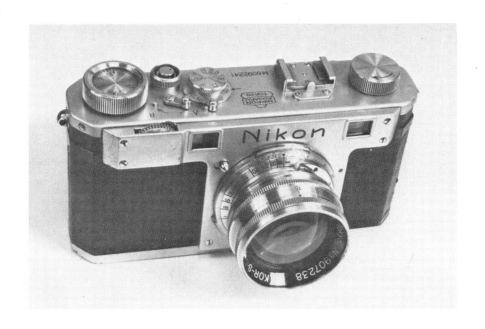

Fig. 15 and 16 *This is an example of a very late nonsynched Nikon M No. 6092241 with a later number than that in Fig. 11 and 12. Mounted is the elusive 50mm f1.5 Nikkor No. 907238 which was made for less than one year (1950).*

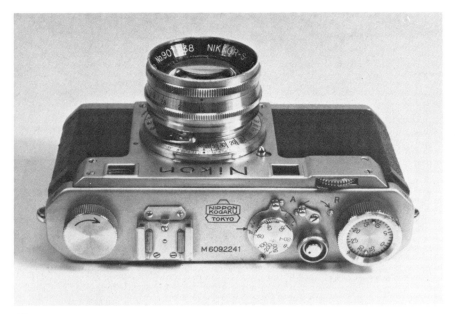

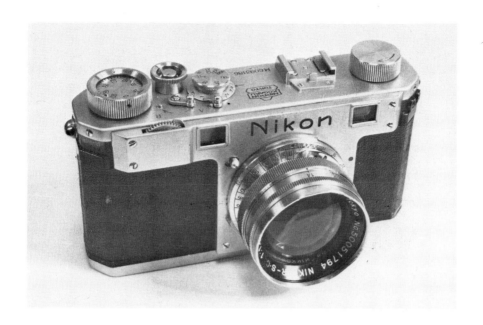

Fig. 17 and 18 *Two views of Nikon M No. 6093186 with an early 50mm f1.4 Nikkor No. 50051794. This camera possesses standard factory synch and is amongst that group considered by the factory to be a Nikon S (1951).*

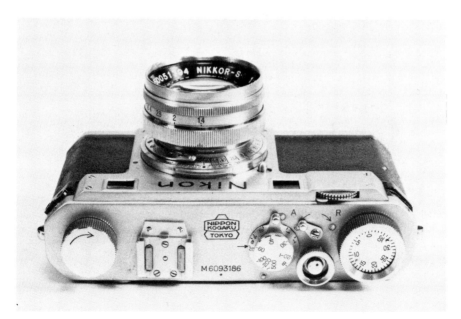

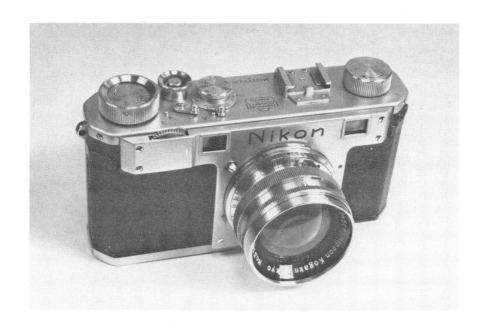

Fig. 19 and 20 *Late Nikon M No. 6093508 with early 50mm f1.4 Nikkor No. 316497. The author believes that the bright chrome Ms begin at about 6093544 which makes this camera one of the last to be made with dull chrome (1952).*

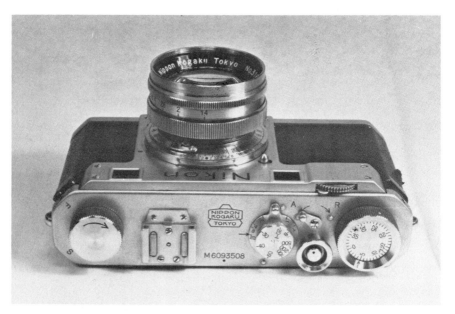

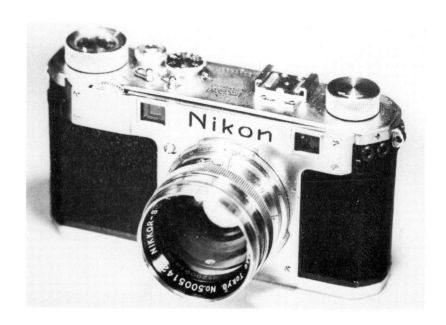

Fig. 21 and 22 *Very late bright chrome Nikon M No. 6093898 with 50mm f1.4 Nikkor No. 50051429. One of the last cameras to have an 'M' in the serial number and it is identical to the early Nikon S (1952).*

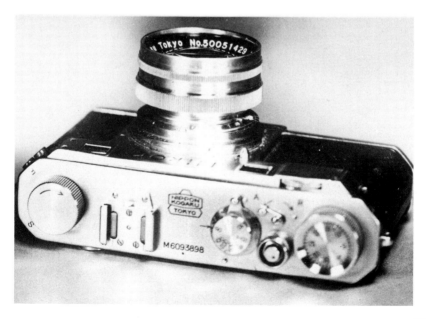

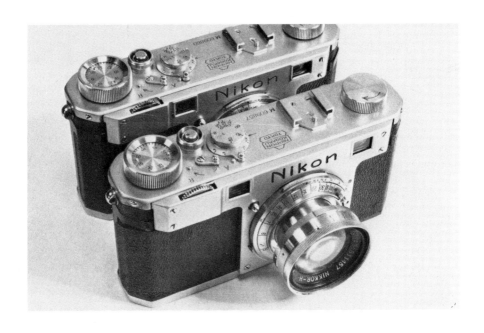

Fig. 23 and 24 *If No. 609760 was actually the first Nikon M then these two cameras are the 97th and 100th manufactured. This is the first time that two Nikon Ms with such close serial numbers have ever been shown in one photograph (1949).*

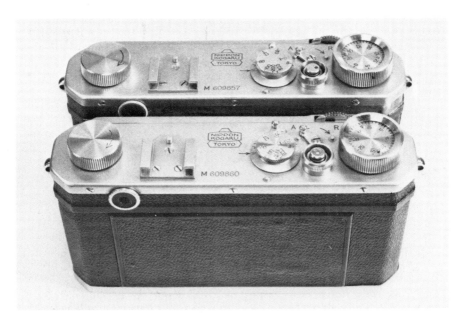

THE NIKON S

The first Nikon to be actively promoted in the United States was the Nikon S, which Nippon Kogaku brought to the market in January 1951, to replace the model M. Up to just a few short years ago most American collectors thought this to be the first Nikon, although we now see that it was actually the third. This came about for the simple reason that very few had seen any information about the previous two models and associated the first advertisements seen for the Nikon with what they thought was also their first camera. As seen in the preceding chapter, Nippon Kogaku considered any 'M' model with flash synch to be a Nikon S regardless of the 'M' in the serial number. Early S cameras are identical to these late M models right down to the body casting. It was a matter of simply having used up all of the top plates having the 'M' engraving, and the next batch was identical except for the missing letter.

The Nikon S, as released by Nippon Kogaku, retained all of the features of the preceding M, even down to the 24 × 34 format, even though it is sometimes stated in print that the S was the first Nikon with the 24 × 36 format. Therefore, at the risk of being repetitious, it must be said that the late Ms and the early Ss are actually the same camera.

I've mentioned the number 6094000 as the probable point at which the letter 'M' is no longer seen in the serial number, but to be honest at this point no one really knows for sure. Factory records are confusing because of the later Ms being called Ss. The number 4000 is a reasonable guess based on recorded numbers of collected cameras, and the fact that it is a nice even number of plates to have been produced in one batch. As of the date of publication we have narrowed it down to between M 6094025 and S 6094153, which is only 127 units! Further collected cameras will narrow it down even more, but at this point 6094025 is assumed to be the approximate breaking point.

Since the treaty to end the Occupation of Japan was signed on September 8 1951, it is logical to assume that the early ones would be marked MIOJ. Camera 6094161 is so marked, but 6094212 is not. It appears that only the first 200 or so Nikon S cameras were built during the Occupation. Cameras made after the Occupation are still identical in all other respects to those marked MIOJ.

There are not a great deal of variations in the Nikon S but some do exist. Besides the MIOJ version there are those made just after that point that still have the 'M' type baseplate and body casting. At around 6095000 an improved casting appears and the baseplate is slightly altered to allow for a different method of mounting the tripod socket. There are also those early Ss that have red synch sockets instead of black which seem to appear somewhere before camera 6094600. There was also a small batch of cameras that were fiinished in black, presumably for *Life* magazine. After camera number 6095000 all remaining S models are identical except for one interesting variation.

As mentioned, Nippon Kogaku retained the 609 prefix and kept adding numbers. After reaching S 6099999 they continued on to cameras numbered over 60910000 which now had an extra digit and are known amongst Nikon collectors as 'eight digit Ss'. Numbers recorded go up to 60911215, or 1215 units. It appears that, at this point the factory realized that, if they kept this up, they would eventually have numbers so large that they would not have room on the top plate to engrave it! Seriously, they

saw that this would not work and reverted back to 6100000, and proceeded through 6110000 and into 6120000's. So we have a small batch of oddly numbered Nikon S cameras to look for, which is about the only time that Nikon did strange things with their numbering system.

Total production of the Nikon S, excluding those 'M' cameras with flash synch, would be 35127 units. Considering that the S was marketed for three years, which is almost exactly the same period as the preceding two models combined, this is a ten-fold increase in production and shows how rapidly the Nikon was catching on.

If you take production figures literally, the last Nikon S should bear the number 6129147, but gaps must exist. The author has recorded three cameras above this number, including 6129520 which is shown in this book and is in the author's collection.

These first three Nikons – I, M and S – were all considered by Nippon Kogaku to be the original 6FB design of 1946. By the beginning of 1953 it was obvious to them that this seven-year-old design was due for a change to allow them to compete in the world market, especially with the re-emerging German cameras. Therefore, starting in mid-1953, the engineers at Nippon Kogaku began to experiment with a successor to the original design which had started it all.

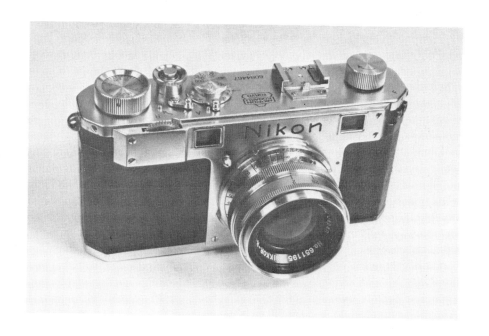

Fig 25 and 26 *Shown is an early Nikon S No. 6094467 with 50mm f2.0 Nikkor No. 651195. It is within the first 500 to have been made after the removal of the 'M' from the serial number. This camera still possesses certain features, such as the baseplate and casting, from the preceding 'M' model (1952). (T. Konno)*

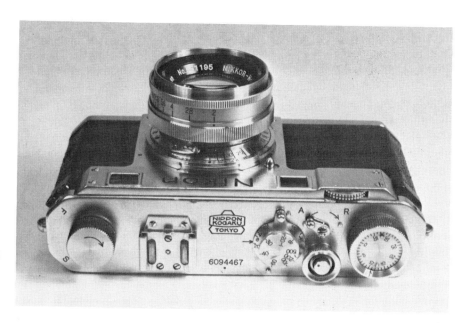

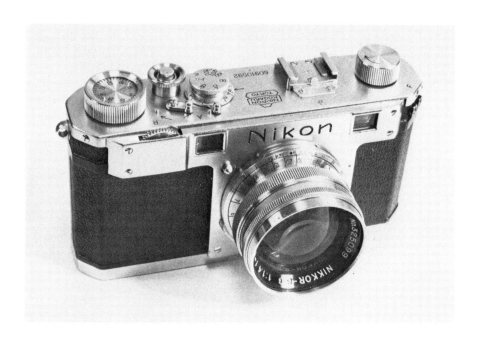

Fig. 27 and 28 *An example of an 'Eight Digit S' is camera No. 60910592 with 50mm f1.4 Nikkor No. 325099 mounted. In all other respects it is identical to a standard Nikon S (1952).*

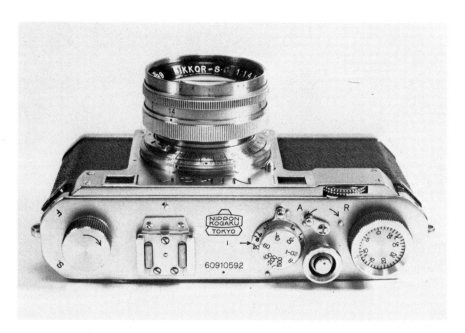

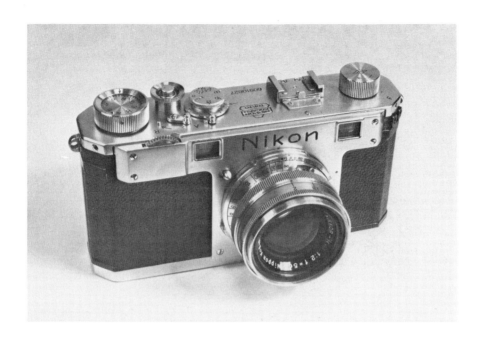

Fig. 29 and 30 *Another eight digit Nikon S No. 60910827 with 50mm f2.0 Nikkor No. 636115. This one is marked with an 'EP' on the rewind knob for sale through the 'PX' shops. This is commonly found on later Nikons but not often on the 'S' model (1952).*

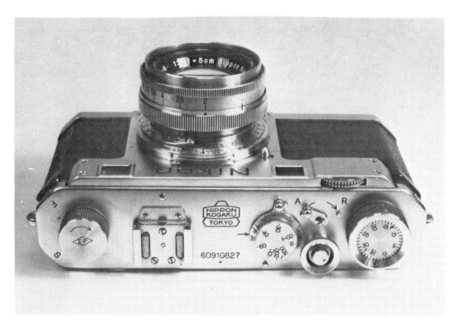

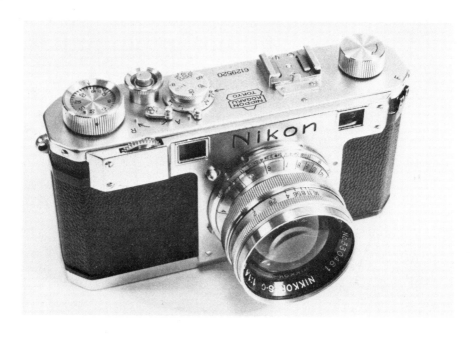

Fig. 31 and 32 *This is the latest Nikon S known to the author to be in an American collection. Shown is camera No. 6129520 with 50mm f1.4 Nikkor No. 330461. This camera is beyond what is normally quoted as the last Nikon S and very close to the 613 type serial numbers (1954).*

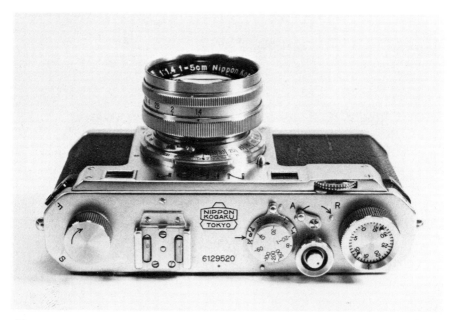

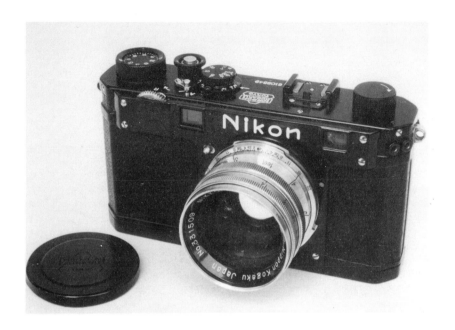

Fig. 33 and 34 *Little is known about the black Nikon S cameras with special wind and rewind knobs that were made for* Life *magazine. A recent find in Japan is this beautiful Nikon S No. 6109549, in a black paint finish, with 50mm f1.4 Nikkor No. 331509 (1952?). (T. Konno)*

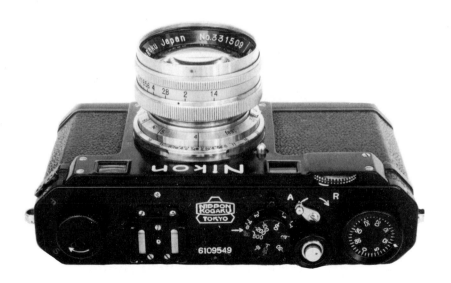

THE NIKON S2

We now come to what is probably the most underrated of all the Nikon rangefinders, the model S2. In a way the S2 occupies the same position as that of the Leica IIIc. Both cameras were actually great technical improvements over the preceding models, yet were made in large numbers and today are considered 'common'. This is really unfair, especially in the case of the Nikon S2, for it represents a quantum leap in Nikon design. This will become apparent when we get to features, but first a little history.

The first experimental S2 was completed on June 28, 1953, and given the code name T-10141. The second came on July 3, 1953, and was assigned T-10142. The S2 went through a long gestation period, probably because of the fact that it was a vast improvement over the Nikon S. Another reason would be that about midway into its development, an individual came along who was destined to have a profound effect on both Nikon and the photographic world in general. That man was Joseph Ehrenreich. On December 17, 1953, Ehrenreich resigned Penn Photo and by March of 1954 had formed Nikon, Inc. and taken over sole distribution in this country. Ehrenreich was a master salesman and a dynamic person. He took frequent trips to the factory and became directly involved in product development. He also solicited comments from working professionals about features that they would like to see. In the meantime the engineers at Nippon Kogaku were bringing along their new camera closer to production. The result of all this was a new Nikon, the model S2. The first production camera was completed in October of 1954, and by the product introduction on December 10, 1954, approximately ten cameras were ready.

The S2 possessed many 'firsts' for Nikon. Some of the many improvements over the Nikon S were: rapid wind and rewind levers replaced the slower knobs; a 1:1 lifesize viewfinder that allowed two-eye focusing, with a bright line for the normal lens and an improved rangefinder spot; a single back lock instead of two to speed up loading; an improved shutter now with a top speed of 1/1000 sec. instead of 1/500; lighter body weight (18 oz. compared to 23 oz.); a single PC socket for all flash with an adjustable synchro dial under the rewind lever and a stud just forward of the accessory shoe that allowed cordless contact with special Nikon flash units; a tougher, leather-like plastic body covering replaced the more damage-prone leather; tripod socket mounted into the body instead of the back for more rigidity; and at long last a standard 24 × 36 format. They did all of this, yet managed to retain important features of the S such as the front mounted focusing wheel, bayonet lens mount, and the removable back. The two cameras may look similar, side by side, but their handling characteristics were much different with the S2 the easier and faster to use.

The product code for the Nikon S2 was 16FB and production orders were from 16FB-1 to 16FB-31. A total of 57,000 cameras were ordered but actually 56,715 were completed, which makes the S2 the largest production Nikon rangefinder. The S2 began at serial number 6135000 which has always struck the author as an odd number to begin with, but there was a reason. If we go back to the Nikon S we see that the highest number recorded so far is 6129520, which is very close to 6130000. As of the date of publication no Nikon S has been recorded with a number over 613 but it is possible they exist. According to Nippon Kogaku they thought that S production could possibly exceed 6130000 and therefore allowed for a gap of 5000 units before starting the S2 to prevent any duplicate numbers. If production figures are taken

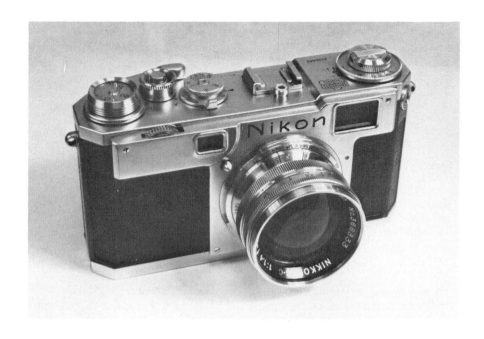

Fig. 35 and 36 An early all chrome Nikon S2 No. 6136682 with a late chrome fl.4 Nikkor No. 366333. Although it cannot be ascertained from the photograph, this camera has the slightly different 'leather' mentioned in the text (1955).

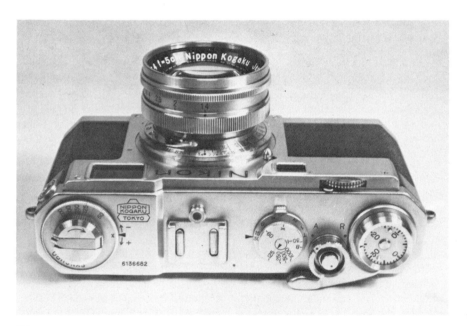

literally the last S2 would be 6191715, but recorded cameras go as high as 6196913 so gaps do exist.

Although the S2 is the easiest model of the Nikon rangefinders to find, it is an interesting camera to collect because of the variations that exist. The S2 was made from December 1954 to March of 1958, or a little over three years, and in large numbers. Nikon has always been the type of company to constantly improve their products without calling them 'new' as so many do. Because of this, variations exist within a model and can only be determined by actually collecting them.

The S2 was introduced with a plastic body covering that resembled leather but was much stronger and easier to grip. This identical covering was used by Nippon Kogaku all the way up to the first F2s that were made. However, there is one variation in the covering. Certain early S2s have a covering with the same pattern but the material is not as glossy and actually looks more like the leather on the S. This variation is hard to spot unless you have two cameras side by side, but they do exist. Early cameras seen with this different covering are 6135721, 6135823 and 6136682, but others within the same group have the more familiar type.

There is a way to date certain S2 bodies. Before the introduction of the following model SP in September 1957, the S2 had a 'live' shutter release. This meant that if you had a flash unit mounted you could fire it off by simply depressing the release without ever advancing the film. The SP had an interlock to prevent this and the S2s of the same period were given this same feature. They also adopted an eventual SP feature starting at camera 6180000 which brought about the major variation, known as the Black Dial S2. They used a more modern black background for the frame counter, shutter dials, synchro dial and distance scale. The Black Dial S2 came out a short time before the introduction of the SP, but the exact date is not known to the author. It appears that about 15,000 of these cameras were made, so they are not rare, but do make an interesting variation. Nippon Kogaku did not call it a new model and no announcement of the improvements was made.

One other major variation exists. As mentioned in the chapter on the Nikon S, a small batch of black cameras was made on special order. However, the S2 was the first Nikon camera to be available with a black finish to the general public, although it was still on special order only. The black S2 was first announced in October of 1955, or less than one year after introduction. Of course, we now see that two versions of the black S2 exist. The first would be the black version of the standard chrome model which has a chrome distance scale. The second would be the black version of the Black Dial S2 and has a black distance scale. Black cameras were made in small batches throughout production. The earliest seen is camera 6137647. Another early example is 6145922 shown in this book.

Many collectors know that when the SP was introduced, in September of 1957, it was right along with its justly famous electric motor drive. It took the public by storm and remains till today one of the most famous aspects of the Nikon RF series. But there is a catch. The hit of the National Photographic Exposition (IPEX) shown in March 1957 was at the Nikon booth. It was the electrified sequence camera, the model S2E! Remember this is March 1957. The SP came out in September 1957! Just exactly what is a Nikon S2E? Nikon never listed it as a different model but early motor manuals do list the motor being used on the S2. It is highly possible that the black dial S2 was being made by this time. It is also probable that the S2Es were modified by the factory just like the SPs and, therefore, never listed separately. Any

way you look at it, the SP was not the first motorized Nikon, regardless of what has been printed previously, because that honour belongs to the 'common' Nikon S2.

The S2 was discontinued in March 1958 but before that occurred it was joined by an additional model,, and they were made concurrently for about six months. Enter the Nikon SP.

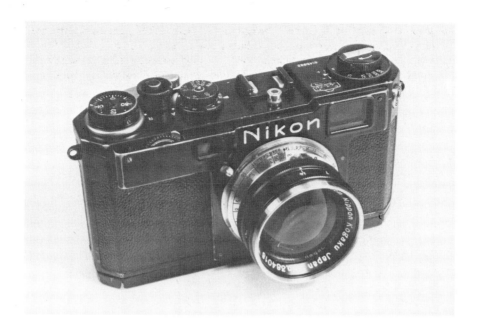

Fig. 37 and 38 *The black version of the chrome dial S2 No. 6145922 with a black 50mm f1.4 No. 384018. This camera differs from the later black dial version in that it has a chrome distance scale (1955).*

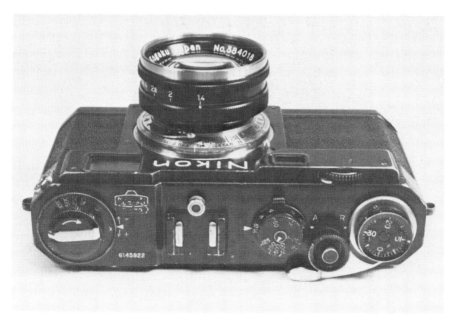

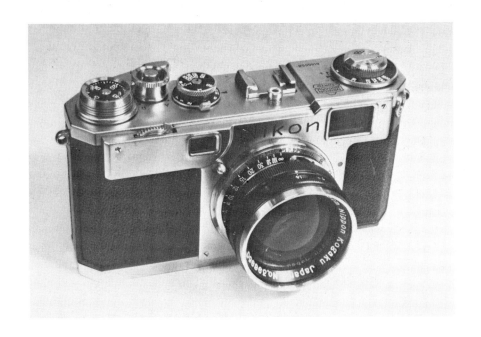

Fig. 39 and 40 *The Black Dial S2. Shown is camera No. 6188658 with black 1.4 Nikkor No. 396950. Note the black facings on the top mounted controls, and the black distance scale (1956).*

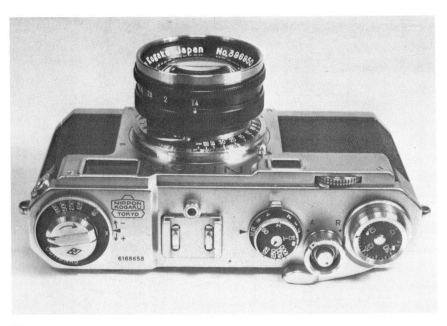

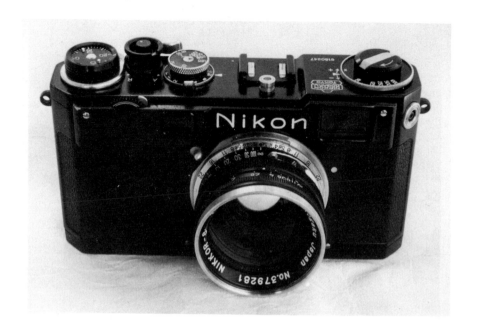

Fig. 41 and 42 *The black version of the Black Dial Nikon S2 differs from that shown in Fig. 37 and 38 because of the black distance scale. Camera No. 6180947 with 50mm f1.4 Nikkor No. 379381 (1956). (K. Watanabe)*

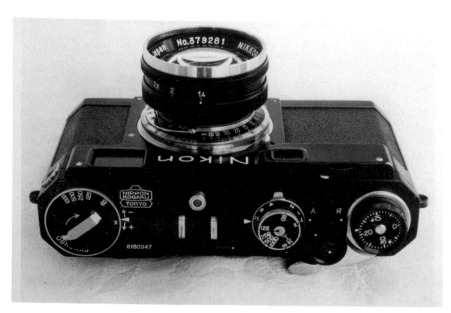

THE NIKON SP

In any series of collectable cameras there always seems to be one model that is special, that has a certain mystique about it. It could be the rarest or the most innovative, or simply the last of its line. The Nikon rangefinder series possesses such a model and, although it is certainly not rare, it is definitely innovative. Even though it was to be followed by three more models, they are simply derivatives of its basic design, which is in essence the culmination of the entire Nikon rangefinder series. This model is the famous Nikon SP.

The SP, for Professional, was introduced in September of 1957 and marked the high point in rangefinder technology for Nippon Kogaku. With the great success of the model S2 Nikon found themselves firmly entrenched in the ranks of the Big Four miniature camera manufacturers, namely Canon, Leica, Nikon and Zeiss. The decade of the 'fifties is now regarded as the classic period for the rangefinder '35' when the manufacturers were constantly improving their systems, and some of the greatest cameras of all time were born. Competition was fierce and, with the arrival of the Leica M3 in 1954, it was obvious to Nippon Kogaku that, in order to survive, they would need to again improve their camera. And improve it they did.

About the only items that the SP inherited from its predecessor were the lens mount, focusing wheel, PC socket, strap lugs and the tripod socket! Once you get beyond this point you are talking about an entirely different camera, which accounts for my calling it innovative. The SP possessed many 'firsts' for Nikon and the list of features is long.

Starting with the most important, the SP possessed the following characteristics. It was the first, and only, Nikon to have true projected, parallax corrected frame lines for the 50, 85, 105 and 135mm lenses which could be selectively keyed by rotating a dial under the rewind lever; a second optical finder with parallax marks for the 28 and 35mm lenses mounted right next to the viewfinder eyepiece which made it the only camera to accommodate six lenses without having to resort to accessory viewfinders; a redesigned shutter with speeds of 1 to 1/1000 sec., B and T, on a single, non-rotating dial; the first Nikon to possess a delayed action selftimer; the inclusion of a motor drive lug to allow any one ever made to be motorized; an automatic resetting frame counter; and an interlock to prevent accidental firing of a flash unit. Also evident is another quantum leap in quality to a point equalling that of the famous Nikon F which would follow just two years later.

I've just mentioned the Nikon F, which I am sure everyone reading this book is familiar with. Almost fifteen years after being discontinued the Nikon F is still considered to be the best professional 35mm SLR ever made. Period! But what a lot of people are not aware of is that the Nikon F actually evolved from the Nikon SP! The reason I say this is that the two cameras shared a great many components. So many, in fact, that, except for their viewing mechanisms, they are actually the same camera. Some of the shared features are: the exact same wind lever and frame counter mechanisms; same shutter release and collar; same rewind lever; identical location of the PC outlet; same selftimer lever and mechanism; exact same loading procedure and removable back; same method of motorization; same 'leather' and strap lugs; same shutter speed dial; same method for keying for different types of flash; the exact same shutter right down to the interchangeable curtains; and the same body casting except that the 'F' is slightly longer to accommodate the mirror

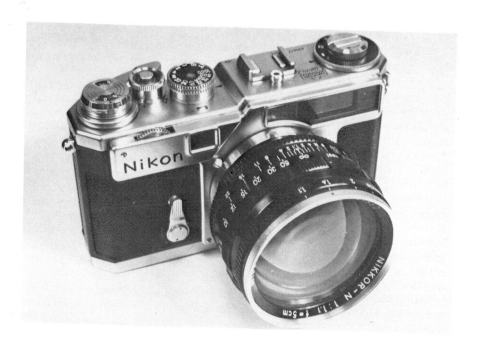

Fig. 43 and 44 *The classic Nikon SP. Shown is camera No. 6204177 with the later, external mounted, 50mm f1.1 Nikkor No. 141560 which came out in June of 1959, and was an improvement over the earlier model (1957).*

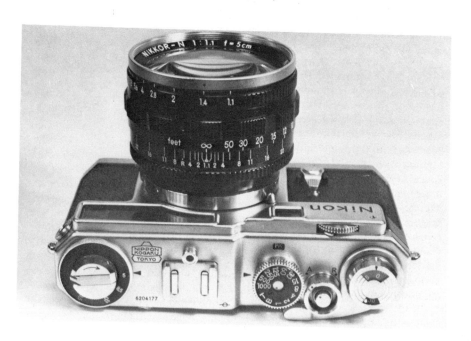

mechanism. Although the tremendously successful Nikon F was born in mid-1959, it actually evolved from a camera that had already been on the market for almost two years. And the vast success of the 'F', with over a million produced, shows that it evolved from the greatest of all the Nikon rangefinders, the model SP.

Probably the one item that has done the most to build the mystique of the Nikon rangefinders, and the SP in particular, is its electric motor drive. As stated in the chapter on the S2, the motor actually existed at least six months before the SP was released, but because the SP was introduced at the same time as its motor, and heavily promoted, this accessory has become closely identified with this model. All of this is well and good because it was the SP that caused the initial enthusiasm for a motor, and started a tradition within Nikon that continued into their SLRs and eventually made them the world leader in motorized photography as we know it today. The SP motor was capable of only one speed, 3 FPS, yet it opened up a whole new world to 35mm photo-journalism. The motor had to be adapted to a particular body exactly the same way that the 'F' motor was, and any SP ever made is capable of being motorized. The SP was the first production camera to be designed from the ground up to be motorized, with a shutter and wind mechanism capable of withstanding 3FPS operation.

The SP code was 26F2B and it was produced under order numbers 26F2B-1 through 26F2B-13. The serial number range assigned to the SP was from 6200000 to 6299999, but they never got close to filling this block. The highest SP recorded at this time is 6232141, which, taken literally, would mean that 32,141 SPs were made. But gaps do exist and the actual number made was 22,348 cameras.

There are not a great deal of variations in the SP. Black cameras were available early on with some recorded in the first 100 serial numbers. There are variations in the rapid wind lever and self-timer lever, with the major change being the shutter curtains. The Nikon F overlapped SP production by at least five years. The 'F' was introduced with titanium foil shutter curtains in June of 1959, and SPs made from about this point were also equipped with foil. This shows up at about camera 6214000, and even though it has been stated at different times that all SPs had foil, we now see that the first 14,000 or so had cloth. There is one other variation that is not generally known. It is rumoured that Nikon made an SP2 with one slight difference. It did not possess the wide angle finder. It is blanked out. I have only two SP2s recorded, 6223719 and 6215374, so it appears that they do exist. It must be pointed out that neither Nikon nor EPOI ever listed such a camera, and they may have only been made for the home market in an effort to lower the price.

Some of you may be wondering why a camera that led to the million-selling Nikon F would itself be produced in such small quantities. Part of the reason might be that the SP was heavily promoted for only two years, at which point all the ad money was put into the Nikon F. Another reason might be that, in 1959, the world was waiting for the first really successful SLR and that the handwriting was on the wall for the demise of the rangefiinder '35'. The year 1959 was a turning point in 35mm photo-graphy which eventually led to a world dominated by the SLR. Any way you look at it the SP was a total system camera of tremendous quality made for only a short period of time and in relatively small numbers. It was at the forefront in an era of cameras the likes of which we will never see again.

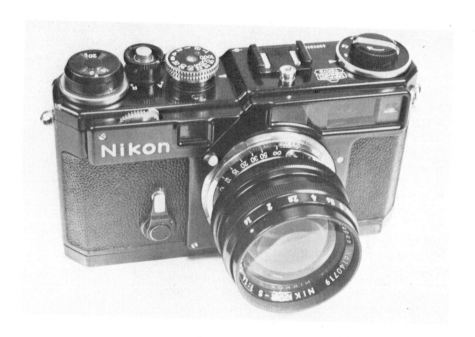

Fig. 45 and 46 *Two views of the exquisite black Nikon SP No. 6202526. Mounted is the modified 50mm f1.4 Nikkor known as the 'Olympic' lens No. 140719. This was an improved formula and differed from the standard model both internally and externally (1957).*

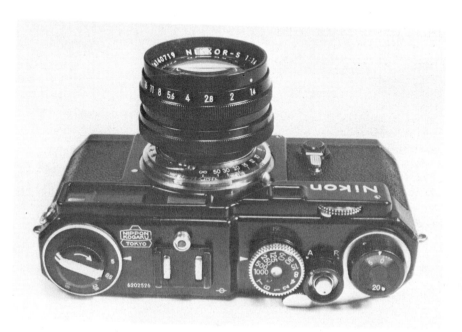

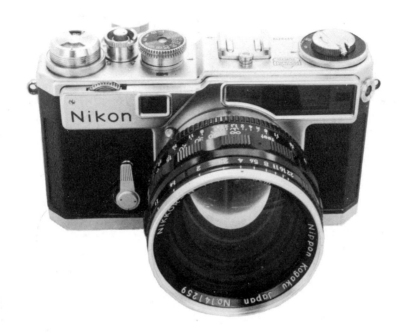

Fig. 47 and 48 *This is the rare Nikon SP2 mentioned in the text. Camera No. 6223719 with 50mm f1.1 Nikkor No. 141259. Bottom photo is the same camera with a 50mm f1.4 Nikkor and the Rangefinder Illuminator mounted (1960). (K. Watanabe)*

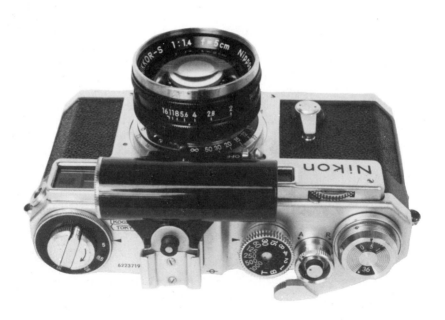

THE NIKON S3

After the introduction of the SP the Nikon S2 remained in production as a companion model, yet it was inevitable that it would soon be replaced. From an economical point of view it doesn't make much sense to have two models in production that share so few components. Nikon kept the S2 in the line for approximately six months as they readied a replacement that more closely followed the design of the SP. Finally in March of 1958 they announced a more appropriate companion for the SP and called it the Nikon S3.

This model was a logical extension of the SP and, at $60 less, made it a little easier for someone to enter the Nikon system. It was also billed as an excellent second body for those who already possessed the SP, and for this reason the two cameras were almost identical. Nikon would follow the same procedure years later with their Nikkormat series, but unlike the Nikkormat, which was really a lesser camera, the S3 owner was really getting the same quality present in the flagship of the line. At this point I would like to say that, except for one feature, the SP and S3 are absolutely identical! Many collectors do not realize this because that one feature caused a rather large difference in the appearance of the two cameras. Because of the necessary second frosted window to illuminate the projected frame lines in the SP, Nikon chose to use a long front glass that stretched from the wide angle finder over to the frosted window and covered almost half of the camera face. This large window is what gives the SP its distinctive look that no other camera possesses. In the S3 Nippon Kogaku decided to use a different finder system. Instead of projected, moving, frame lines the S3 uses etched lines for the 35, 50 and 105mm lenses with parallax markings. Since a second frosted window was no longer necessary the S3 had the more conventional looking viewfinder glass and, therefore, lost the distinctive look of the SP. Because of this the cameras do look different at first glance. However, after closer examination it becomes obvious that these two cameras are really the same. They share the exact same body casting, wind mechanism, frame counter, shutter dial, accessory shoe, rewind lever, PC outlet, self-timer lever and mechanism, removable back, wind gears and shutter. Because of the difference in the viewfinder windows the front plates are not interchangeable. Everything else, both externally and internally, was the same. The S3 uses the same motor and every one ever made can be motorized. It also accepts the same exposure meter and camera case. Except for the finders these two cameras are identical. By eliminating the wide angle finder and opting for etched lines the S3 could only be used with three lenses instead of six before accessory finders were needed. But this one change lowered the price of the camera $60 and still allowed the buyer to possess a camera with the same high standards present in the top of the line SP.

The S3 code was 26F1B and it was given the serial number block from 6300000 to 6399999 but never came close to filling it. In all 14,310 units were made including about 2000 black cameras made for the Japan Olympics in 1964. The S3 was available to the general public up to about 1961, therefore, its entire production run coincided with that of the SP. It went through the same upgrading that the SP did, acquiring foil shutter curtains after the release of the Nikon F in June of 1959. There are not a great deal of variations in the S3, major ones being the foil shutter and black finish.

Since the S3 was made in fewer numbers and yet was of the same quality as the SP, their desirability as a collectable is growing steadily.

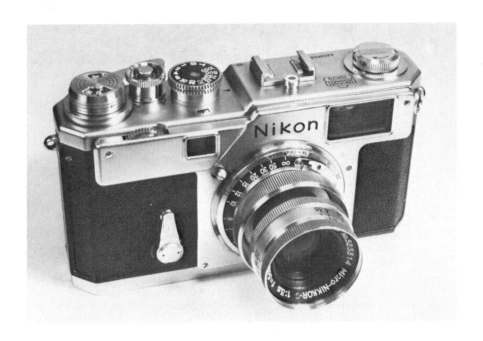

Fig. 49 and 50 *This is a very early example of the chrome Nikon S3 No. 6300046. Mounted on the camera is the elusive 50mm f3.5 Micro-Nikkor No. 523314. In 1956 this lens sold for more than the faster f1.4 Nikkor and is not very common (1958).*

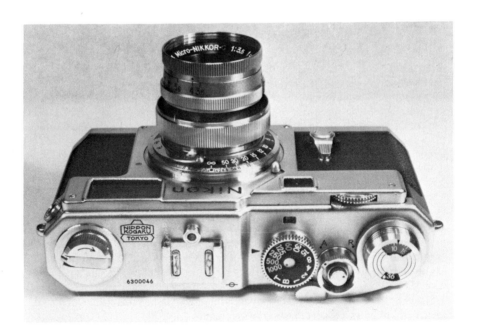

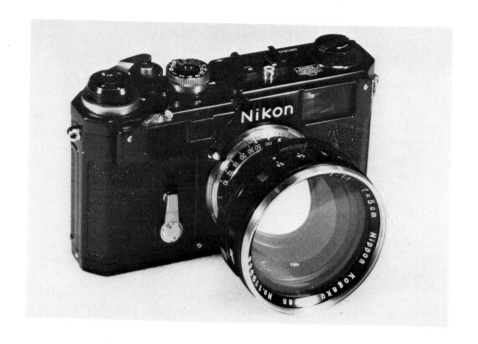

Fig. 51 and 52 *The black version of the Nikon S3. Shown is camera No. 6320540 with 50mm f1.1 Nikkor No. 119938 in the internal mount. Approximately 2000 black S3s were made which makes it the easiest of the black Nikons to obtain (1960).*

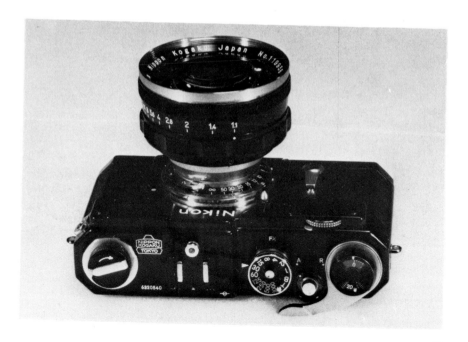

THE NIKON S4

We now come to a model that, until recently, was practically unknown in the United States. It appears that in early 1959 the people at Nippon Kogaku decided to further reduce the price of getting into the Nikon system. They took the basic Nikon S3 and removed a few features. They took off the self-timer, installed a manual resetting frame counter similar to that of the S2, removed the 35mm frame line from the finder, and left off the motor drive lug under the take-up spool. They did all of this yet retained everything else present in the SP/S3 models and called their camera the Nikon S4. The announced it in March of 1959 and then ran into a snag. Joe Ehrenreich refused it! Actually he did not need it. He had both the SP and the S3 and was waiting for his first shipments of the Nikon F which came out three months later. All that the S4 would have done was deprive sales from the S3 so you can see why Ehrenreich didn't want it. Because of this the Nikon S4 was never imported into the United States. The factory decided to go ahead with the production and sold this model in the home market, the PX system and, supposedly, South America. A total of 5898 units were made which makes the S4 one of the lowest production Nikon rangefinders.

The code for the S4 was 26F4B and it was assigned the serial number block from 6500000 to 6599999, although it appears that a few were made beginning with '63' like the model S3. Some of you at this point may be wondering why Nikon went from 6300000 to the 6500000 type numbers. What happened to 6400000? Well, that number was assigned to that success story known as the Nikon F. Actually the F was the first Nikon to exceed its number block and eventually went over 7400000, or one million units! Anyway, most S4s begin with 65 and the highest recorded is 6505899 which is one unit higher than the total production quantity so gaps do exist. As mentioned, some S4s begin with 63 like the S3. It is not known why some were given this type number, but they do exist. As far as can be determined the S4 was made only in chrome, although a black camera does exist and it has one of those 63 type numbers. Only cloth curtains have been seen, which goes along with Nikon's attempt to keep the price down.

Except for those few features that were removed the S4 is of exactly the same quality as the SP/S3 models and is identical in all other respects. It could even be motorized. Late motor manuals state this which means that the motor lug could be added and reinforces the fact that the S4 is just as good a camera as the S3.

Because it was never imported it is not known just how much less the S4 would have sold for in dollars, nor how long it was manufactured. Since less than 6000 were made a one-year production period seems logical. Many were sold in the PX shops and found their way to the US so they are available in this country, although they are much easier to find in Japan.

The reader can now see that both the S3 and the S4 are merely derivatives of the basic SP design which I mentioned earlier was the final exercise in rangefinder design at Nippon Kogaku. We now come to the final Nikon rangefinder which is also a derivative, but has a few unique features of its own.

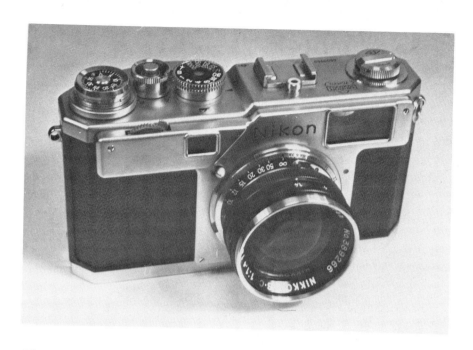

Fig. 53 and 54 *This is a 'standard' Nikon S4 from the more common '65' group. Shown is camera No. 6500950 with 50mm f1.4 Nikkor No. 389266. Note the 'EP' marking which is very common in the S4 because so many were sold in the 'PX' shops (1959).*

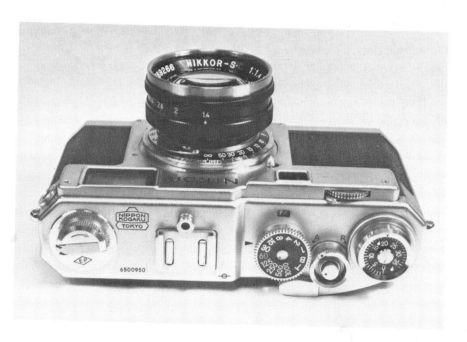

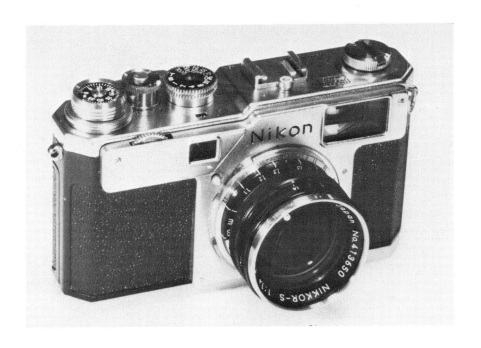

Fig. 55 and 56 *As stated in the text there is a small group of Nikon S4s that begin with '63' instead of '65'. Shown is camera No. 6322712 with 50mm f1.4 Nikkor No. 413650 (1960).*

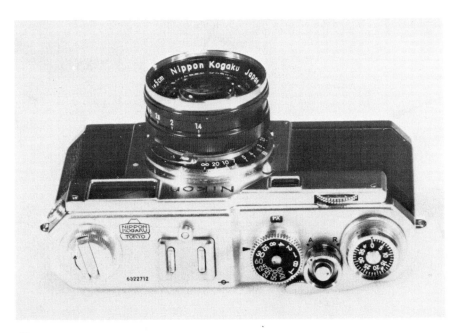

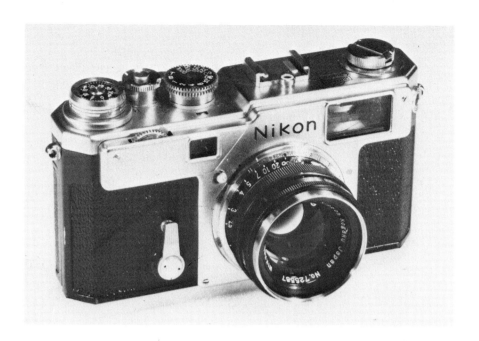

Fig. 57 and 58 *A very uncommon camera indeed! Nikon S4 No. 6504341 with 50mm f2.0 Nikkor No. 725587. This is the only example of a Nikon S4 with a selftimer known to the author (1959).*

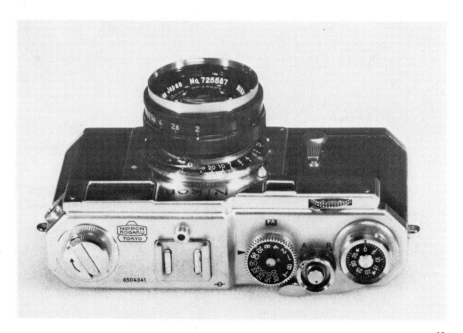

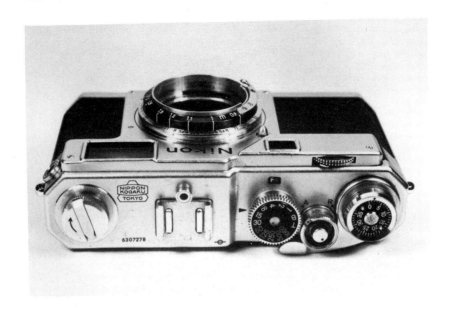

Fig. 59, 60 and 61 *Three additional examples of the rare '63' type Nikon S4. From top to bottom are cameras No. 6307278, 6304327 and 6309055. All three are in meters which suggests that these were intended for the Japanese market and never exported (1959).*

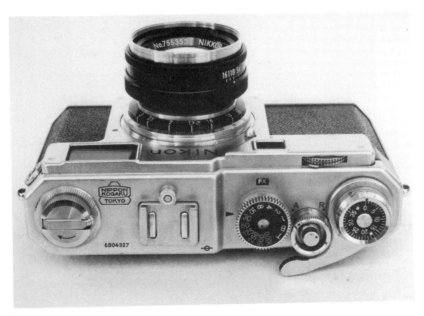

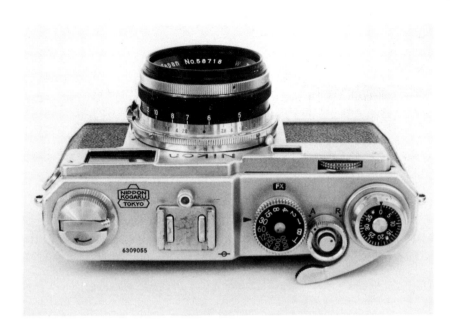

THE NIKON S3M

Even as the Nikon F was being introduced Nippon Kogaku had one final rangefinder camera on the drawing boards. It was released in April of 1960, and this one was imported by Ehrenreich. Nikon again took the basic S3 and, instead of removing features, actually added two and came up with the Nikon S3M. This camera possessed all of the features of the S3 and was not a stripped-down version like the S4. However, it possessed two features that set it apart. First, it had parallax corrected frame lines for the 35, 50 and 105mm lenses that were individually keyed by a sliding lever on the back of the camera near the viewfinder eyepiece. These were not projected like the SP, therefore the frosted window is not present, but it was better than the etched lines of the S3. The second feature made the S3M unique amongst Nikon cameras. It was the first, and only, half-frame Nikon ever made! It was Nikon's version of the Leica 72 but they went them one better. The 'M' designation meant that they were motorized. Most of the S3Ms left the factory with motors already adapted, for this camera was meant for motorized use. It had its own S72 motor and framing rates as high as 12FPS were possible. Although it was only listed in black by Nikon USA, chrome versions do exist, as do some without motors. The code for the S3M was 26F1MB and it was assigned the number block from 6600000 to 6699999, but only 195 units were produced. Serial numbers have been reported as high as 6600221 so gaps do exist. Not only is the S3M the most unique of all the Nikon rangefinders but, based on production, also the rarest.

The S3M was the final Nikon rangefinder to be released, yet both the S3 and SP were still available at its introduction. The S3 was gone soon after but the SP was still available for at least five more years. Therefore, the design that was the inspiration for these last three models outlived them all – which is only another reason why the SP is to this day the flagship of the line.

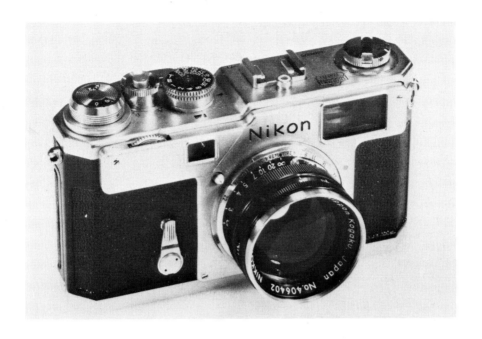

Fig. 62 and 63 *The last of the Nikon rangefinders. Nikon S3M No. 6600075 with 50mm f1.4 Nikkor No. 406402. This is the less common chrome version (1960).*

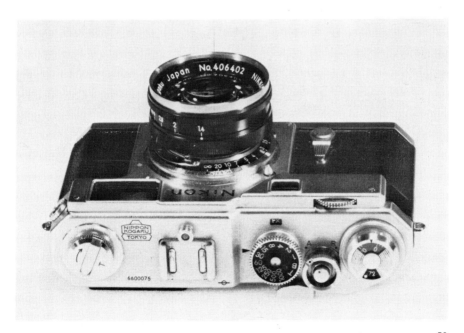

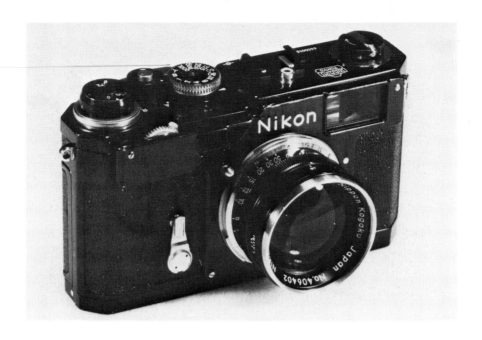

Fig. 64 and 65 *Nikon S3M No. 6600015 in black with 50mm f1.4 Nikkor No. 406402.*
It appears that the majority of these cameras were made in black (1960).

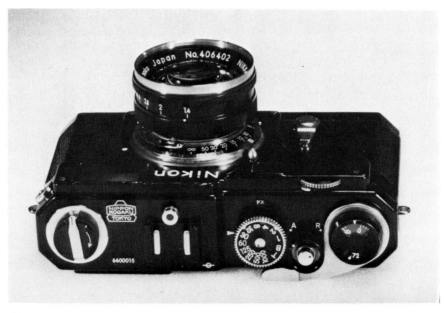

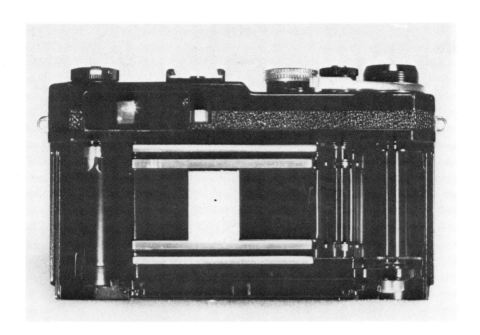

Fig. 66 and 67 *Fig. 66 is a rear view of S3M No. 6600015 showing the half-frame format. Fig. 67 is of S3M No. 6600075 with the proper S72 motor mounted. Note the lever next to the eyepiece used to change frame lines (1960).*

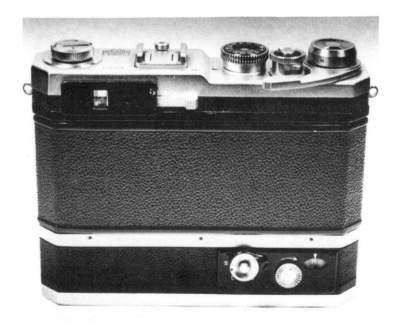

EARLY PRODUCTION

In this chapter I would like to give the reader an idea of what was going on at Nippon Kogaku in the early years, mainly 1946 to about 1955. This period is the most difficult to obtain information about, especially during the Occupation. It appears that totally precise records are not available, either because of loss or neglect. The following represents many hours of research by the author which was made a little easier with the help of fellow Nikon collectors.

When I talk about the exact number of cameras produced I mean the number which actually passed the quality tests after reaching the end of the production line. 'Order' stands for 'Production Order' which shows what, how many, and when. As soon as an order was issued production of a given product was begun, and then a report of the test results was made at the final stage. In these orders are letters and numbers (codes) identifying products. 6FB referred to the product which is now known as the Nikon.

The product codes for each type of Nikon rangefinder were as follows:

Nikon I, M and S 6FB
Nikon S2 . 16FB
Nikon SP . 26F2B
Nikon S3 . 26F1B
Nikon S3M . 26F1MB
Nikon S4 . 26F4B

Although a product was manufactured with consecutive serial numbers (usually), it was done by lot order. A production order was issued for each lot and has a discernment number following the product code to determine each consecutive lot. As far as Nippon Kogaku is concerned, the production order, 6FT-1, was issued on April 15 1946. However, this order was not a usual production order, but an order to make twenty miniature cameras as an experiment. The serial numbers engraved on these twenty experimental cameras ran continuously from 6091 to 60920. Out of the twenty cameras the following were used in the three official tests:

1st Test (the end of November, 1947) – 6094 and 60911.

2nd Test (the beginning of December 1947) – 6093, 60912 and 60917.

3rd Test (the end of December 1947) – 6095, 6098, 60914 and 60920.

In the second test another camera, 60921, was used in addition, therefore a total of ten cameras was used in the test to decide the fate of the first Nikon. However, the production order, 6FT-1, was not a usual one and the cameras produced for it should not be included in the actual production quantity. The first regular order was issued on June 10, 1946, and was called 6FB-1. The lot orders were as follows:

6FB-1 . 300 cameras
6FB-2 . 600 cameras
6FB-3 . 600 cameras
6FB-4 . 600 cameras

The above totalled 2100 units and the next order for 500 6FB-5s was not issued until four years later on March 29 1950.

```
6FB-5  . . . . . . . . . . . . . . . . . . . . .    500 cameras
6FB-6  . . . . . . . . . . . . . . . . . . . . .    500 cameras
6FB-7  . . . . . . . . . . . . . . . . . . . . .    500 cameras
6FB-8  . . . . . . . . . . . . . . . . . . . . .    500 cameras
```
6FB-9 through 6FB-43 were 1000 cameras each.

However, order 6FB-43 was changed to 1027 cameras later on so a total of 39,127 6FB type Nikons were ordered. These included types I, M and S. It seems easy, but in fact is difficult to figure out how many of each type was actually produced. That these three types of Nikons were produced under the same product code means that each type was not a completely new design, but one born of some changes in the preceding type, and they were all made on the same production line. This fact makes it difficult to determine the production quantity of each type. Actually, some Nikons produced in the early years passed the quality tests but were not considered good enough to be sold.

There is a record called 'Completion Ledger' that is regarded as an official record of production quantity in those days. This was made by the Production Management Dept. on the basis of reports from the quality tests. According to this record production quantity of each type of 6FB Nikon was as follows:

```
Nikon 1   . . . . . . . . . . . . . . . . . . .       738 cameras
Nikon M  . . . . . . . . . . . . . . . . . .       1,643 cameras
Nikon S   . . . . . . . . . . . . . . . . .       36,746 cameras
          Total   . . . . . . . . . .       39,127 cameras
```

The production orders looked like this:

	Model I	Model M	Model S
6FB-1	300		
6FB-2	438	162	
6FB-3		600	
6FB-4		600	
6FB-5		281	291
6FB-6 through			
6FB-42			1000 each
6FB-43			1027

However, these figures are not necessarily the exact ones. Since 6FB was used for three models, the production of Models I, M and S were sometimes intermixed. Order 6FB-2 is a mixture of Is and Ms, and 6FB-5 of Ms and Ss. The completion ledger says that 6FB-2 consisted of 438 Is and 162 Ms, but other records show different figures. An example is a conference dated August 4 1949, at which it was decided to stop the production of model Is after just three more cameras were made. By the meeting date 436 model Is had been completed, therefore the total would be 439 and not 438, a difference of only one unit! This would mean that 161 model Ms were made in that batch. Since the factory believes for certain that 1643 Ms were made (remember that these are Ms without flash synch and those that followed are recorded as Ss by the factory!) the figure 161 seems more likely. This causes two changes in the production ledger.

(1) The quantity of I models was 739 (300 6FB-1 and 439 6FB-2), which is larger than the completion ledger by 1.

(2) If the quantity of Ms was 1643 then there were 282 Ms out of the 500 6FB-5 cameras and the result is that one less S model was made.

The actual production quantity of Nikon Is has something to do with how camera 60921, which was used in the second test, is handled. This is the number given to the first 6FB-1 camera. However, this camera did not become the first Nikon because it was used for the experimental test, 6FT-1, and was not completed. In fact the decision to use 60921 as an experimental camera was made at a conference on March 7 1948. If this is true then 299 model Is were made in order 6FB-1 and, added to 439 in 6FB-2, gives 738 model I Nikons. This means that the first official Nikon would be 60922. It should be understood that even official records of those days remain vague.

It follows then that the serial numbers for the Nikon I ran from 60922 to 609759; M models from 609760 to 6092402; and S models from 6092403 and up (the first 1600 or so being Ms with flash synch). This is probably not exactly right because there was some intermixing and crossing of numbers in each model. It is improbable that all of the cameras were assembled in numerical order because two different models were to be produced on only one production order. All of the top plates were manu-factured and numbered at one time so in the assembly process could very well have been made slightly out of order. There was a record called the 'Nikon Product Number Ledger' for each camera on the date of completion and where it was sold, but this has been lost. So there is no method except existing cameras to check for intermixing and absent numbers.

The absent numbers are those of defective cameras which could not be sold even though they were regarded as completed by inspection reports. They were not handled by the sales people at all and their numbers were abolished.

The sales department of Nippon Kogaku has a record entitled 'Receiving, Shipping and Inventory'. This is a record of quantity. According to this, the total number of Nikon Is received is 648 units. This means that 90 of the 738 cameras produced never got to the sales department. They were not sold and those 90 numbers are absent. Since the 'Product Number Ledger' is lost it is difficult to determine those numbers exactly.

There is another reason why some Nikon Is are missing. Some of the Is sent to the sales department were converted to Nikon Ms! The 24 × 32 format was not popular so the sprocket mechanism was changed and the Model M, with a 24 × 34 format, began in August of 1949. At that time there were about 200 Nikon Is in inventory in the warehouse and, since they could not be sold any longer, it was decided to convert them to Nikon Ms and they were sent back to the factory. It is difficult to determine the exact number involved, for no order was issued, but it is thought that approximately 230 Nikon Is were converted to Ms. Therefore, the number of true Is that reached the market is in the vicinity of 400!

The numbering system began at 6091 and continued by adding digits at the end. The number of digits became too many after 6099999 so the number 6100000 was used. However, there are about 1500 S models with eight digits in their serial numbers such as 60910592 shown in this book. They are referred to as 'Eight Digit Ss' by Nikon collectors and constitute one of the few cases of odd numbering seen. Anyway, they stopped this and continued on with 6100000 and went up into the 612s. The very last Nikon S should be 6129147, if you take production quantities literally,

but of course there are gaps with cameras numbered higher, such as 6129520 shown in this book.

The Nikon S2 began at 6135000, and the reason was that the factory thought it was possible that the S would exceed 613 and left a gap of 5000 units to prevent any duplicate serial numbers. The S2 replaced the S in December of 1954. Orders for 57,000 S2 cameras were issued but actually only 56,715 were completed. The first Nikon S2 was ready in October of 1954 and only about ten cameras were completed in time for the announcement on December 10 1954. The product code for the S2 was 16FB and production orders were from 16FB-1 to 16FB-31.

The Nikon SP followed the S2 in September 1957, and they were actually made concurrently for about six months. The SP code was 26F2B and it was produced under order numbers 26F2B-1 through 26F2B-13. Full production was for only two years, or until 1959. Production was suspended for a while after the Nikon F came out, but demand caused the final two production numbers, 12 and 13, to be made. The final production run, 26F2B-13 was to be 1000 cameras, but in fact only 994 were made. The total quantity of SP models was 22,348. Serial numbers began at 6200000 and you would think that it should end at 6222348, but in actuality goes into the 6230000s because of gaps.

NIKON I PRODUCTION DATES

Month	Quantity	Serial Numbers
11/47	2	6091-6092
12/47	2	6093-6094
01/48	0	—
02/48	8	6095-60912
03/48	2	60913-60914
04/48	9	60915-60923
05/48	33	60924-60956
06/48	11	60957-60967
07/48	4	60968-60971
08/48	2	60972-60973
09/48	9	60974-60982
10/48	76	60983-609158
11/48	31	609159-609189
12/48	121	609190-609310
01/49	40	609311-609350
02/49	85	609351-609435
03/49	85	609436-609520
04/49	42	609521-609562
05/49	91	609563-609653
06/49	60	609654-609713
07/49	44	609714-609757
08/49	1	609758

The SP was followed by the S3 in March of 1958 and made concurrently. S3 production totalled 14,130 units including approximately 2000 black cameras made in a special run in 1964. The S4, a simplified version of the S3, came out in March of 1959 but was never imported into the United States, and the total production was only 5898 cameras. The last Nikon rangefinder model was the S3M half-frame camera which debuted in April of 1960 and of which only 195 cameras were completed.

From the table below the reader can see how monthly production varied considerably in these early years. Note that in August of 1949 only one Nikon I was constructed along with 33 Nikon M bodies. This was the month that Nippon Kogaku shifted from the I to the M model. November 1950 was the last month that cameras were made without flash synch. The next month began the production of the Nikon with synch called the Nikon S within the factory, although the following 1600 cameras would still have the 'M' in their serial number. Body No. M6092401 is not the absolute breaking point for there is some intermixing of numbers with unsynched cameras showing up with later numbers as well as earlier numbered bodies with synch. These numbers are based on actual monthly production figures and do not take into account any intermixing caused by carelessness on the assembly line which caused some cameras to be constructed slightly out of numerical order.

NIKON M PRODUCTION DATES

Month	Quantity	Serial Numbers
08/49	33	609759-609791
09/49	27	609792-609818
10/49	49	609819-609867
11/49	53	609868-609920
12/49	70	609921-609990
01/50	108	609991-6091098
02/50	101	6091099-6091199
03/50	103	6091200-6091302
04/50	136	6091303-6091438
05/50	87	6091439-6091525
06/50	170	6091526-6091695
07/50	200	6091696-6091895
08/50	50	6091896-6091945
09/50	230	6091946-6092175
10/50	200	6092176-6092375
11/50	26	6092376-6092401
12/50	Flash synch added. Begin production of Nikon S. (Nikon M with synch).	

PRODUCTION QUANTITIES OF
CAMERA BODIES BY BATCH NUMBERS

6FB (Nikon I, M and S)

6FB-1	300	6FB-12	1000	6FB-23	1000	6FB-34	1000
6FB-2	600	6FB-13	1000	6FB-24	1000	6FB-35	1000
6FB-3	600	6FB-14	1000	6FB-25	1000	6FB-36	1000
6FB-4	600	6FB-15	1000	6FB-26	1000	6FB-37	1000
6FB-5	500	6FB-16	1000	6FB-27	1000	6FB-38	1000
6FB-6	500	6FB-17	1000	6FB-28	1000	6FB-39	1000
6FB-7	500	6FB-18	1000	6FB-29	1000	6FB-40	1000
6FB-8	500	6FB-19	1000	6FB-30	1000	6FB-41	1000
6FB-9	1000	6FB-20	1000	6FB-31	1000	6FB-42	1000
6FB-10	1000	6FB-21	1000	6FB-32	1000	6FB-43	1027
6FB-11	1000	6FB-22	1000	6FB-33	1000		

Total = 39,127 cameras

16FB (Nikon S2)

16FB-1	2000	16FB-9	1000	16FB-17	2000	16FB-25	2000
16FB-2	2000	16FB-10	1000	16FB-18	2000	16FB-26	2000
16FB-3	2000	16FB-11	2000	16FB-19	2000	16FB-27	2000
16FB-4	2000	16FB-12	2000	16FB-20	2000	16FB-28	2000
16FB-5	2000	16FB-13	2000	16FB-21	2000	16FB-29	2000
16FB-6	1000	16FB-14	2000	16FB-22	2000	16FB-30	2000
16FB-7	1000	16FB-15	2000	16FB-23	2000	16FB-31	1715
16FB-8	1000	16FB-16	2000	16FB-24	2000		

Total = 56,715 cameras

26F2B (Nikon SP)

26F2B-1	400	26F2B-5	2000	26F2B-9	2000	26F2B-13	994
26F2B-2	2000	26F2B-6	2000	26F2B-10	2000		
26F2B-3	2000	26F2B-7	2000	26F2B-11	1500		
26F2B-4	1998	26F2B-8	2000	26F2B-12	1456		

Total = 22,348 cameras

26F1B (Nikon S3)

26F1B-1	300	26F1B-4	2000	26F1B-7	2010	26F1B-10	2000
26F1B-2	2000	26F1B-5	2000	26F1B-8	Cancelled!	(Olympic)	
26F1B-3	2000	26F1B-6	2000	26F1B-9	Cancelled!		

Total = 14,310 cameras

26F4B (Nikon S4)

26F4B-1	2000	26F4B-2	2000	26F4B-3	1898

Total = 5898 cameras

26F1MB (Nikon S3M)

26F1MB-1	100	26F1MB-2	95

Total = 195 cameras

DISPLAY "DUMMY" NIKONS

Nippon Kogaku has supplied display, or 'Dummy', cameras to dealers for many years. The earliest known example is a Nikon S camera No. 6108988 with a chrome 1.4 Nikkor No. 337311 which is also a 'Dummy'. At this time it is the only example of a Dummy Nikon S seen by the author but more may be found. It is not known if any Dummy Model I or M Nikons were made, but it does seem unlikely. The most commonly found Dummy rangefinder Nikon is the model S2. To date the author has inspected five such Dummies and knows of at least one more. An unusual point is that no Dummy Nikons of later vintage, such as the SP, S3, S4 or S3M have been found, yet if the S2 was made surely some of the later models were also. It is known that Dummy Nikon F and F2 cameras were produced which bracket the post-S2 rangefinders, so it is possible that the SP and S3 models could have been made. Since most of the information is available on the Dummy Nikon S2, this chapter will be devoted to that model to give the reader some idea of what to look for when searching for this camera.

Nikon did not give their display cameras special serial numbers or markings of any kind. Actually a Dummy S2 will go unnoticed until it is held in one's hand because they appear identical to the production cameras. It seems that when the decision was made to produce some display cameras a small batch was simply removed from the assembly line at a certain point, which accounts for the fact that their serial numbers fall within the standard production numbers. The Dummy cameras are identical to the regular models in that all external parts are the same and cannot be told from the real thing until actually inspected. Internally there are many differences. The film guide rails have not been polished and appear the same black as the rest of the interior. This casting was taken through all production steps save this polishing procedure. No shutter curtains are present nor any rangefinder parts. Only a plain front glass is used on the windows and eyepiece and the rangefinder cam is also missing. The focusing wheel does move but it is not coupled to the mount although this mount also moves, as on the standard cameras. The wind and rewind levers also work but they are not connected to anything. The shutter release button and synchro dial are frozen but the A-R collar does rotate. The slow speed dial will rotate but the high speed dial is frozen in place, therefore many external parts do operate while others do not. The camera back is removed in exactly the same way and has a functional back lock. However, in most cases there is no pressure plate on the back, although one example does have this. The body covering appears identical except in one case where it has a more coarse and cheaper feel to it. All of the above makes the Dummy S2 appear to be a production camera until closely inspected, and one can see that, as a display item, it appeared to be quite real.

The lens supplied with the cameras was always the 50mm f1.4 Nikkor which also possessed regular production serial numbers. Since all Dummies seen have been early chrome dial S2s all the 1.4 lenses have also been chrome, although black ones may exist, especially if Dummy SP and S3 cameras were made. The lenses have a front glass that appears real but no other elements are present. The diaphragm ring is frozen and no blades are used in these lenses. All but one seen are blackened internally to reflect light like a real lens with one example still shiney chrome.

The serial numbers on the Dummies seen to date generally show that these display cameras were produced in batches. Numbers recorded by the author are: Nos.

6135700, 6137600, 6137628, 6141482, 6141505 and 6141633. The lenses, in the same order as the bodies are: Nos. 357033, 356944, 356305, 355306, 344562 and 356781, most of which are from the same vintage. An interesting point is the type of number seen on the camera backs. These differ from those on the top plates and most fall within the very early S2 production numbers. The Nikon S2 began at No. 6135000 and the back numbers on these Dummies include Nos. 6135042, 6135058, 6135079 and 6136043. Three of these numbers are amongst the first 100 allotted numbers for the production S2s! Whether or not these numbers were used on production cameras, or that these early backs did not pass inspection and were later used on the Dummies, is not known. The author has yet to record a production camera with the same number as any one of the backs. Another point is that some of these backs have the serial and patent numbers painted in in white, which is never seen on the production cameras.

More information needs to be found concerning the Nikon rangefinder Dummies. It was only a little over one year ago that the first Nikon S Dummy was found so it is possible that other models were made, especially the SP and S3. It is doubtful that a Dummy I, M, S4 or S3M was ever made since those models were such low production items, but anything is possible!

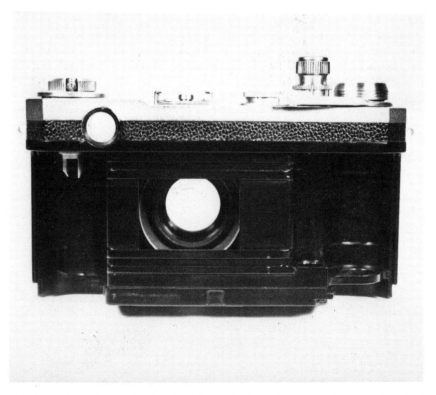

Interior view of 'Dummy' Nikon S2. Note lack of any shutter curtains, sprocket wheel and take-up spool. The film guide rails have not been polished. Camera No. 6137628.

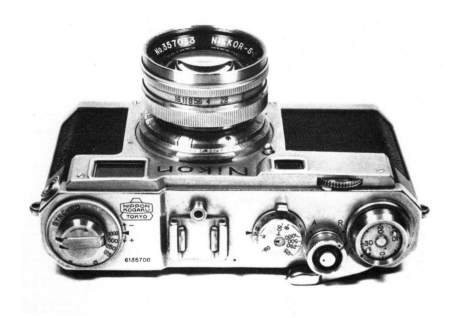

Four Nikon S2 'Dummy' display cameras.
No. 6135700 with f1.4 No. 357033.
No. 6137628 with f1.4 No. 356305.

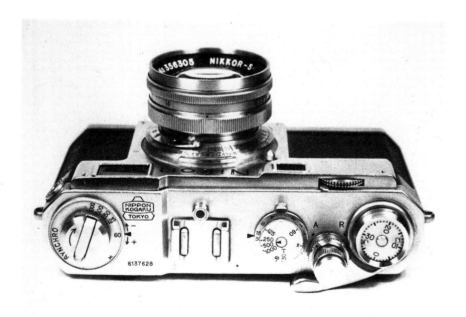

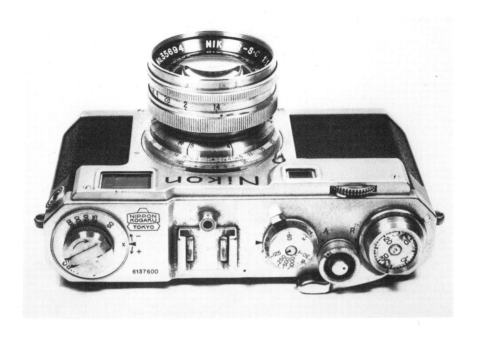

No. 6137600 with f1.4 No. 356944.
No. 6141633 with f1.4 No. 356781.

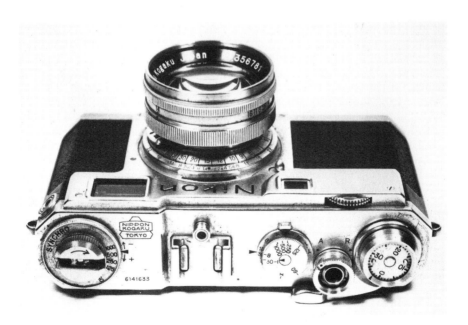

PART II

INTRODUCTION

The first part of this volume incorporates, with some additions, the original book written by the author, which was published in June 1981. That first book, entitled 'The Nikon, an Illustrated History of the Nikon Rangefinder Series', dealt primarily with the evolution of the various camera models produced by Nikon during the period of years they were involved with the rangefinder type camera. It was a self-published book that was done as a labour of love and fulfilled a dream that this author had had for many years. Because of costs I was limited to approximately eighty pages and a press run of 1100 copies. I had to abandon any thoughts of making it a hardbound edition and decided to handle the advertising and distribution myself. I had been working on the manuscript for over a year, and it included both the cameras and lenses, but because of size and cost limitations I had to limit myself to just the camera variations, which I thought to be the most important items. Fortunately, the first book was a complete sell-out and has been unavailable since August 1982. The fact that the entire printing did sell, plus the many calls and letters I have received from those who purchased it requesting a follow-up book on lenses and accessories, prompted me to continue to develop the manuscript pertaining to these items. I began photographing the many lenses and accessories within six months after the release of Book I, with the hope that a second, and much more comprehensive, book was more than just a dream. Fortunately, Mr. D.R. Grossmark, the dream became a fact. This volume contains all the information, plus additional photographs, from Book I, plus a detailed discussion of the many lenses and accessories made for the Nikon rangefinder system. This second venture became a much larger undertaking than the first for the simple reasons of the sheer quantity of equipment to be covered, and that a larger percentage was not in the author's own collection. I required the assistance of fellow Nikon collectors to bring together actual examples of nearly ninety-five percent of all the known variations in the lenses and accessories. All who helped proved to be very generous and supplied me with either photographs, or actual examples, of many rare and unusual Nikon items. For their help I wish to acknowledge the following gentlemen: John Angle who is a new, but extremely enthusiastic, Nikon collector; my friend from Michigan who requests anonymity; Tsuyoshi Konno from Tokyo, who is a leading Japanese collector; Bill Kraus who is the owner of one of the major collections in North America; and Akito Tamla, also of Tokyo, and a member of the Nikon Club in that country. Each provided items lacking in my collection and without which this book would have been incomplete. Gentlemen, my sincere gratitude.

I hope that all those who called or wrote requesting this book will feel that it was worth the wait. I also have great hopes that this book will reach many more collectors than was possible with the first one. With the help of Hove Foto Books I feel this to be much more than just a dream.

ROBERT ROTOLONI
March 31, 1983

HISTORY

Any history of the Nikon camera and Nippon Kogaku is, by necessity, a history of optical design and technology. As mentioned in the historical chapter in Book One, Nippon Kogaku was, from the beginning, an optical manufacturer first and a camera manufacturer second. This optical heritage was briefly described in Book One. However, since that first book was basically about cameras, and not the lenses, emphasis was put on the development of that part of the system. The author would now like to devote more time to the historical and technical aspects of the famous Nikkor lens system which was, in reality, what the reputation, and eventual dominance, of the Nikon founded on.

Nippon Kogaku began the process of melting optical glass in 1918, only one year after its founding. Although most of its initial production was for military purposes, they quickly diversified. By 1929 they were making aerial lenses for the military but had also begun research and development of other types of optical equipment including camera lenses for general use. By 1932 the name 'Nikkor' could be found on lenses of 75mm, 105, 120, 180, 500 and 700mm! Within five years their 50mm f4.5, 3.5 and 2.0 lenses were ready and made available on the famous Hansa Canon of 1937. Before the start of World War II the 50mm f1.5 had been designed as well as the 35mm f3.5, although they were not yet being actually produced. For the duration of the War they were preoccupied with fulfilling military orders and further development of photographic lenses, except the aerial type, was abandoned. After the end of the War they were reorganized for civilian production only, which is where the history of Nikon, and photography, became intertwined to the benefit of the entire photographic world.

Development of the Nikon I began in late 1945 and early 1946, but it would not be ready until March 1948. During this time Nippon Kogaku produced their 50mm f3.5 and 2.0 lenses in both Canon bayonet and Leica screw mounts. They also may have begun to make the 135mm f4.0 Nikkor-Q sometime in 1947, probably in screw mount only. Since they were bringing their camera closer to its final design, development of the original series of Nikkors that were released with the Nikon I had also begun. In March 1948 the camera was ready and so were five Nikkors, now in a Contax type bayonet mount. Those five original Nikkors were the: 35mm f3.5; 50mm f3.5 and 2.0; 85mm f2.0 and the 135mm f4.0. All, except possibly the 85mm, had been made previously and were not new to Nikon, but were now mounted for their camera. A sixth lens, the 50mm f1.5, was added in late 1949 or early 1950, and by the time the Nikon M was released in March 1950 the 1.5 was replaced by the famous 1.4 and the 135mm f4.0 was changed to an f3.5 design. The year 1950 was a turning point for Nikon, for the Korean War had begun, and it was at this time that the Nikon, and its lenses, were 'discovered'.

It is an interesting story with a cast of world-famous photographers and a noted writer. It all started in June 1950 when David Douglas Duncan and Horace Bristol, of *Life* magazine, were in Tokyo on their way to shoot the Korean conflict. A young Japanese photographer showed them photos taken with an 85mm f2.0 Nikkor that were extremely sharp. When Duncan and Bristol learned that it was made only a few miles away they went to the factory and obtained permission to choose lenses and cameras at random. They discovered that they could duplicate the results with ease. Duncan acquired an entire set of Nikkors in screw mount to use on his Leicas, and

shot the entire War with them. His famous book, 'This Is War' was shot with a Leica camera, but every photo was made through a Nikkor lens! Bristol also used them on his Leicas and Carl Mydans acquired a set for his Contaxes. In August Hank Walker arrived and discarded his cameras and went on to shoot the War with a late model Nikon camera and its lenses. After returning to New York, Duncan and Mydans brought their newly acquired lenses and cameras to Eastern Optical Co. for testing. Their optismistic field reports were confirmed and *Life* magazine purchased a considerable number of camera and lens outfits for their staff, as did *Look* magazine. Word spread quickly amongst professionals about the superior resolving power, and amazing consistency, of these unknown Japanese lenses. Finally, on December 10 1950, Jacob Deschin, in his Sunday *New York Times* photography column, told the entire story and the rest is history.

Thus the words 'Nippon Kogaku', 'Nikon' and 'Nikkor' were introduced to the photographic world, and the ascent of Nikon began. Eventually the demand for these 'new' cameras and lenses exceeded supply. Nippon Kogaku then began a feverish programme of upgrading and designing new lenses and optical equipment for their new-found worldwide customers. An example of how quickly they progressed is a 1954 catalogue. It states that over 70 percent of their production was now being exported and that they were producing 80 different types of glass. Some of the items shown besides cameras and lenses were: binoculars, microscopes including polarizing and stereoscopic types, Apo-Nikkors for photo-engraving, movie and projector lenses, transits, levels, surveying instruments, shadowgraphs, micro-testers, coronagraphs and astronomical telescopes, eyeglass lenses and other technical and scientific equipment. Also shown, of course, is their camera which is now complemented by ten lenses plus finders, flash units, close-up attachments and microscope adapters. Truly astonishing growth!

The lenses made for the Nikon rangefinder system are many and varied. Each type will be discussed in following chapters by focal length and speed. To prevent repetition when describing each lens the author wishes, in this chapter, to describe general characteristics and trends within the system.

Optical Formula: A fine point to remember is that the optical formula of any given Nikkor was finalized before introduction and would remain basically unchanged throughout the life of the lens. Since Nippon Kogaku started to coat lenses as early as 1945, all lenses made for the Nikon were coated from the beginning. The post-war period saw most manufacturers intent on advertising that their lenses were coated because it was an important selling point. Nippon Kogaku did the same and actually marked their lenses as such. The identification ring at the front of every Nikkor contained specific information. Included were the name of the company, focal length, speed and the word 'Nikkor' followed by two letters. The first letter determined either that the lens was a wide-angle (the letter 'W') or designated the number of elements (for normal lenses and longer) using the Greek or Latin alphabet. The first letter was then followed by a red 'C' which stood for coated, and not Contax, as some believe. Nikon would retain this red 'C' up until about 1957 or 1958 when it was deleted, probably because the general public assumed that all lenses were being coated by that date. Therefore, lenses made before and after this date can be found with, and without, the 'C' engraving. Since they are identical they cannot be classified as a variation but it needs to be mentioned to prevent any confusion.

Examples are as follows:

35mm f3.5 Nikkor would be engraved:

Nippon Kogaku Japan No. W-Nikkor-C 1:3.5 f = 3.5cm

50mm f.1.4 Nikkor-S would be engraved:

Nippon Kogaku Japan No. Nikkor-S-C 1:1.4f = 5 cm

By reading the identification ring the owner could determine exactly what he had. The 'S' on the 50mm f1.4 stood for 'Septem', or seven, for it had seven elements. The red 'C' only means that it is coated and would later be deleted. The 35mm has the 'W' meaning wide-angle and no designation of the number of elements was used. The only exception was the 21mm f4.9 Nikkor-O which came out very late. The 'O' meaning 'Octo', or eight elements. For the reader's information the letters used were as follows:

U for 1 element (Uns)
B for 2 elements (Bini)
T for 3 elements (Tres)
Q for 4 elements (Quatour)
P for 5 elements (Pente)
H for 6 elements (Hex)
S for 7 elements (Septem)
O for 8 elements (Octo)
N for 9 elements (Novem)
D for 10 elements (Decem)

It is interesting to note that Nikon would use this system of nomenclature on all the lenses made for the Nikon F reflex series up to at least 1974!

Vintage: Three basic identification points can be used to determine the vintage of a lens besides the serial number. On all lenses made during the Occupation, and for a short time after, Nikon used the words 'Nippon Kogaku Tokyo' on the front ring. After the Occupation this was changed to 'Nippon Kogaku Japan'. Lenses marked 'Tokyo' are older and actually belong on either the Nikon I, M or very early S models. Any lens that was introduced during the Occupation, and still being made after, can be found with both the 'Tokyo' and 'Japan' engravings.

The second point is the barrel. Most lenses introduced before 1956 were in chrome on brass barrels. If that same lens was still being made after 1956 it was changed to a black painted aluminium barrel, but there are exceptions. Certain lenses were initially made in black and never in chrome, and two lenses were made only in chrome and never changed to black. Examples of lenses that were eventually changed to black from chrome are: 25/4.0, 28/3.5, 35/3.5, 35/2.5, 50/2.0, 50/1.4, 85/2.0 and the 135/3.5. Those lenses that were black from the beginning and never made in chrome are: 21/4.0, 35/1.8, 50/1.1 – both internal and external – 50/1.4 Olympic, 85/1.5, 105/2.5, 105/4.0, 135/4.0 short mount and the lenses made for the reflex housing such as the 180, 250, 350, 500 and 1000mm. Two lenses that were never changed even though they were made after 1956 are the 35mm Stereo-Nikkor and the 50mm Micro-Nikkor. There were also a few lenses made during the early years that did not last until 1956 and were made only in chrome. They are the: 50/3.5 and 2.0 collapsibles; 50/1.5 and the 135mm f4.0 Nikkor from the Occupation.

The third point is the presence, or lack of, the red 'C' engraving on the front ring.

Usually this was removed by 1957 or 1958 and can be used as a guide to date lenses in black mounts.

One other item to remember is that Nikon would lighten their lenses as time passed. The only fault that Duncan and the others could find with their new Nikon equipment was weight. They thought that most items were too heavy and would benefit by losing some weight, and Nikon obliged. Some lenses were lightened only when changed to black but others had even their chrome barrels changed, especially those made from the Occupation on. A rule would be that a lighter lens would be a later lens.

In an effort to graphically simplify all of the above the author has constructed a table as a guide. Listed is every lens Nikon made plus its proper nomenclature, number of elements, MIOJ or not, if the red 'C' was ever used and whether or not it was made in chrome and/or black.

TABLE OF LENSES

	Elements	MIOJ?	Chrome	Black	'C' (yes/no)
21mm f4.0 Nikkor-O	8	No	No	Yes	No
25mm f4.0 W-Nikkor	4	No	Yes	Yes	Both
28mm f3.5 W-Nikkor	6	No	Yes	Yes	Both
35mm f3.5 W-Nikkor (old)	4	Yes	Yes	No	Yes
35mm f3.5 W-Nikkor (new)	4	No	Yes	Yes	Both
35mm f2.5 W-Nikkor	6	No	Yes	Yes	Both
35mm f1.8 W-Nikkor	7	No	No	Yes	Both
35mm Stereo-Nikkor	4	No	Yes	No	No
50mm Micro-Nikkor	5	No	Yes	No	Both
50mm f3.5 Nikkor-Q	4	Yes	Yes	No	Yes
50mm f2.0 Nikkor-H (collapsible)	6	Yes	Yes	No	Yes
50mm f2.0 Nikkor-H	6	Yes	Yes	Yes	Both
50mm f1.5 Nikkor-S	7	Yes	Yes	No	Yes
50mm f1.4 Nikkor-S	7	Yes	Yes	Yes	Both
50mm f1.4 Nikkor-S (Olympic)	7	No	No	Yes	No
50mm f1.1 Nikkor-N (Int.)	9	No	No	Yes	Yes
50mm f1.1 Nikkor-N (Ext.)	9	No	No	Yes	No
85mm f2.0 Nikkor-P	5	Yes	Yes	Yes	Both
85mm f1.5 Nikkor-S	7	No	No	Yes	Both
105mm f4.0 Nikkor-T	3	No	No	Yes	No
105mm f2.5 Nikkor-P	5	No	No	Yes	Both
135mm f4.0 Nikkor-Q	4	Yes	Yes	No	Yes
135mm f4.0 Nikkor-Q (Bellows)	4	No	No	Yes	Both
135mm f3.5 Nikkor Q	4	Yes	Yes	Yes	Yes
135mm f3.5 Nikkor-Q (New)	4	No	No	Yes	Both
180mm f2.5 Nikkor-H	6	No	No	Yes	Both
250mm f4.0 Nikkor-Q (Manual)	4	No	No	Yes	Yes
250mm f4.0 Nikkor-Q (Preset)	4	No	No	Yes	Both
350mm f4.5 Nikkor-T	3	No	No	Yes	No
500mm f5.0 Nikkor-T	3	No	No	Yes	Both
1000mm f6.3 Reflex-Nikkor	3	No	No	Yes (also grey)	No

70

Nippon Kogaku would mark anything made during the Occupation with the 'Made in Occupied Japan' engraving, which the author abbreviates as MIOJ for simplicity. One exception would be the normal lenses of which none marked MIOJ have yet been found. All the other lenses from the period are so marked and it is unknown why the normals were not, for there is sufficient room on the barrels. Also the lenses from the Occupation lacked clickstops, with the exception of the 50mm f1.4 Nikkor-S. When a lens was still made after the Occupation the clickstops were added as well as additional f-stops. Examples of this are the 35mm f3.5 which went from f16 to f22, and the 85mm f2.0 and 135mm f3.5 lenses which went from f16 to f32!

QUANTITY: The reader will notice that all quantities listed are approximate figures. This is because no definitive numbers are available from Nippon Kogaku. In order to arrive at a close approximation the author had to resort to a method he has used for over a decade. Beginning in 1969 every serial number seen by the author has been recorded, along with certain characteristics such as chrome or black, MIOJ or not, the presence or absence of clickstops and other small bits of information. By listing all these serial numbers in numerical order, by lens or accessory type, a definitive picture begins to unfold. The determining factor is the quantity of recorded serial numbers. To date the author has acquired approximately 5,000 assorted numbers. Some items have been easier to compile simply because they are common, such as the normals. Others have been difficult because of their relative scarcity, such as the Stereo-Nikkor. However, with a lot of hard work, and a fair share of luck, a representative sampling of serial numbers has been compiled for most of what Nippon Kogaku produced. Fortunately each item was given its own type of serial number. Some retained just one type of number and simply progressed numerically upward. Others may have as many as three different serial number types, yet each type progresses normally and can be mapped out. If a quantity of early, as well as late, numbers can be found, the range for a particular item can be deduced. The author has acquired many numbers from fellow collectors from as close as Chicago and New York, to as far afield as Tokyo, Hong Kong and Switzerland. By discussing these figures with other knowledgeable Nikon collectors a 'picture' of Nikon range-finder production can be seen. It is the combination of all these recorded serial numbers, plus some deductive reasoning, that has allowed the author to make a reasonably accurate estimate of production for each item covered. However, the author would be the first to admit that these figures are only approximate. Even though they have been well researched, in the end they are still estimates, which can be improved on. The author hopes to someday gain access to records at Nippon Kogaku which, hopefully, would improve the picture. Until that can be done the constant collecting and cataloguing of serial numbers will continue in the hope of shedding more light on this fascinating system from the era of the great rangefinder '35s'.

21mm f4.0 NIKKOR-O

Introduced:	June 1959
Apertures:	f4.0–f16
Angle of View:	92 degrees
Elements:	8
Foc. range:	3ft to Inf.
Filter size:	43mm
Weight:	4.5 ounces
Original Price:	$199.50
Quantity:	Approx. 500

Although it is the widest of all the RF Nikkors, the 21mm f4.0 Nikkor-O was one of the last to be introduced. It was announced at the same Exhibition that saw the introduction of the 50mm f1.1 with external bayonet mount, the 350mm and 1000mm short mount lenses, and the famous Nikon F reflex. Because it came out so late it remained in production for only a short period of time, possibly less than two years. The last listing in Nikon price sheets is December 1961. Identical in optical formula to the reflex version, also shown at the same time, the RF 21mm lens closely resembles the type of barrel used on the reflex lenses. Made only in satin black with more modern engravings, it follows a pattern of design used by Nippon Kogaku for its reflex lenses during the 'sixties and early 'seventies. Faster than the contemporary Zeiss lens, it also benefited optically by coming out at such a late date. It contained rare earth elements and special coatings that would have made it impossible to produce just a few years earlier, and it compares well with current wide-angle lenses.

Because of its short run the 21mm f4.0 Nikkor-O is a rather difficult item to find today, nearly 20 years after being discontinued. From recorded serial numbers it appears that less than 500 were ever made. The range of numbers seen to date are from No. 621000 to a high of No. 621330 illustrated here, although they probably do run higher.

A special screw-in shade was available as was a special rear cap designed to mount the separate optical finder. The finder made for the RF version was distinct from that made for the Nikon F reflex because of a difference in the style of mounting shoe, and are not interchangeable.

Protruding less than one inch when mounted, the 21mm f4.0 Nikkor-O makes for a very compact shooting arrangement and is highly prized today for both its quality and its scarceness.

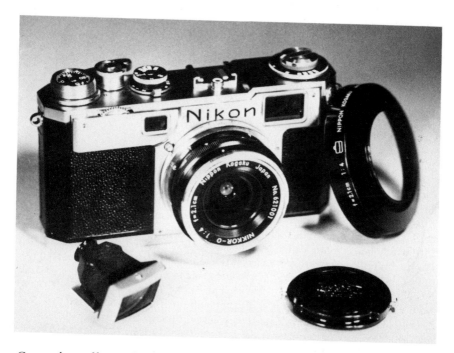

Group photo of lens with its finder, cap and scarce shade. Lens is No. 621001 which is the first production 21mm Nikkor!

21mm Nikkor No. 621330 (1959)

Nikon 21mm optical finder

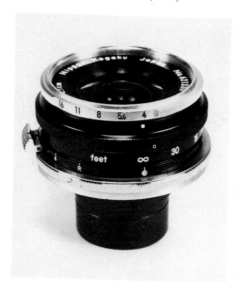

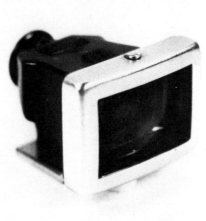

25mm f4.0 NIKKOR

Introduced:	November 1953
Apertures:	f4–f22
Angle of View:	80.5 degrees
Elements:	4
Foc. range:	3ft to Inf.
Filter size:	Series VII
Weight:	4.5 ounces (chrome) – 2.5 ounces (black)
Original Price:	$169.50
Quantity:	Approx. 2500

First marketed in November of 1953, the 25mm Nikkor became available just one year before the release of the Nikon S2. This is less than six years after Nippon Kogaku made their first camera. It remained the widest of all Nikkors for six years until the introduction of the 21mm lens. It was listed in price sheets until at least late 1961 which gave it a production run of eight years. A perfectly symmetrical optical formula and the use of rare earth elements allowed it to deliver exceptional flatness of field and minimum vignetting. It was first made in a chrome on brass mount from No. 402500 to about No. 403500, then a lighter black mount up to about No. 405000, for a total production in the area of 2500 units. It is an extremely compact lens because of its unique diaphragm and focussing mechanisms. The user would actually reach into the recessed barrel to change stops and the focussing was controlled by the wheel on the camera since the lens lacked an external focussing ring of its own. This allowed for a very compact barrel that protrudes less than one half-inch when mounted. It used a bayonet type system for mounting both the lens cap and Series VII shade which are unique to this lens. Also a special deep set plastic rear cap was made. A high quality optical finder was made and was necessary since no Nikon camera ever had a built-in viewfinder this wide.

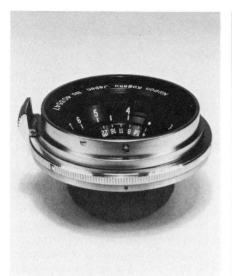 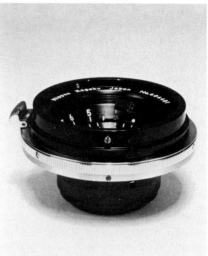

Chrome 25mm Nikkor No. 403547 (1953) *Black 25mm Nikkor No. 404481 (1956)*

Black 25mm lens on black SP No. 6200082 with finder and shade

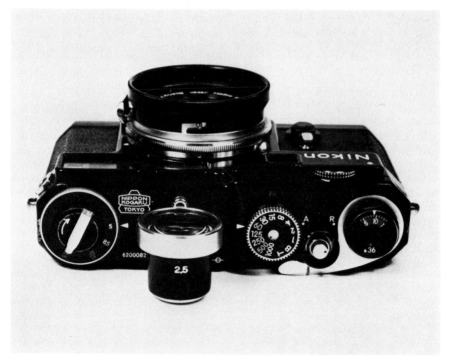

28mm f3.5 NIKKOR

Introduced:	1 September 1952
Apertures:	f3.5–f22
Angle of View:	74 degrees
Elements:	6
Foc. range:	3ft to Inf.
Filter size:	43mm
Weight:	5.0 ounces (chrome) – 3.4 ounces (black)
Original Price:	$149.50
Quantity:	Approx. 10,000

Only the second wide angle lens to be designed for the Nikon rangefinder series, the 28mm Nikkor came out in late 1952 and was listed as late as April 1964, making it one of the longest running lenses for the system. Because of its relatively low price, less than that of the 1.4 normal, it proved to be a very popular lens with approximately 10,000 having been made. Comprised of six elements with an overly large rear element to provide unusual sharpness and minimum vignetting, it ranks as one of the best lenses of this focal length available during the 1950s. The first series featured chrome on brass construction from No. 346000 to about No. 349000 when the numbering system was changed. This second series was numbered from No. 712000 to about No. 714000 still in a chrome mount, but slightly lighter. At approximately No. 714000 a new, even lighter, black aluminium mount became standard although the optical formula remained basically unchanged throughout production. It must be remembered that some intermixing of chrome and black mounts occurs for the break is not abrupt, and it is possible to find a chrome lens with a slightly later number than that of a black one. Recorded examples such as lens No. 714362 in black and No. 714369 in a chrome mount, and lens No. 347128 in black in the author's collection, point this out.

A special combined 43mm lens hood/filter adapter was made to use Series VII filters or 43mm filters could be screwed directly into the lens. The separate finder made for the 28mm Nikkor was of chrome construction, no black one having been made, and was an optical finder and not a bright line type. However, the owner of the Nikon SP of 1957 could use the built-in finder of the camera itself and eliminate the accessory finder altogeher. This was the widest lens that the SP finder system could accommodate, but it was the only high quality camera of the era that went beyond the 35mm focal length. This ease of using such a wide angle lens on a rangefinder camera could also account for the rather large number of 28mm Nikkors made, and the fact that many are found today without the accessory finder, which was sold separately. This lens used a special deep-set rear cap first made in metal and later in plastic.

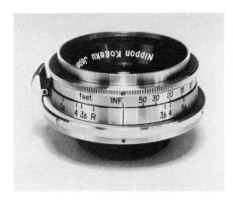

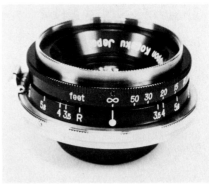

Chrome 28mm Nikkor (1952)

Black version of 28mm Nikkor (1956)

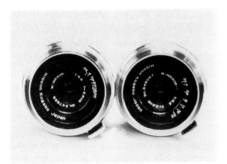

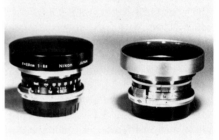

Two chrome lenses No. 347968 with decreasing diaphragm scale. No. 349067 has an equidistant scale.

Both chrome and black shades were produced. Their shapes are identical yet the earlier chrome version is not identified

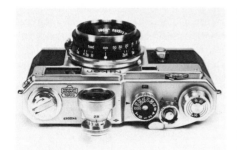

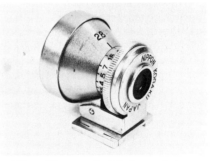

Black 28mm lens on early Nikon S3 No. 6300046 with finder

Nikon 28mm optical finder made in chrome finish only

35mm f3.5 NIKKOR (Occupied)

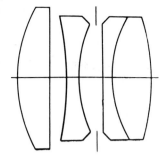

Introduced:	March 1948
Apertures:	f3.5–f16
Angle of View:	63 degrees
Elements:	4
Foc. range:	3ft to Inf.
Filter size:	None
Weight:	6.5 ounces
Original Price:	Unknown
Quantity:	Approx. 2400

When the Nikon I was released in March 1948 it could be purchased with what have come to be called the original five lenses, namely the 135mm f4.0, 85mm f2.0, 50mm f3.5, 50mm f2.0 and the 35mm f3.5. These five were the only lenses available until 1950 and comprise the core of what was to become one of the largest rangefinder systems ever made. Many versions of the Nikkor 35mm exist and I will start with those made during the Occupation of Japan. Three distinct numbering systems have shown up in this group. The first is a small batch beginning with the numbers 612 such as lens No. 61245 known to the author, which is different in that the diaphragm scale is in the opposite direction from any other Nikkor made. From information available these lenses could have been a trial run made in 1946 even before the Nikon I was ready. The more common series is the second one which begins at No. 9101 and goes to about No. 9101700. All of the lenses in this series were made during the Occupation and are so marked near the rear element. They also lack click stops and stop down to only f16 as opposed to f22 in later versions. First officially marketed in March 1948, along with the Nikon I, they were set in a very heavy chrome on brass mount with a distinctive, fluted, ring at the front of the lens used to change the diaphragm. Recorded numbers to this date run from No. 91037 to No. 9101640 at which point the third numbering scheme shows up. This third, and final, numbering system begins at No. 425000 and only goes as high as about No. 426000 after which the same serial number progression is used but none marked Occupied have shown up. At this time it appears that less than 2400 lenses were made with the MIOJ markings.

The author has not been able to determine if an individual finder was made for these early production lenses. All the literature available shows only the Imarect type Variframe finder which covered focal lengths from 35mm to 135mm. Although a chrome 35mm optical finder is readily available none have been found marked MIOJ so it can be assumed that Nippon Kogaku felt that most Nikon users would purchase the Variframe finder. The proper lens cap for this vintage Nikkor 35mm is the chrome, felt-lined, slip-on version. Also the rear cap usually found on these lenses is a heavy chrome-plated brass item that does not appear in later production.

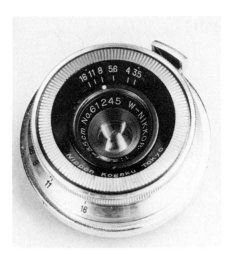

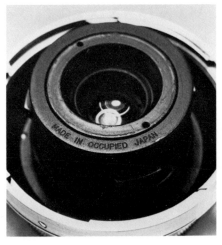

Earliest known example No. 61245.
Note diaphrgam scale works in the
opposite direction from all others made
(1946?) – (A. Tamla)

Rear view showing location of MIOJ
engraving

A collector's delight! Two MIOJ lenses with consecutive serial numbers! Lenses are
Nos. 910878 and 910879 and were acquired over a period of ten years.

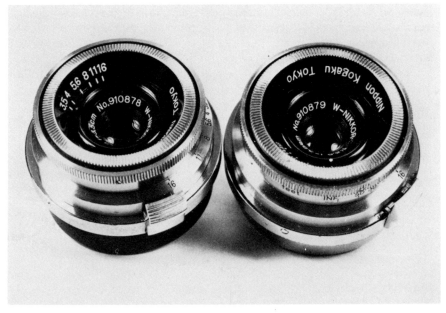

35mm f3.5 NIKKOR (Old Style)

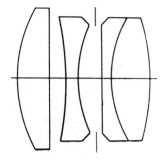

Introduced:	1952
Apertures:	f3.5–f22
Angle of View:	63 degrees
Elements:	4
Foc. range:	3ft to Inf.
Filter size:	None
Weight:	6.5 ounces
Original Price:	$89.50
Quantity:	Approx. 8000

This version of the 35mm f3.5 Nikkor is basically the same as the preceding one. The differences are that they are no longer marked MIOJ but only Made in Japan near the rear element. This version also stops down to f22 instead of f16 and possesses click stops. The reason that the author refers to it as the Old Style type is because the barrel is identical to the first version, although it was soon to be redesigned. This lens still has the fluted diaphragm ring and the heavy brass construction, along with the identical Tessar derived optical formula. All specifications are the same for both versions. Beginning where the MIOJ marked lenses end at about No. 426000, they are seen up to about No. 434000 for a production of approximately 8000 units. This particular mount was made up to 1954, or only two years, before being changed. It took the same accessories as the MIOJ version except that the chrome front cap was now made from aluminium and the rear cap from a much lighter metal and painted black. The author has never been able to determine whether or not a lens shade was really ever made for this mount for none have shown up, although the literature suggests it does exist. If so it would have to be a slip-on variety for there is no other way to mount it, and would probably be chrome on brass. It is also probable that the individual 35mm finder was being made by this time. It is of chrome construction with parallax correction, and an optical finder as opposed to a bright line type which was to replace it later on.

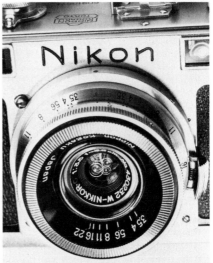

Rear view showing the change in engraving after the end of the Occupation. Lens mount is otherwise identical.

No. 430232 is now engraved 'Japan' and stops down to f22 with clicks (1952)

Post-Occupation version still in the old style mount engraved 'Nippon Kogaku Japan' instead of 'Tokyo', with click-stops (1952)

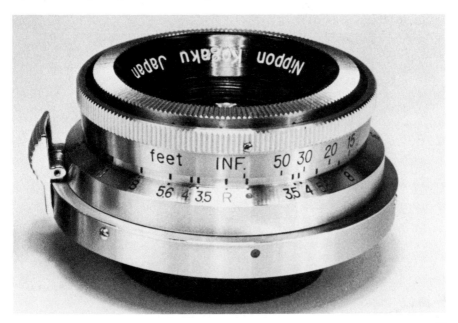

35mm f3.5 NIKKOR (New Style)

Introduced:	1954
Apertures:	f3.5–f22
Angle of View:	63 degrees
Elements:	4
Foc. range:	3ft to Inf.
Filter size:	43mm
Weight:	5.5 ounces (chrome) – 3.5 ounces (black)
Original Price:	$89.50
Quantity:	Approx. 9000

Sometime in 1954 Nippon Kogaku decided to redesign the now eight-year-old 35mm f3.5 Nikkor. The faster f2.5 version had already been released and, to keep the barrels as similar as possible, they modernized the venerable f3.5 lens. A nice note is that they did this without raising the price, although they only changed the barrel and not the proven optical formula. All of this brought the f3.5 Nikkor more into line with the 28mm f3.5 and 35mm f2.5 lenses for ease of handling. The tiny filter mount was changed to what was becoming the predominant filter size at Nikkon, 43mm. Also the diaphragm ring was changed to that of the 28mm lens dropping the fluted front-mounted ring of the older mount. This combined filter/diaphragm ring proved to be much easier to use, and was retained to the very end. The new mount was also lighter in weight but used the same serial number scheme, taking up where the previous mount ended. Serial numbers began at No. 434000 to about No. 439000 still in a chrome barrel. However, less brass was used so this chrome lens weighed less. It was then followed by an even lighter black aluminium mount in July 1956 from about No. 439000 up to at least No. 443000, for a total production in the area of 9000 units. This lighter black mount was identical to the chrome version and just differed in types of metal used.

The proper front cap would be, first the black metal slip-on type and, later, the plastic 43mm snap-on version. Also a black snap-on metal shade was available that would also fit the f2.5 lens. The chrome finder was changed to a black bright line type which was more compact and one of the brightest finders made. Usually the chrome finders are seen with chrome lenses and black with black simply because of when they were made. By the time the black lens was being produced the 35mm f3.5 Nikkor was not only a very modern lens but, at $89.50 the least expensive lens Nikon ever made and a real bargain.

82

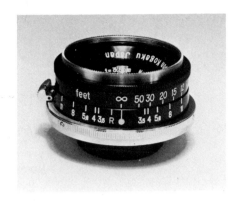

Chrome 35mm f3.5 Nikkor in the new style barrel (1954)

Black version first made in 1956

Both chrome and black (bright-line) finders were made

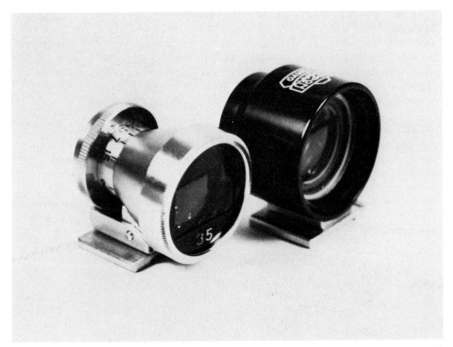

35mm f2.5 NIKKOR

Introduced:	September 1952
Apertures:	f2.5–f22
Angle of View:	63 degrees
Elements:	6
Foc. range:	3ft to Inf.
Filter size:	43mm
Weight:	7.0 ounces (chrome)
	– 3.75 ounces (black)
Original Price:	$139.50
Quantity:	Approx. 28,000

The 35mm f2.5 Nikkor ranked as the fastest wide angle lens for the Nikon system until the advent of the 35mm f1.8 four years later. It was available until at least 1962 for a ten-year production run and proved to be extremely popular, having the rather large run of about 28,000 units, making it the most popular wide angle Nikkor of all. With ample speed and an advanced optical formula it was well suited as a general purpose wide angle when picture quality was paramount and extreme speed only secondary. It consists of six elements in an almost symmetrical configuration with an overly large rear element to reduce vignetting. It was introduced in September 1952 shortly after the end of the Occupation, so none are marked MIOJ. It appears that the very early examples lack click stops although this is only within the first few months of production. It was first available in a chrome on brass mount from No. 243000 to about No. 259000. In July of 1956 the mount was changed to a lighter black aluminium barrel up to about No. 268000. Another change was made in late 1959 that produced a variation that is practically unknown to most collectors. Starting at No. 270000 an entirely new barrel was introduced which closely resembles that used on the 35mm f1.8 Nikkor and can actually be mistaken for the faster lens without looking closely. It is a more modern barrel with a much easier to use diaphragm ring, and recorded serial numbers go up to No. 271208 which would suggest a production of approximately 1200 to 1300 units! This version qualifies as one of the more unique variations in the entire lens line.

It used standard 43mm accessories with the front cap first made in a black metal slip-on version and later a plastic snap-on type. A black reversible snap-on lens shade was made although an earlier chrome shade may have been produced but none is known to the author. The chrome finder was available during the first half of the production run, but the more advanced black bright line finder was probably made by the time the black barrels show up. However, since both the Nikon SP and S3 had frame lines for the 35mm focal length, a separate finder was not necessary and less black finders were made. Although the 35mm f2.5 Nikkor is readily available today, mint specimens are hard to find and the last version is very difficult.

Early 35mm f2.5 Nikkor No. 247438 with smooth mounting ring (1952)

Later version with knurled mounting ring No. 252156 (1954)

Latest black version No. 259137 (1956)

Very scarce version of 35mm f2.5 Nikkor mounted in a barrel similar to that used for the f1.8 lens No. 271184 (1960) – (A. Tamla)

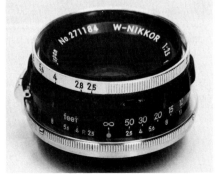

35mm f1.8 NIKKOR

Introduced:	September 1956
Apertures:	f1.8–f22
Angle of View:	63 degrees
Elements:	7
Foc. range:	3ft to Inf.
Filter size:	43mm
Weight:	5.5 ounces
Original Price:	$179.50
Quantity:	Approx. 8,000

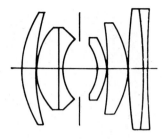

One of the fastest wide angles available during the decade of the 'fifties was the 35mm f1.8 Nikkor. Its development was completed in January 1956 and it was marketed in September of that year. A truly modern lens it used rare earth lanthanum glass to provide an unusually flat field and excellent correction despite its fast speed. The optical formula consisted of seven elements with an overly large rear element and a front group large enough to cover f1.4! All of these features considerably decreased vignetting over other wide angle formulas of the period. The 35mm f1.8 Nikkor was the fastest wide angle ever made for the Nikon RF system, and also one of the sharpest. It therefore ranks as one of the more desirable Nikon rangefinder lenses sought after by collectors today. Production began at No. 351800 and the highest serial number recorded to date is No. 359952, for a total of approximately 8000 units. There are two distinct variations available, although the difference is only in the barrel. It is generally encountered in its standard black aluminium barrel with chrome mounting and diaphragm rings, which is the way the vast majority were made. However, it was first introduced with a black painted diaphragm ring instead of chrome, but only in the first 100 or so made, which makes it one of the more unusual variations seen in the entire lens line. Serial numbers recorded with the black diaphragm ring range from No. 351800 to No. 351880, although more may surface. As mentioned, the barrel was black and made of lightweight aluminium with a pronounced type of knurling that is unique to this lens. A much easier-to-grasp focussing ring resulted and it is unknown why Nippon Kogaku did not use it on their other lenses, especially the 21mm, which came out at a later date. They did, however, use it for the redesigned 35mm f2.5 as mentioned in that section, and for those lenses made for the Nikon F from 1959 on.

The Nikkor 35mm f1.8 took the now standard 43mm filters and required a deepset rear cap because of its large protruding rear elements. An oddity is that it does not take a 43mm snap-on front cap, but because of the large front-mounted diaphragm ring, a 48mm cap is needed. Available for one year before the arrival of the Nikon SP, it was generally used with the black bright line finder, after which the built-in frames of the SP and S3 made a separate finder unnecessary. The 35mm f1.8 is listed in Nikon price sheets as late as mid-1964 for a production of eight years, or an average of 1000 units a year.

Very early 35mm f1.8 No. 351818 with black diaphragm ring (1956) – (A. Tamla)

Another with almost a consecutive serial number. Lens No. 351820!!

Lens with shade mounted on black SP No. 6200082 (1957)

35mm f3.5 STEREO-NIKKOR

Introduced:	December 1956
Apertures:	f3.5–f16
Angle of View:	45.5 degrees (each lens)
Elements:	4
Foc. range:	3ft to 10ft (lens alone)
	10ft to Inf. (with prism)
Filter size:	40.5mm (special bayonet)
Original Price:	$274.00 (included: lens, prism, haze filter, and finder in a fitted leather case)
Quantity:	Approx. 170

Formula unknown!!

First announced in May 1956 but not available until December 1956, the Stereo-Nikkor was listed in Nikon price sheets as late as October 1961. Although this is a fairly long period its production only totalled about 170 units! Therefore, based on quantity made, the Stereo-Nikkor would rank as the rarest of all production RF Nikkors. Mounted only in a chrome barrel with a black face, it consists of two matched 35mm f3.5 lenses each with an acceptance angle of 45.5 degrees. The effective separation of the two optical centres is 18mm and a septum prevents image overlap on the two stereo frames, each 17 × 24mm, which fill the standard 24 × 36 frame. It couples with the Nikon rangefinder from 3ft to infinity like the regular RF lenses. Unique to this lens is a bayonet-mounted 40.5mm haze filter supplied as regular equipment and a bayonet-mounted hood which was an option at a cost of $8.50. Also standard was a Stereo-Prism which increases the effective lens separation to 80mm for use from 10ft to infinity. The prism uses total internal reflection rather than mirrored surfaces for a bright, undistorted image, and bayoneted to the prime lens.

The lens by itself produces an ortho-stereoscopic image from 3ft to 10ft, although it could be used to infinity, but the stereo effect would be reduced. Beyond 10ft the Stereo-Prism was used to maintain correct stereo imaging. The kit also included a 35mm black bright-line finder with the proper 17 × 24mm vertical frame line for correct composition, and the entire outfit was supplied in a fitted leather case. The only other option besides the lens hood was a Nikon-made transposing Stereo-Viewer which took standard 2 × 2 cardboard mounts and cost $25.00. Although the author has not been able to obtain the optical formula for this lens it can be assumed that it is probably identical to that used for the standard 35mm f3.5 Nikkor.

Recorded serial numbers run from about No. 241800 to approximately No. 242100, but gaps do exist. The actual production was 170 units but not all were sold. Because of Japanese tax laws, which put a value on inventory, 28 Stereo-Nikkors were actually destroyed in the presence of the taxman. It is rumoured that this was done with a hammer! If this did occur only 142 Stereo-Nikkors were sold to the public.

Modelled after the Leitz Stemar unit, the Stereo-Nikkor does not break new ground in stereo lens design, but does represent the only attempt at an inter-changeable stereo objective for a rangefinder camera ever made besides those from Leitz and Zeiss.

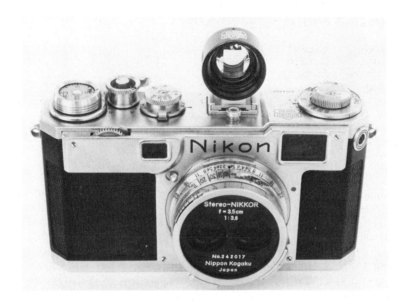

*Stereo-Nikkor No. 242017 with finder on Nikon S2 No. 6154496 (1957) –
(T. Konno)*

*The Stereo-Nikkor kit consisting of the lens, shade, filter, finder, prism attachment
and special viewer (1957) – (T. Konno)*

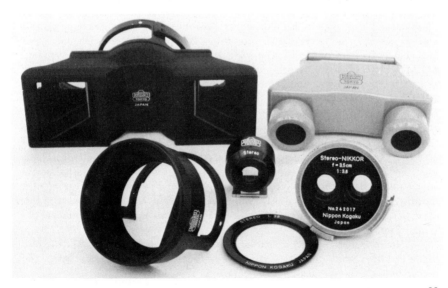

50mm f3.5 MICRO-NIKKOR

Introduced: October 1956
Apertures: f3.5–f22
Angle of View: 46 degrees
Elements: 5
Foc. range: 3ft to Inf. (extended)
 1.5ft to 3ft (collapsed)
Filter size: 34.5mm
Weight: 4.7 ounces
Original Price: $199.50
Quantity: Approx. 1500

When this lens was first introduced many wondered how Nippon Kogaku thought that such a slow lens would be a success, especially when it sold for more than the 50mm f1.4 normal. Would quality win out over speed in the era of available light photography when everyone was trying to make faster lenses? And at $200.00? Although it never really hurt the sales of the faster normals, the same optical formula was used four years later for the reflex version of the Micro-Nikkor which is, to this day, one of Nikon's best and most popular lenses. In essence it started the trend to extremely corrected, close focussing lenses that almost every manufacturer includes in his lens line today.

The RF Micro-Nikkor provided resolving power beyond the capacity of most films available at the time. It also had a high degree of colour correction, assuring precise focus of all primary colours on the film plane. It was ideal for colour work, microfilming, copying and general photography where ultra speed was not required, and had greater fine-line resolution than any other lens made for the camera. It is a development of the Petzval symmetrical formula, especially computed for high accutance at short subject-to-lens distances and reached maximum resolution at image reductions of 1:12. Made only in a chrome collapsible mount, it was used in the extended position for general photography from 3ft to infinity as an extremely sharp normal lens. At very close distances down to 1.5ft it could be collapsed and a device was inserted to make aperture settings convenient. This special collar was available as an accessory and sold for $8.50, and is rather difficult to obtain today. The Micro-Nikkor could also be used with the Nikon Repro Copy outfits down to 1:1 and with the bellows attachment for even greater magnifications.

The serial numbers began at No. 523000 and have been recorded as high as No. 524413, though they may go higher, with the screw mount lenses intermixed. No lens shade was ever made but it was not necessaary since the optics were deeply recessed in the barrel. It used 34.5mm accessories and a plastic snap-on front cap was made. For the rear cap the standard one used for all the internal mount normals was used. There are two distinct variations seen in the Micro-Nikkor. The vast majority are engraved on the front rim, Micro-Nikkor. However, in the original press releases the lens pictured is engraved as Micro-R-Nikkor! No lens has been found with this 'R' engraving on the rim so it may only have been used on the prototypes and not the production lenses.

The 50mm f3.5 Micro-Nikkor is today one of the most sought-after RF Nikkors. Made in rather small quantities, it also is a unique lens and, as mentioned, the precursor to the entire line of Micro-Nikkors so popular today.

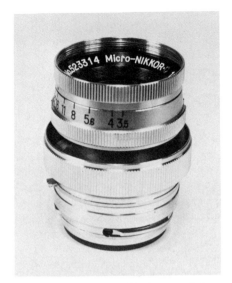

Micro-Nikkor No. 522314 in extended position (1956)

The collapsed position used for copying

Micro-Nikkor with collar on Nikon S4 No. 6502976

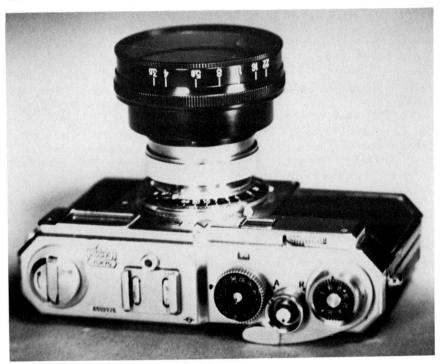

50mm f3.5 NIKKOR-Q

Introduced:	July 1937 (for Hansa Canon)	
	December 1945 (Nikon mount)	
Apertures:	f3.5–f16	Formula unknown!!
Angle of View:	46 degrees	
Elements:	4	
Foc. range:	3ft to Inf.	
Filter size:	Unknown	
Weight:	Unknown	
Original Price:	Unknown	
Quantity:	Unknown	

Nippon Kogaku made a series of 50mm lenses for the pre-war Hansa Canon as well as the post-war SII. This continued up to some time in 1947 at which point Canon began to make their own lenses. These early Nikkors can be found in both the unique Canon bayonet and the Leica screw mount. The series consisted of 50mm lenses of f4.5, f3.5, f2.8 and f2.0 apertures. When Nippon Kogaku decided to make their own camera it was natural for them to select their first normal lenses from this already existing series, which is what they did. It is not known if the optical formulas are exactly the same but it is probable that they are very similar with some small improvements. The first two normals that were produced in the Nikon mount were the following f2.0 and the f3.5. It appears that the majority of the early Nikon I and M cameras were supplied with the collapsible 50mm f2.0 Nikkor and it can be considered the 'standard' normal of the period. However, a small number of these early cameras were equipped with the 50mm f3.5 Nikkor-Q lens in an effort to offer the buyer some choice.

At this time very little is known about the 50mm f3.5 Nikkor-Q. What is known is that the vast majority that have been seen are in the Canon bayonet or Leica screw mounts. Secondly the serial numbers used on this lens are extremely varied and confusing, thus determining how many were made is very difficult. Some examples of the types of serial numbers recorded, in chronological order, are: 501xx, 505xx, 506xx, 507xx, 508xx, 570xx, 610xx, 703xx and 705xx! Numbers with 5, 6 and 7 digits exist with the first three digits constant. Probably what Nikon was doing was using the date of production to determine the serial numbers, which is a practice they followed in the early years. Those numbered 501xx were made in January 1945 while those numbered 508xx were made in August 1945. All of this can be confusing and the result is a group of lenses with more types of serial numbers than any other lens Nippon Kogaku ever made. To date the only numbers seen in the Nikon mount begin with '705', which denotes May 1947, and is the time period during which the Nikon I was released. Examples in Nikon type mount are Nos. 7051107, 7051973 and 7052290.

In this chapter are pictured two 50mm f3.5 Nikkors. Lens No. 7052252 is in Leica screw mount and No. 7051107 in Nikon bayonet which is on black Nikon I No. 609431. More information is needed about these early lenses to determine how many were made and if any other types of serial numbers exist.

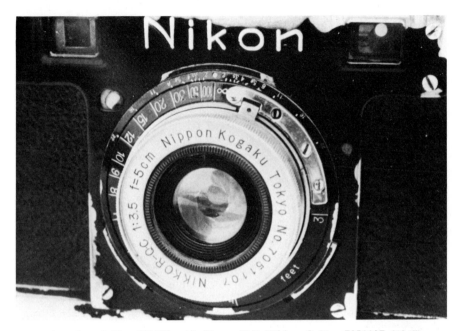

Black Nikon I No. 609431 with 50mm f3.5 Nikkor-Q No. 7051107 (1947) –
(S. Abe)

Lens No. 7052252 in Leica screw mount (1947) – (S. Abe)

50mm f2.0 NIKKOR-H-Collapsible (OCCUPIED)

Introduced:	Autumn 1946
Apertures:	f2.0-f16
Angle of View:	46 degrees
Elements:	6
Foc. range:	3ft to Inf.
Filter size:	40.5mm
Weight:	4.8 ounces
Original Price:	Unknown
Quantity:	Approx. 3000

Although the 50mm f3.5 Nikkor-Q qualifies as the first normal lens designed for the Nikon, it was made in small quantities, and it is this lens, the 50mm f2.0 Nikkor-H, that was first promoted with the original Nikon I and M models. It was first designed in August of 1937 but not marketed in a Nikon mount until the autumn of 1946. Pre-war versions would either be in screw mount or the Hansa Canon mount. Actually Nippon Kogaku made all of the normals for the Hansa Canon including the f3.5 and f4.5 versions. This chapter deals with only the collapsible mount, although a rigid type using the same formula was also made during the Occupation, but will be covered in the next chapter.

There are at least four distinct serial number batches used for this lens, plus others found in the pre-war Hansa mount. The first type of number seen begins with '609' just like those numbers used for the first cameras! Examples seen to date are No. 60929 on Nikon I No. 60941, and No. 60969 seen on Nikon I No. 609111. Nippon Kogaku probably chose the '609' prefix for the same reason they did for their camera, which is explained in the first part of this book. It is not known how many were made for more examples need to be found. The second type of number encountered is a batch beginning with '708'. Lenses recorded in this batch run from No. 7084 to No. 708691 and are usually seen on a Nikon Model I. The third batch begins with '806' and recorded numbers run from No. 80625 to No. 806511, though most in this batch have turned up in screw mount, but not exclusively. The fourth, and final, type of serial number seen in these collapsible lenses begins with '811', and accounts for the bulk of lenses recorded. The number range seen to date runs from No. 81116 to No. 8111700, with a fair amount of screw mount lenses intermixed. Despite the different types of numbers used all of these lenses are actually the same item. In the early years Nikon tended to number items based on the date, or year, of manufacture, though they would eventually discontinue this practice. Taking all four batches together suggests a total production in the area of 3000 units, which would be almost one for every Nikon I and M made, but many were in screw mount, possibly as much as one-half. All of these lenses belong on either a Model I or M because the rigid mount was introduced before Nikon M production ceased, and those found on later cameras are really a mismatch.

Based on a proven optical design it was a fine lens for its time and every one ever made was coated. All used 40.5mm accessories but it has not been determined if a shade was ever made or what it might have looked like. The proper front cap for this vintage would be chrome, first in a slightly 'domed' configuration and later a flat type, both slip-on. No snap-on cap was ever made. At times a collector will encounter a Nikon I or M with a later, improper, lens because some owners have upgraded.

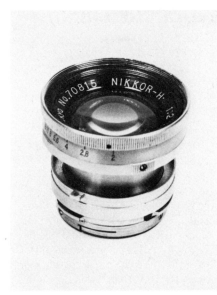

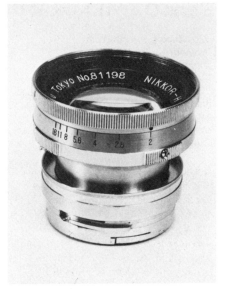

Very early version of 50mm f2.0 No. 70815. This lens came on Nikon I No. 60939 (1948)

Early example of the more commonly found 50mm f2.0 No. 81198. This vintage generally found on Nikon M bodies (1949)

The knurling varied between the early, No. 81198, and the late, No. 8111425, versions of this lens.

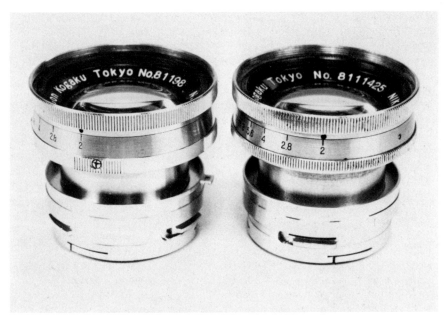

50mm f2.0 NIKKOR-H-Hybrid (OCCUPIED)

Introduced:	1949?
Apertures:	f2.0–f16
Angle of View:	46 degrees
Elements:	6
Foc. range:	3ft to Inf.
Filter size:	40.5mm
Weight:	5.3 ounces
Original Price:	Unknown
Quantity:	Approx. 500–1000

We now come to a version of the 50mm f2.0 Nikkor-H that is practically unknown to most collectors. The exact date of introduction is not known but it did precede the following lens because it still used the '811' type serial numbers seen in the previous chapter. For the sake of differentiating it from other types, the author has chosen to call it the 'Hybrid' 50mm f2.0 Nikkor-H, mainly because, as evident from the illustrations, it is made up of parts from the collapsible version, but is rigid and differs from the lens in the following chapter. It is obvious that the front lens flange and rear section of the barrel are identical to that used on the collapsible version with the addition of a truncated sleeve to prevent the user from collapsing the lens. This sleeve is permanently mounted, and not removable, and finished exactly like the rest of the barrel, Nippon Kogaku was thinking of abandoning the collapsible mount and had probably begun development of the following rigid barrel, but decided to use up what parts were left for the collapsible lens and came up with this oddity. Ranking as probably one of the strangest lenses Nikon ever made, it is available in only small numbers. The first example recorded to date is No. 8111780 and others have been found up to No. 8112903. Note that the serial numbers are a continuation of the last collapsible number batch. Serial numbers would suggest that about 1200 units were manufactured, but many screw mount lenses, which were still collapsible, are intermixed. It is not known whether a screw mount version of this hybrid mount was ever made. Probably less than 1000 lenses were made in Nikon mount and the number could go as low as 500! This makes the 'Hybrid' 50mm f2.0 Nikkor-H one of the least common Nikon normals, and a fine collectible. This lens belongs on a Nikon M and most that have been found are mounted on late, unsynched, and early, synched, Nikon M bodies ranging from No. M6092000 to about No. M6092500!

This version takes the same accessories and uses the identical optical formula as the collapsible type as well as the standard rigid lens that follows.

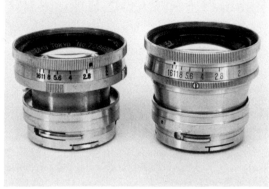

*50mm f2.0 Nikkor in the Hybrid mount
No. 8112411 (1950?)*

*Comparison photo of collapsible and
Hybrid type barrels – (T. Konno)*

Hybrid lens mounted on No. M6092038 – very early shade (1950)

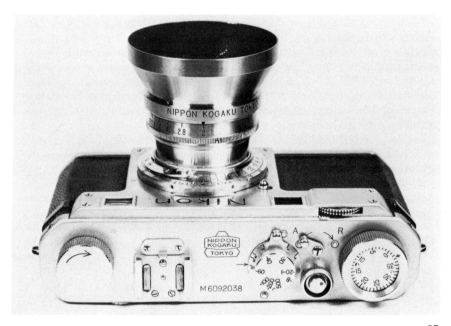

50mm f2.0 NIKKOR-H-Rigid (OCCUPIED)

Introduced:	1950
Apertures:	f2.0–f16
Angle of View:	46 degrees
Elements:	6
Foc. range:	3ft to Inf.
Filter size:	40.5mm
Weight:	6.5 ounces
Original Price:	Unknown
Quantity:	Approx. 6000

Sometime in 1950 Nippon Kogaku decided to redesign the 50mm f2.0 collapsible lens in favour of a rigid mount, and would never again use a collapsible barrel except for the Micro-Nikkor. The result was a lens of the same optical formula, but a much more massive and heavy barrel. It is possible that they believed a rigid mount would provide better optical performance but at the expense of compactness and weight. The 50mm f2.0 Nikkor in rigid mount is a very heavy chrome on brass lens typical of Nikon construction of the period. This new barrel would remain basically the same, except for weight, throughout the entire rangefinder era and was available until at least 1964. This chapter is concerned with only those made during the Occupation, later versions being covered in the next chapter. Lenses from this period are engraved 'Tokyo' on the front ring instead of 'Japan' as in later versions, and lack clickstops. They again changed their serial numbers and actually ended up using two distinct numbering schemes. The first set of numbers begin with the prefix '5008' which at Nikon would denote the year 1950 and the eighth month. This date could either be the date that the design was finalized, or the actual start-up of production. Serial numbers recorded to date range from No. 50080000 to No. 50080781, or 781 units, although they probably run higher. However, total production was under 1000 units, at which point a second type of serial number batch was chosen. This second group begins at No. 617000 and goes up to about No. 622000, at which point 'Tokyo' disappears from the front ring and is replaced by 'Japan'. These numbers would suggest a total production of about 5000 units plus 1000 from the first batch for a sum total of approximately 6000 units. The reader should remember that this is not a new lens but only a new barrel and those made ten years later were still the same lens with again changes in the barrel.

The rigid 50mm f2.0 Nikkor used the same 40.5mm front thread as its predecessor. Front caps were first chromed brass, then aluminium and then black metal and the slip-on variety. A chrome on brass two-piece combined shade and filter holder was made which would fit the earlier lens, but it is not known if it was made that early. Most of the early rigid 50mm f2.0 Nikkors marked 'Tokyo' were originally sold on Nikon M bodies although the very last ones could have come on very early Nikon S cameras. To determine if you have one of these early rigid lenses refer to the serial number, Tokyo engraving, weight and check for clickstops.

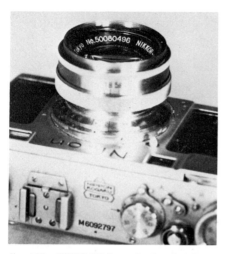

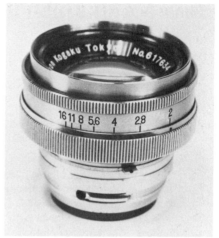

Lens No. 50080496 from the first batch made on M No. 6092797 (1951)

Very early example of the second type which used a new serial number system. Lens No. 617634 (1951)

Comparison photo showing collapsible and rigid versions of the early 50mm f2.0 Nikkor

Lens No. 617634 mounted on Nikon M No. 6091975 (1950)

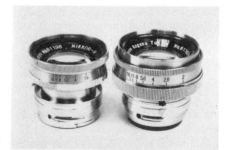

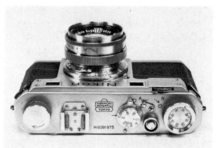

Rigid lens with proper caps

Close-up of lens No. 617634 which is a very early rigid lens

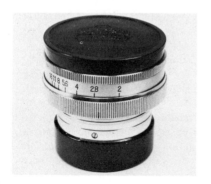

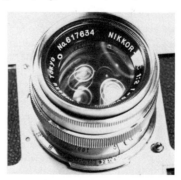

50mm f2.0 NIKKOR-H

Introduced:	1953
Apertures:	f2.0–f16
Angle of View:	46 degrees
Elements:	6
Foc. range:	3ft to Inf.
Filter size:	40.5mm
Weight:	6.0 ounces (chrome)
	– 4.5 ounches (black)
Original Price:	$125.00
Quantity:	Approx. 60,000 (see text)

This chapter will cover the more common 50mm f2.0 made from just after the end of the Occupation up until at least 1964. Again we are talking about the same optical formula as the previous examples with variations seen in the types of barrels. The serial numbers used were a continuation of those on the MIOJ version which ended at approximately No. 622000. However, two distinct types of numbers are seen in this version, which was produced for at least ten years. The first type of numbers used range from No. 622000 to about No. 662000 for a maximum total of 40,000 units, but more on quantity later. The vast majority of lenses in this group are chrome although a few black examples have shown up. The earliest versions are as heavy as those made during the Occupation, but are engraved 'Japan' and possess clickstops. By No. 650000 the barrel has lost some weight with the addition of more aluminium, but the exact number is not known. The heavy lenses weigh 6 oz, while the lighter units come in at 5 oz. There are some examples that weigh somewhere between these two figures for Nippon Kogaku lightened the barrel in increments as time passed, and not all at once. Suddenly this type of serial number ends and is replaced by an unrelated type beginning at No. 714000 with no lenses seen between this number and No. 662000. It appears that this new serial number type was chosen to differentiate the new black barrel lens from chrome, but the break is not clean. As mentioned, a few black lenses show up in the previous numbers and some of the earliest lenses in this new batch are finished in chrome. However, the vast majority of the newly numbered lenses are finished in a black on aluminium barrel. Recorded numbers seen to date run as high as No. 768206 with screw mount lenses intermixed throughout both the chrome and black versions. These recorded numbers suggest a total production of about 90,000 units if taken literally. However, this figure is much too high even accounting for screw mount units. If you take the number of 50mm f1.4 lenses made and the f2.0 version, you end up with twice as many produced as were camera bodies. The only explanation the author can suggest is that there are significant gaps in the serial numbers used, which is something that is common in the numbering of the camera bodies. The author uses the figure 60,000 as a more logical number made and it would add up to 70,000 when all previous versions are included.

Two versions of the black 50mm f2.0 Nikkor exist. The more common is that with a chrome filter ring, but a small amount were made with a black ring and are dispersed throughout production and do not show up as a definite batch. The proper front cap for this lens would be first a black metal slip-on followed by the black plastic snap-on type. A chrome screw-in two-piece shade was first made but the more common type is the black metal, reversible, snap-on shade.

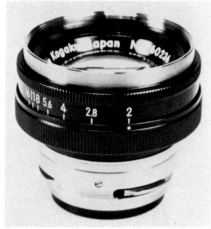
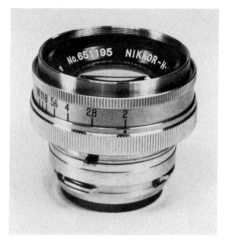

*Standard chrome f2.0 Nikkor
No. 651195 from post-occupation era*

*Later black version made after 1955.
Lens No. 760236*

*Comparison photo of chrome and black
versions*

*Lens No. 651195 on Nikon S
No. 6109521 (1953)*

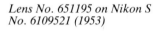

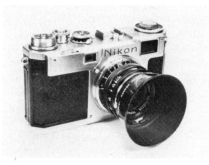
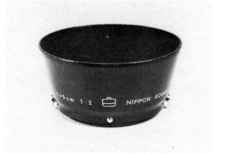

*Lens No. 760236 on black dial Nikon S2
(1957)*

*Black snap-on reversing shade for
50mm f2.0 Nikkor*

101

50mm f1.5 NIKKOR-S

Introduced:	1950	Formula unknown!!
Apertures:	f1.5–f11	
Angle of View:	46 degrees	
Elements:	7	
Foc. range:	3ft to Inf.	
Filter size:	40.5mm	
Weight:	6.6 ounces	
Original Price:	Unknown	
Quantity:	Approx. 800	

The 50mm f1.5 Nikkor-S is one of the least known RF Nikkors ever produced. Introduced in early 1950, it was discontinued the same year in favour of the 1.4 lens. This is the shortest run of any production lens made for the rangefinder series. Obviously designed to compete with the famous Zeiss Sonnar 1.5, its optical formula is unknown, but may be similar to the Zeiss lens. Made only during the Occupation, all examples are engraved 'Tokyo' on the identification ring, and lack clickstops. Note that it only stops down to f11 and it is the only Nikkor normal to do so. Because it was designed in late 1949 the serial numbers begin with a '9' following Nikon's normal practice at the time. Two types of serial numbers are encountered. The earliest lenses are numbered from No. 9051 to a high of No. 90538, although more may exist. After this point all remaining lenses begin with '907' and recorded serial numbers range from No. 9071 to No. 907734. All of this suggests a production in the area of 800 units with probably well under 1000 actually produced. Made up of seven elements, as was the following 1.4 version, its barrel differs slightly from that used for the Nikkor 1.4, being slimmer and having the diaphragm ring placement reversed. It used 40.5mm accessories like the f2.0 lens. The black slip-on front cap for the f1.5 will fit the f2.0 and the f1.5 can use the snap-on black shade for the f2.0 lens.

Because of its production period the 50mm f1.5 Nikkor-S belongs on midproduction Nikon M bodies and those found on later Ms and Ss are a mismatch. Those recorded by the author have been found on Nikon M bodies ranging from No. M6091139 to No. M6092320, although some have shown up on later cameras.

The reason that the 1.5 Nikkor was made for such a short time may be that Nippon Kogaku, using a different formula, had perfected their soon-to-be-famous f1.4 lens. The first ads seen for the f1.4 Nikkor actually use the phrase 'The first normal lens faster than F1.5!' to promote it, so it appears that they thought they needed something 'faster' than f1.5 to compete in the world market. Today the difference is rather moot but the early 1950s was a time when most manufacturers were trying to come out with faster and faster lenses, and speed sold equipment. Whatever the reasons, the result was a lens made for a very short time and in small numbers which today is one of the most collectible lenses in the Nikon rangefinder series.

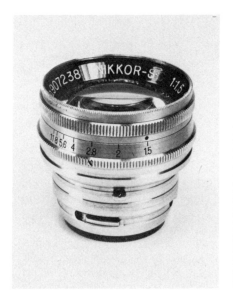

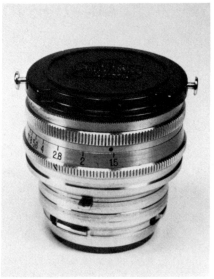

Rare 50mm f1.5 Nikkor No. 907238 (1950)

The snap-on cap for the 50mm f2.0 Nikkor will also fit the 1.5

Lens No. 907238 mounted on Nikon M No. 6091406 (1950)

50mm f1.4 NIKKOR-S (OCCUPIED)

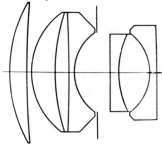

Introduced: December 1950
Apertures: f1.4–f16
Angle of View: 46 degrees
Elements: 7
Foc. range: 3ft to Inf.
Filter size: 43mm
Weight: 6.8 ounces (average)
Original Price: Unknown
Quantity: Approx. 8000

The short-lived 1.5 Nikkor was replaced within one year by the lens that established Nikon's reputation for fine optics worldwide, and became the most famous Nikkor of all. This lens was the 50mm f1.4 Nikkor-S of late 1950, which remained virtually unchanged optically throughout the entire rangefinder era, and was listed as late as 1962. This was Nikon's most successful lens and was made in very large numbers when compared with other RF Nikkors. Although it contained seven elements like the f1.5 lens, it was a completely new optical formula using glasses of higher refractive index, enabling better corrections and a slightly faster speed. Its design was completed by May 1950 but actual production did not begin until December. There were two batches that were made during the Occupation, each of which had its own serial number scheme. Nippon Kogaku again chose to use dates to determine the serial numbers of the very first batch. Using the May 1950 design completion date the first 50mm f1.4 Nikkor-S lenses began with the prefix '5005', for the fifth month of 1950. Recorded numbers seen to date range from No. 50050001 to No. 50051987 for a production of about 2000 units. Again these are the very first f1.4 Nikkors and were sold as original equipment on mid- to late-production Nikon M bodies. Before the end of the Occupation, possibly as early as late 1951, the numbers were completely revised and a new series, starting at No. 316000, is seen. Both types of lenses are actually identical and it is not known why the serial numbers were changed, although they did the same thing with the 50mm f2.0 and 135mm f3.5. The second series runs as high as No. 321999 at which point the 'Tokyo' engraving was changed to 'Japan', for a total of 6000 units. Adding this to the first batch gives a total of about 8000 f1.4 Nikkors made with the 'Tokyo' engraving. Since the change in engraving did not coincide exactly with the end of the Occupation, some were made after. Refer to the 'Introduction to the Lenses' for further discussion of this point.

Both batches used standard 43mm accessories, although some slip-on items do not fit all examples because of a slight difference in the thickness of the filter ring metal. The very first lenses use a thinner gauge metal and even though the filter thread is still 43mm, the outer diameter does vary. All of these lenses, even the very first, have clickstops, which makes the f1.4 Nikkor the first lens Nikon made so equipped. The first type of front cap used was aluminium and then black painted metal, both slip-on. The proper shade for this vintage is a chrome on brass, two-piece, combined shade and filter holder which was the screw-in type. No snap-on accessories were made in these early years.

This is the lens that Nikon advertised as 'The first lens for 35mm photography faster than f1.5', and it was the focal point of many adverts up to 1953, even at the expense of the camera itself.

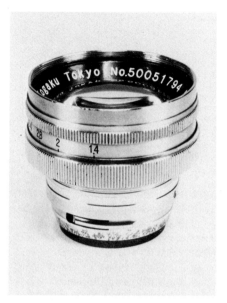 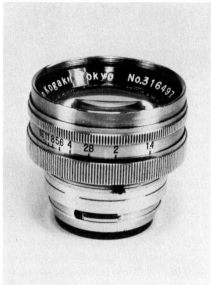

Example from the first run is lens
No. 50051794 (1950)

The second type seen would be lens
No. 316497 (1950?)

Comparison photo of the 1.5 and 1.4 Nikkors of 1950

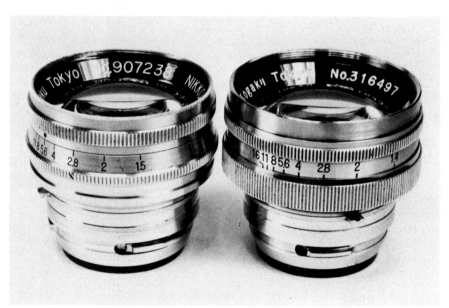

50mm f1.4 NIKKOR-S

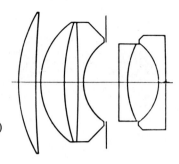

Introduced:	1953
Apertures:	f1.4–f16
Angle of View:	46 degrees
Elements:	7
Foc. range:	3ft to Inf.
Filter size:	43mm
Weight:	5.1 ounces (chrome)
	–4.7 ounces (black) (Averages)
Original Price:	$169.50
Quantity:	Approx. 90–100,000 (see text)

This chapter will deal with those 50mm f1.4 Nikkors made sometime after the end of the Occupation and at the point where 'Japan' is substituted for 'Tokyo' on the identification ring. They begin at No. 322000 and proceed more or less consecutively to a recorded high of No. 417862. If the serial number range is taken literally it would mean a production run of somewhere between 90,000 to 100,000 units! However, included in this figure would be the screw mount lenses which were not given separate numbers. Lenses made in screw mount could account for as much as one-third of the total production, especially in the early years when Nippon Kogaku supplied this lens to other manufacturers, such as Nicca, who also used them on their Tower brand cameras. These cameras sold in great numbers during the early 'fifties and many screw mount lenses appear during that period. Also the author believes that there are some gaps in the serial numbers due to some experimental batches which will be covered shortly. A sensible estimate of the number made in Nikon mount would be in the area of 70-80,000 units, including those made during the Occupation. Even this slightly lower figure would mean that the 50mm f1.4 Nikkor-S had the highest production quantity of any RF Nikkor, including the slower, and less expensive, 50mm f2.0 lens.

Any lens made in such quantities and for so long must have variations, and this lens is no exception. They were made in a chrome mount from No. 322000 to about No. 374000, but the barrel was lightened gradually as more aluminium was substituted for brass. From No. 374000 on only the lightweight black aluminium barrel is seen and its weight remained fairly constant. However, the break from chrome to black is not a clean one. At least four batches of black lenses have been seen amongst the chrome lenses. These early black lenses differ slightly from the later version and will be covered separately. Once you get beyond No. 374000 only the black barrel lenses with a chrome filter ring are found and, as mentioned, they remained fairly constant. At about No. 396000 the red 'C' on the identification ring was deleted. This red 'C' was used by Nikon from the very beginning to denote that the lens was coated. However, all Nikkors from the original 1946 versions had always been coated, but it was a good selling point in the early years, hence the 'C' engraving. By late 1958 and early 1959 everyone assumed that lenses were being coated, which was the case worldwide, and Nikon decided the 'C' was no longer necessary and removed it. This is true for all of their lenses that came out before 1958 and were still being made after 1959.

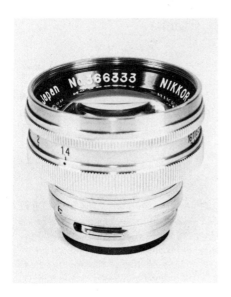 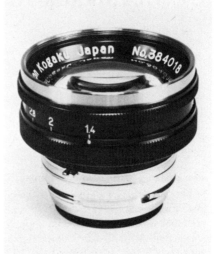

Chrome post-occupation 1.4 Nikkor
No. 366333 (1953)

Standard black version No. 384018
made after 1956

Comparison photo of the chrome and black versions of the 1.4

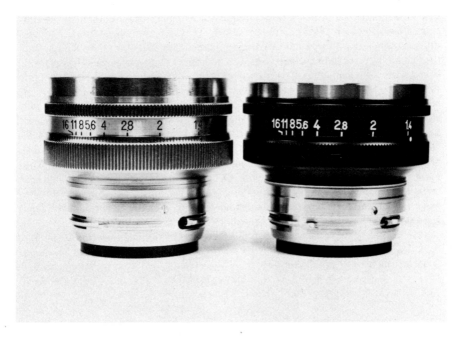

50mm f1.4 NIKKOR-S (Early Black)

Introduced: 1954 (or earlier)
Quantity: Approx. 500

The post-Occupation chrome 1.4 Nikkors range in serial numbers from No. 322000 to No. 374000. Within this range can be found at least four batches of black lenses appearing much too early than they should. Most of these very early black versions are much lighter than their contemporary chrome lenses because of a greater use of aluminium. Most also have black aluminium filter rings instead of chrome on brass, which is why they are referred to as 'all black 1.4s' amongst collectors. Some believe that they were simply experiments to determine the feasibility of lighter weight alloys. Others believe that they were intended for the early black cameras such as the Nikon S2. The author feels that both are correct.

About the only complaint that professionals had of the early Nikon equipment was weight. Most of what was made up to 1956 was heavy. This was the result of the liberal use of brass and chrome in both their cameras and lenses, plus the desire of the people at Nippon Kogaku to produce quality goods, In the early 'fifties weight was directly proportional to quality and Nikon went all out. As time passed they realized that they had used a little overkill and decided to lighten their equipment by the careful use of aluminium and different alloys. They did, however, continue to use brass and phosphor-bronze in key parts of the focussing helixes of their lenses. But the demand was for lighter equipment, hence these early black lenses. The external barrel parts were mainly black painted aluminium which reduced the average weight from 148gm to 130gm, with no loss in precision. The first batch seen is between No. 331000 and No. 331200 which is before the black S2 was available, and all have black filter rings. The second group appears at No. 358000 to about No. 358100 and have been generally found on black S2s. The third batch is at No. 365000 to about No. 365300 in which some have chrome filter rings and some black. The last is the batch numbered between No. 369400 and No. 369500 with chrome filter rings. The author feels that the first two batches are Nikon's first attempts at aluminium barrels and were intended for professional use, hence the black finish. The third may also be experimental and the fourth possibly just made during an interim period when they were shifting over to black but still had some chrome parts to use up.

More lenses in these groups will show up as time passes and even more batches may be determined, but it is oddities such as these that keep our interests as collectors high.

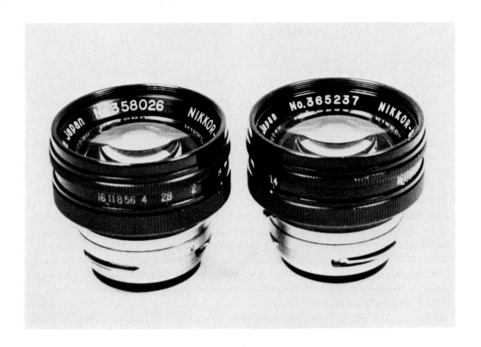

Above example plus lens No. 358026 which is from the second batch. Note the difference in the style of engraving

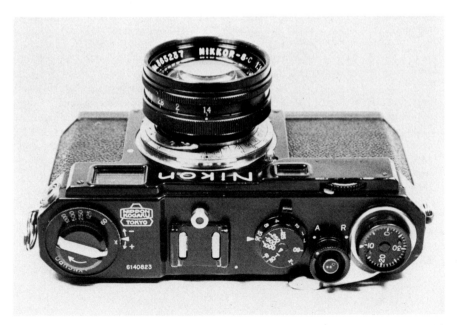

50mm f1.4 NIKKOR-S (ALUMINIUM)

Introduced: 1955–56
Quantity: Approx. 300

One of the batches of early black 1.4s mentioned in the previous chapter was numbered between No. 358000 to No. 358100. Adjacent to this number group is another experimental batch that most collectors are unaware of. Between No. 358100 and about No. 358400 exists a group of lenses known as the Aluminium 50mm f1.4 Nikkors. They appear to be identical to other chrome on brass lenses from the same period until you hold them in your hands, at which point one will notice their very light weight. Not all of the lenses within the serial number range are aluminium, for standard chrome barrels are also encountered. The aluminium lenses look the same as any chrome lens until they are closely inspected. A slight difference in hue is noticed as well as the weight difference. These aluminium lenses weigh in at 120gms compared to an average of 155 gms for chrome lenses of the same vintage. The entire outer barrel including the filter ring is aluminium as well as many internal components. However, brass is still used for some internal construction. All other specifications for these lenses are identical to the standard 1.4 Nikkors.

It is not known if any other batches exist or how many lenses of this type were actually made. The fact that they are adjacent to a batch of early black lenses leads one to believe that they were an extension of the same experiment that produced the black barrelled units. Most of the aluminium lenses have been found on Nikon S2 bodies of the same vintage and it appears that they were sold to the general public. Because of this they have been dispersed to such a point that discovery today is usually accidental. Also some of the lenses may have been separated from their original camera and can be found almost anywhere. All of this makes the Nikkor 1.4 Aluminium lens an item that is available to the general collector who is willing to search for it.

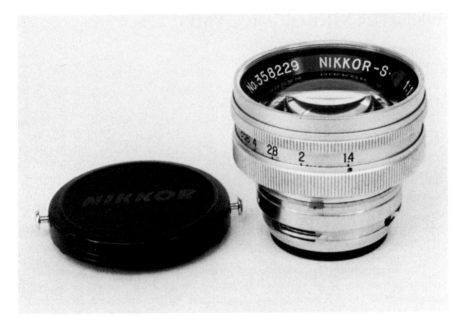

Aluminium 1.4 Nikkor No. 358229– (T. Konno)

The very scarce Aluminium 50mm f1.4 Nikkor mounted on a Nikon S2. Lens No. 358262, body No. 6205010

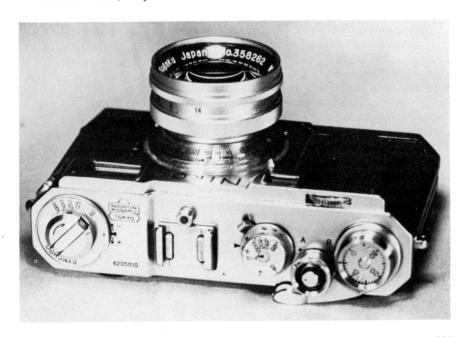

50mm f1.4 NIKKOR-S (OLYMPIC)

Introduced: 1962–64
Apertures: f1.4–f16
Angle of View: 46 degrees
Elements: 7
Foc. range: 3ft to Inf.
Filter size: 43mm
Weight: 6.0 ounces
Original Price: Unknown
Quantity: Approx. 2000 Formula unknown!!

The final version of the long-running 50mm f1.4 Nikkor-S incorporated the first real change in the optical formula as well as a significant change in the barrel. It is not known exactly when this occurred but it is known that the new lens was available in time for the 1964 Japan Olympic Games, hence the name the Olympic 1.4. This name is used strictly amongst collectors to distinguish this version from all the others, and was not used by the factory.

The change in the optical formula consisted of an enlarged rear element and improved coatings, all of which makes this version the finest example of the most famous RF Nikkor ever made. Nippon Kogaku also chose to completely redesign the barrel for this lens. Since the reflex era at Nikon was well under way, the design of this barrel was strongly influenced by the type used on the reflex lenses. It is an all-black barrel, including the filter ring, with broader knurled surfaces. The aperture index is now on the front ring instead of the rear, and this lens uses much larger and easier-to-read numerals. Also the apertures are now equidistant, which the standard f1.4 never had. A more modern type of engraving is used on the identification ring identical to that used on the reflex lenses of the period. Because of the larger rear element, and possibly more inside, the barrel is appreciably larger and heavier than the standard 1.4 it replaced, which reversed a twelve-year trend at Nikon for lighter weight optics! However, the Olympic 1.4 is a beautifully finished and constructed lens and can easily be mistaken for one made for the Nikon F reflex.

A new serial number was used on these lenses beginning at No. 140000, with a high of No. 141541 recorded to date. This could mean a production as high as 2000 units, which does not make this lens rare. What it does mean is that it is likely that these lenses could have been supplied as original equipment with what is known as the Olympic S3 cameras mentioned in that chapter. This was a batch of black S3s supposedly made for the Olympics from left-over parts, and it is said a total of 2000 cameras were produced! The numbers do match and many Olympic 1.4s have been found on these late black Nikon S3 cameras. Whether or not you possess the proper camera, any Nikon collection would benefit from the inclusion of the last version of the system's most famous lens, the 50mm f1.4 Nikkor-S.

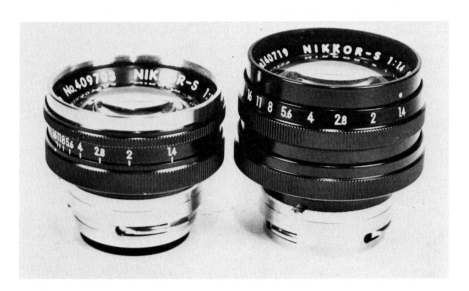

Comparison photo of standard and Olympic 1.4 Nikkors

Lens No. 140719 mounted on Nikon SP No. 6204177

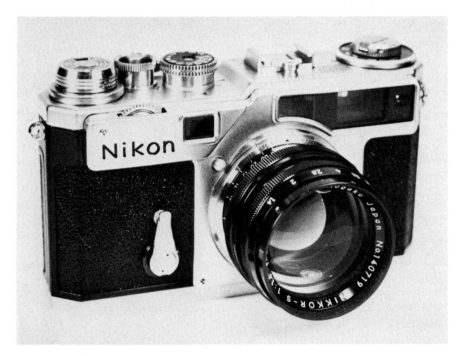

50mm f1.1 NIKKOR-N (INTERNAL MOUNT)

Introduced:	February 1956
Apertures:	f1.1–f22
Angle of View:	46 degrees
Elements:	9
Foc. range:	3ft to Inf.
Filter size:	62mm
Weight:	12.25 ounces
Original Price:	$299.50
Quantity:	Approx. 1500

Optical research was Nippon Kogaku's primary interest, and in early 1956 they were able to produce a lens that would have been impossible just a year earlier. Due to advances in surface coatings and glass technology that allowed for split elements and air spacing, February 1956 saw the introduction of the super fast 50mm f1.1 Nikkor-N. This lens would reign as the fastest normal lens made by the Big Four rangefinder '35' makers until the announcement of the Canon f0.95 in the 'sixties. The Nikkor f1.1 was a radical lens for its time using nine elements, some of which were very thin split elements. Weighing in at over twelve ounces, it was also the heaviest normal lens Nikon ever made. Stopping down all the way to f22 with clickstops, it used an elaborate 13-blade diaphragm. This first version was made to mount on the camera using the same internal bayonet as the other normal lenses, therefore, it is known as the 'Internal Mount 1.1' to differentiate it from the second version discussed in the next chapter.

Serial numbers for this lens begin at No. 119600 and have been recorded as high as No. 121084, with screw mount lenses intermixed. Total production of the internal mount may run as high as 1500 units minus those in screw mount. The author believes that approximately 1200 were made in the Nikon mount making this lens a rather difficult item to find today. It was discontinued in mid-1959 for a run of a little over three years, so annual production was around 500 units! This low production was due to both the very high price for the times, nearly twice that of the 1.4 lens, and the fact that it was a special purpose item that was used mostly by professionals.

It used 62mm accessories and was supplied with its own black plastic snap-on front cap. A special, vented, hood was made which has to rank as the most impressive lens shade ever made, and came in its own leather case! This special shade is usually seen in plastic although they were also made in metal. It is possible that two versions of this lens exist. Illustrated is the only version found to date but photos exist of another type that differs only in the diaphragm ring. This second type has the aperture index dot on the front rim with the scale reversed and the knurled ring placed lower on the barrel. Since none have been found it is possible that those seen in photographs may be prototypes only.

As mentioned this was a very heavy lens, so heavy that it was discovered that its weight could distort the camera mount and cause some rangefinder error. This was due to the use of the internal bayonet which was never designed to carry such a heavy lens. Because of this the internal 50mm f1.1 Nikkor-N was replaced by a new version covered in the next chapter.

Very early example of the Internal f1.1
Nikkor No. 119629 (1956)

Lens No. 119629 mounted on Nikon S2
No. 6149999 (1956)

The shade for the f1.1 Nikkor ranks as one of the most impressive ever made for a rangefinder camera

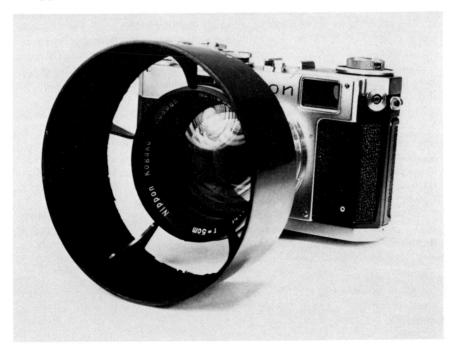

50mm f1.1 NIKKOR-N (EXTERNAL MOUNT)

Introduced: June 1959
Apertures: f1.1–f22
Angle of View: 46 degrees
Elements: 9
Foc. range: 3ft to Inf.
Filter size: 62mm
Weight: 14 ounces
Original Price: $299.50
Quantity: Approx. 1800

Nikon was aware of the possible camera mount distortion caused by the internal Nikkor f1.1 and began development of a replacement by mid-1958. The obvious solution would be to redesign the barrel to use the same external bayonet as the wide-angles and telephotos. This would distribute the mass over a larger surface and use a mount designed to carry the heavier weight. This is what Nippon Kogaku did using the same optical formula as the earlier lens, therefore, this second version of the Nikkor f1.1 is actually a new barrel and not a new lens. However, the new barrel was completely different and the result was a lens that shared very few similarities with the internal version.

The use of the external bayonet required that the new lens have its own focussing helix individually cut for each lens. The internal version used the helix built into the camera itself for coupling to the rangefinder cam. Any lens mounted to the external bayonet had its own helix for this purpose, which overrode that which was built in. This provided for more focussing accuracy, especially with heavier lenses such as the telephotos. Not only did Nikon change the mount but they also produced one of the few RF Nikkors ever made that incorporated a parallel focussing mount, eliminating the revolving front element common to the era. All of this made the External 50mm f1.1 Nikkor-N one of the most modern lenses made for the Nikon rangefinder system.

Finished only in black with a chrome filter ring, the external f1.1 began at serial No. 140700 and have been seen as high as No. 142484 for a production of about 1800 units. All examples of this lens are in Nikon mount only, for the screw mount lens remained unchanged. It was listed in Nikon price sheets as late as October 1964 so this second version was made for a longer period of time and in greater numbers than the internal mount. It used the same cap and exotic shade as the internal version for it retained the same 62mm filter thread.

Nikon would never make an f1.1 lens for the reflex cameras, getting only as close as f1.2, which makes the RF lens unique. Any lens of such size and speed, not to mention price, made over twenty years ago would qualify as extremely collectable today, and the 50mm f1.1 Nikkor-N is no exception.

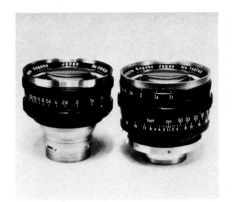

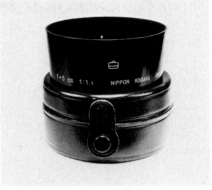

Comparison photo of both the internal and external f1.1 Nikkors

The same shade, shown here with its leather case, was used for both the internal and external f1.1 Nikkors

Lens No. 140740 mounted on Nikon S3 No. 6305149 (1959)

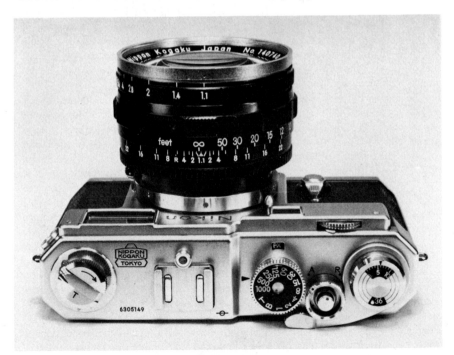

85mm f2.0 NIKKOR-P (OCCUPIED)

Introduced: March 1948
Apertures: f2.0–f16
Angle of View: 28.5 degrees
Elements: 5
Foc. range: 3.5ft to Inf.
Filter size: 48mm
Weight: 15 ounces
Original Price: Unknown
Quantity: Approx. 2000

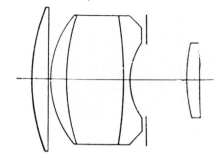

The 85mm f2.0 Nikkor-P was one of the original five lenses that were released along with the Nikon I in March of 1948. Because it was available until at least 1964 many variations exist and this chapter will concern itself with only those made during the Occupation. A fine five element telephoto design, the optical formula remained unchanged during its sixteen-year production, and was the basis for the 105mm f2.5 Nikkor of 1955 as well as the reflex type.

The version made during the Occupation was a heavy chrome on brass lens typical of Nikon construction of the period. It lacked clickstops and stopped down to only f16. All examples covered in this chapter are engraved 'Tokyo' on the identification ring and are marked MIOJ. Three distinct serial numbers were used on these early lenses. The earliest examples yet found are numbered beginning with the prefix '801', which means that the design was finalized in January 1948. Only three lenses have been seen to date and they are No. 80138, No. 80176 and No. 801168, which suggests a possible production of about 200 units! These first lenses are engraved MIOJ on the underside of the barrel exterior which is unique to this batch only. Such things as diaphragm blades and engravings on this batch exhibit a certain 'roughness', almost to the point of appearing hand made, yet the glass is bubble-free and the construction leaves nothing to be desired.

The second batch used a totally different serial number and are identical to the earlier lenses except that the MIOJ engraving is now partially hidden on the outer surface of the focussing cam at the back of the lens, and they no longer appear hand made. The serial number range seen to date is from No. 9031 to No. 904089 for a total of about 1000 units and this type is the most commonly seen of the Occupied 85mm f2.0 Nikkors. The third batch again used a different serial number which begins at No. 286500 and has been recorded as high as No. 287300, or 800 units! They are identical to the second batch except for the serial numbers. The total of all three types is approximately 2000 lenses which also includes screw mount units that are intermixed. Actually a significant amount of lenses in the last two batches were made in screw mount, therefore, those in Nikon mount were made in much fewer numbers than the figure 2000 suggests.

All three types used the same accessories. The proper shade is a chrome slip-on type that could be stored in reverse position. The cap that was then placed over the reversed hood was also chrome, the first over heavy brass with the word 'NIKKOR' engraved in large letters, the second a lighter metal with the Nippon Kogaku logo stamped in. The rear cap was also heavy chrome on brass but had no markings of any kind. No caps or shades have been found marked MIOJ, although they may exist.

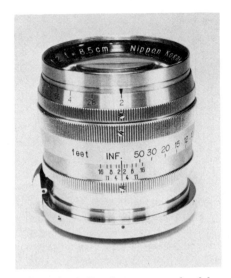
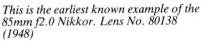
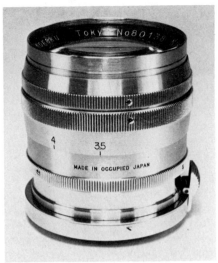

This is the earliest known example of the 85mm f2.0 Nikkor. Lens No. 80138 (1948)

Another view of lens No. 80138 showing the external location of the MIOJ engraving. Only the '801' type lenses, of which three are known, have the engraving in this position (1948)

Lens No. 80138 on Nikon M No. 609857 with Variframe finder No. M901123. Entire outfit is MIOJ! (1948?)

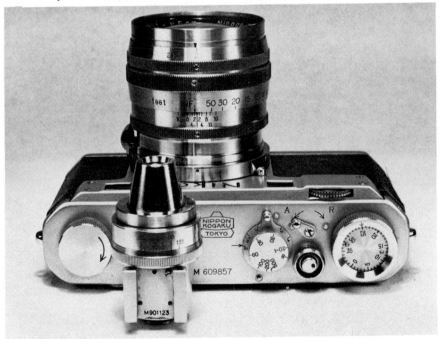

85mm f2.0 NIKKOR-P (TOKYO)

Introduced:	1951–52
Apertures:	f2.0–f16
Angle of View:	28.5 degrees
Elements:	5
Foc. range:	3.5ft to Inf.
Filter size:	48mm
Weight:	15 ounces
Original Price:	$175.00
Quantity:	Approx. 1700

This version of the 85mm f2.0 Nikkor-P was an interim model of sorts. It continues where the last batch of Occupied lenses leaves off at about No. 287300 to a recorded high of No. 288941, or about 1700 units, with screw mount lenses intermixed. It shared some characteristics of the previous lens and differed slightly from those that followed. The major points of identification are stops to f16 without clicks, the same heavy barrel, Tokyo and not Japan on the front ring, and 'Made in Japan' in the identical position as the MIOJ engraving. In essence this version is exactly the same as the occupied type except it is not marked MIOJ! All of this can be misleading to the prospective buyer who may believe he is purchasing an MIOJ lens when he really isn't. The only way to differentiate this version from the MIOJ type is to look for the engraving of origin on the rear focussing cam, which is difficult to see.

Although not a variation in type, lenses made just after the end of the Occupation, in September 1951, are interesting items to search out. They were generally made in small quantities and the versions that replaced them were improved types. Most lenses from this period are usually found along with early examples of the Nikon S, which replaced the Model M. It is not known how long they were made before the improved version was released, but a period of one year is a sound assumption based on recorded serial numbers. The author wishes to point out that the lack of clickstops and the 'Tokyo' engraving does not necessarily mean that a lens was made during the Occupation, but can only be used as a guide. Close inspection by a knowledgeable collector is required to determine the actual vintage of these early lenses.

This version of the 85mm f2.0 Nikkor-P used the same accessories as the MIOJ type and still came with the slip-on reversible shade, and not the later screw-in type.

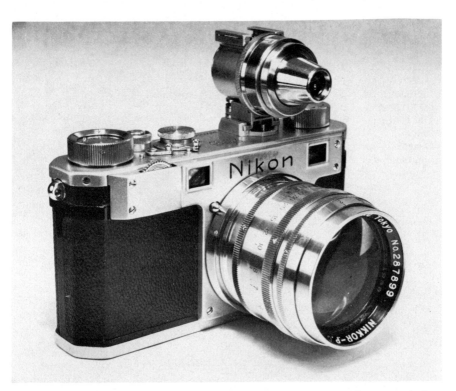

A small number of early lenses are still engraved 'Tokyo' but are no longer marked MIOJ. Example is lens No. 287899 seen here on Nikon M No. 6091571 (lens – 1952?)

All three known types of shades seen on the early 85mm f2.0 Nikkors. Two on left are slip-on type while the right version is screw-in.

85mm f2.0 NIKKOR-P

Introduced:	1953
Apertures:	f2.0–f32
Angle of View:	28.5 degrees
Elements:	5
Foc. range:	3.5ft to Inf.
Filter size:	48mm
Weight:	13 ounces
Original Price:	$175.00
Quantity:	Approx. 19,000

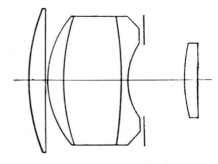

We now come to the much more readily available version of the 85mm f2.0 Nikkor-P that was made from 1953 until the end of the rangefinder era in 1964. Three separate serial number types were used for these lenses, as well as three different barrels. All, however, possessed the following characteristics. They now stop down to f32 instead of f16 and are clickstopped and use 'Japan' on the identification ring in place of 'Tokyo'. They also lack any engraving of country of origin on the rear focussing cam like the previous versions. The barrel is identical, although it is now lighter, and would lose more weight as time passed.

The first type of serial number takes up where the previous version leaves off at about No. 289000. Lenses of this type range to a high of No. 296664, or about 8000 units, with screw mount lenses intermixed. All seen to date have been chrome except one black lens, No. 293661, which is in screw mount. Suddenly the first digit changes and a new batch of numbers beginning at No. 396700 is seen. It is not known if any lenses between No. 296664 and No. 396700 exist, for the author has yet to encounter any, or if Nikon just simply decided to change the first digit. This second batch runs continuously to a high of No. 404386 for a total of a little less than 9000 units. Within this second group is seen the arrival of the black barrel 85mm Nikkor starting at approximately No. 398800. However, the black lenses are only seen occasionally with more chrome barrels seen than black. Also by this time less screw mount units have been recorded as their production dropped off. Chrome lenses have been seen as high as No. 404273 and lens No. 403134 is illustrated in this chapter, as well as black lens No. 404386, which is the highest number in this batch recorded by the author. The third type of number begins at No. 496000 and range up to a high of No. 497643 for a total of about 2000 units. All examples in this batch are black and they also represent the first real external change in the barrel. A new type of knurling is used on the focussing as well as the mounting rings, and the front chrome rim is shallower. Shown are two black lenses that illustrate these differences. Taking all three types together gives a total production of about 19,000. Adding the previous versions increases that total to almost 23,000 lenses, which makes the 85mm f2.0 Nikkor-P one of the more popular RF Nikkors made.

All used the same size accessories. The chrome lenses came with chrome, reversible, screw-in shades, with first chrome, then black, screw-in caps. The black lenses were first supplied with black screw-in reversing shades and then a snap-on type, which also used a plastic snap-on cap. The rear caps were first chrome then black metal, and finally black plastic.

As the reader can see many versions of the 85mm f2.0 Nikkor-P exist, and more may surface.

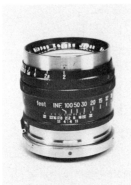 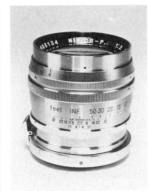 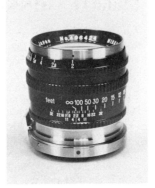

First type of black 85mm lens, No. 404386. Barrel is identical to the earlier chrome type (1956)

Chrome post-occupation 85mm f2.0 Nikkor No. 403134 (1956)

Latest version of black 85mm lens, No. 496424 (1959)

Three comparison photos showing both types of chrome barrels, the chrome and early black. Both types of black barrels. Note the different knurling.

Both chrome optical and black bright-line type finders were made for the 85mm lenses.

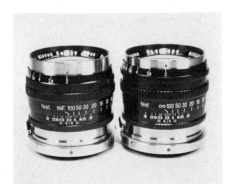 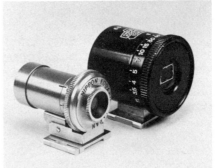

85mm f1.5 NIKKOR-S

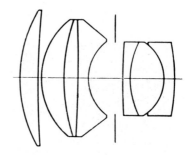

Introduced:	January 1951
Apertures:	f1.5–f32
Angle of View:	28.5 degrees
Elements:	7
Foc. range:	3.5ft to Inf.
Filter size:	60mm (Series VIII)
Weight:	19.25 ounces
Original Price:	$299.50
Quantity:	Approx. 2000

In January 1951 Nippon Kogaku released the fastest telephoto lens ever made for their rangefinder series. By slightly modifying the optical formula of the 50mm f1.4 Nikkor-S they were able to develop the super fast 85mm f1.5 Nikkor-S. One of the most exotic of the RF Nikkors, it is a massive lens weighing almost eight ounces more than the 85mm f2.0 lens. Not only was it nearly twice as fast as its slower counterpart, it was also correspondingly more expensive, selling for $300.00, which was a great deal of money in 1951. Although not as sharp as the 85mm f2.0, a lens of this speed has a certain mystique about it, making it a desirable, if not a practical, alternative. Available until at least 1961, it enjoyed a ten-year production run but was not made in large numbers, probably due to the relatively high price. Recorded serial numbers range from No. 264345 to a high of No. 266046 for a possible production of 2000 units, with screw mount lenses intermixed. This would mean an average production of 200 lenses a year which accounts for its relative scarcity today. It is not known how many were made in screw mount, but the author's information suggests as much as 25 percent, leaving somewhere around 1500 available in Nikon mount.

It was supplied only in a black barrel from the very beginning and qualifies as the first RF Nikkor to be series produced in black. This was necessary to hold down the weight and one can imagine how much a chrome-on-brass version of this lens would have weighed. The author has only been able to identify two variations in this lens. It appears that it remained virtually unchanged until almost the end of its production, at which point the knurling on the barrel was modified causing a noticeable difference. These later lenses use a type of knurling on the focussing and mounting rings like that on the 105mm f2.5 Nikkor and the last version of the black 85mm f2.0. It is not known at what serial number this occurred but illustrated are two lenses in the author's collection that are very close in number but have the different types of barrels. Lens No. 265662 has the original type while lens No. 265850 possesses the new style, and they are less than 200 units apart!

The 85mm f1.5 Nikkor-S was supplied with a black two-piece, screw-in shade and cap that reversed for storage. Two types are known to exist. The earlier version is not marked while the later type is engraved 85/1.5. It has also been reported that the very latest lenses may have come with a plastic shade but the author has yet to see one.

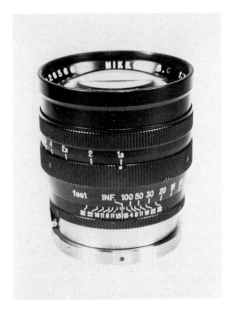

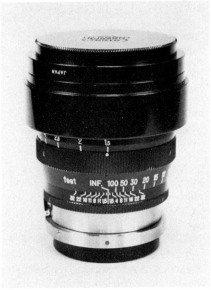

85mm f1.5 Nikkor No. 265662 (1951)

85mm f1.5 Nikkor with proper caps and shade

Comparison photo showing both types of knurling found on the 85mm f1.5 Nikkor. Left No. 265662, right No. 265850

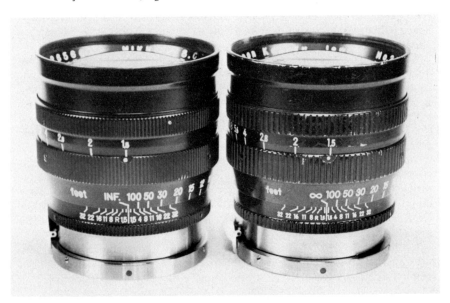

105mm f4.0 NIKKOR-T

Introduced: June 1959
Apertures: f4.0–f22
Angle of View: 23.5 degrees
Elements: 3
Foc. range: 4ft to Inf.
Filter size: 34.5mm
Weight: 9 ounces
Original Price: $79.50
Quantity: Approx. 2000

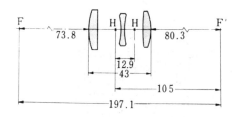

It seems that every manufacturer sooner or later makes a lens that strikes one as being a little strange, or at least out of the ordinary. The 105mm f4.0 Nikkor-T is such a lens. First announced at the IPEX show in June 1959, it was not actually marketed until May 1960, and is listed as late as 1964. Why would Nippon Kogaku make such a slow lens at such a late date when optical technology made small maximum apertures unnecessary? Their 105mm f2.5 lens was not only the sharpest medium telephoto they ever designed, but also one of the most popular. And why make it at the tail end of the rangefinder era when the Nikon F had already been introduced? Whatever the reasons they decided to produce this little lens which, on closer examination, proves to be rather interesting.

The 105mm f4.0 Nikkor-T consisted of three elements set in a very light weight and slim barrel. It weighed only nine ounces making it the lightest telephoto RF Nikkor made and the barrel was so slim that it had a pronounced flare at the rear to mate with the external bayonet on the camera. Finished only in satin black with a heavily chromed mounting ring just below the focussing grip, it closely resembles the early reflex Nikkors. Since it came out after the Nikon F, and was also made in a reflex mount, it was logical for Nikon to use its latest barrel design for this lens. One feature that it possessed that the f2.5 version never had was a preset diaphragm mechanism similar to that used on the lenses made for the reflex housing, such as the 180mm and 250mm lenses.

When mounted on a camera it proved to be a very pleasant lens to use. It was not front heavy like the other telephotos and the slim barrel did not protrude into the finder area. Its light weight made it ideal for one to carry it for hours at a time without fatigue, which may be its ultimate reason for existing.

Recorded serial numbers suggest a range from about No. 408500 to around No. 410500 for a production of about 2000 lenses. As mentioned, it was also made in a direct mount for the Nikon F but a different type of serial number was used on that version. Besides the 21mm f4.0 and the 1000mm f6.3, this is the only lens that was produced in a reflex mount with out any change in the optical formula, only the barrel. It is not known if this lens was ever made in screw mount for no listing has been found nor any examples recorded. It is probable that it was not, for Nippon Kogaku ceased making their lenses in screw mount at about the same time this lens was released.

The 105mm f4.0 Nikkor-T used 34.5mm accessories. It was supplied with its own shade that reversed for storage and used the snap-on method of mounting. A plastic snap-on cap was made and the plastic rear cap was standard by this time.

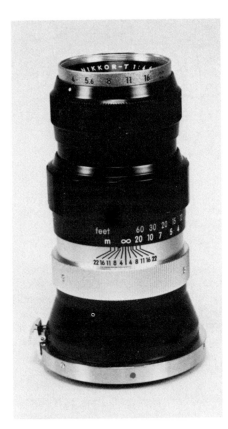

105mm f4.0 Nikkor No. 410259 (1959)

105mm f4.0 Nikkor with proper shade

105mm No. 410259 mounted on Nikon SP with exposure meter

Snap-on cap and shade for 105mm f4.0 Nikkor

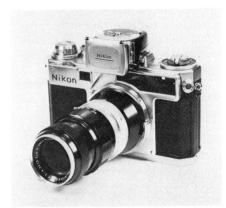

105mm f2.5 NIKKOR-P

Introduced: December 1953
Apertures: f2.5–f32
Angle of View: 23.5 degrees Formula
Elements: 5 unknown!!
Foc. range: 4ft to Inf.
Filter size: 52mm (Series VII)
Weight: 18.5 ounces
Original Price: $152.50
Quantity: Approx. 22,000

This intermediate telephoto was to become not only one of the most popular RF Nikkors, but one on which the legendary Nikon optical reputation was founded. The optical formula proved to be so well developed that this lens went on, virtually unchanged, to become one of the most famous Nikkors for the reflex Nikons. Even to this day, nearly thirty years later, it is still acknowledged to be one of the finest lenses ever made for 35mm photography.

A general purpose medium telephoto, similar in formula to the 85mm f2.0 Nikkor, it possessed high speed and unusual resolution. First introduced in December 1953, it was not marketed in the United States until mid-1954. It consisted of five elements mounted in a modern black barrel with a heavily chromed front rim and rear mounting ring. Weighing in at nearly 19 ounces it was certainly no light weight, but the result was a very solid lens able to withstand heavy professional use. The liberal use of chrome and brass, especially in its focussing helix, account for its solid feel. The barrel was unchanged throughout its production to 1963. The only external variation is that the early examples have two small posts mounted to the outer surface of the front rim that were used to mount the shade in a bayonet fashion. Later these were removed and the shade was changed to a snap-on type.

Two types of serial numbers were used. Production began at serial No. 812000 and continued up to about No. 821000 at which time a new type of number is seen. This second batch began at No. 912000 and have been recorded as high as No. 924900. The total production of both types is approximately 22,000 lenses, with screw mount units intermixed, making it as popular as the 85mm f2.0.

This was the first Nikkor to use 52mm accessories which became the standard size for the bulk of the lenses made for the Nikon reflex cameras in later years. The early lenses up to about No. 816000 were supplied with a bayonet type shade that reversed for storage and had a slip-on metal cap. Later lenses used a snap-on shade that was shallower and also reversible. This new shade used a snap-on plastic cap and was made in at least two variations. Early examples are not marked but later ones are engraved 105/2.5 for identification. An interesting item, that was also standard equipment, was a screw-in adapter ring that could be mounted between lens and shade to allow use of Series VII filters instead of the 52mm screw-in type.

The 105mm f2.5 Nikkor-P is regarded as a landmark lens in the history of Nippon Kogaku. It substantiated the fact that they were one of the premier optical manufacturers in the world and capable of producing a truly first class lens. Eventually the world would acknowledge this with the tremendous success of their reflex cameras during the next two decades when their lens system became the one that others would be compared to. What is interesting is that a 1953 design would be one of the cornerstones of that great optical arsenal.

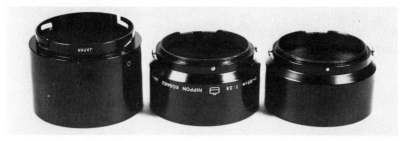

All three types of shades from the earliest bayonet version, left, to the two types of snap-ons

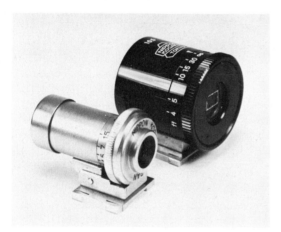

Both chrome optical and black bright-line type finders were made for the 105mm lenses

Comparison photo of early and late 105mm f2.5 Nikkors. Lens on the right is No. 914855 and lacks the studs for the bayonet shade

Very few RF Nikkors were made with a metric distance scale. This is lens No. 923645 which is from the very late production period and may have been sold in Europe (1960)

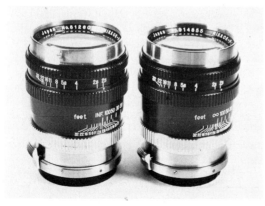
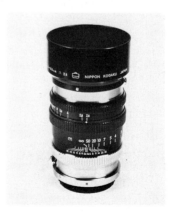

129

135mm f4.0 NIKKOR-Q

Introduced:	1947	
Apertures:	f4.0–f16	
Angle of View:	18 degrees	
Elements:	4	
Foc. range:	5ft to Inf.	Formula unknown!!
Filter size:	40.5mm	
Weight:	18 ounces	
Original Price:	Unknown	
Quantity:	Approx. 900	

The 135mm f4.0 Nikkor-Q was the fifth member of the original lens system available when the Nikon I was released in March 1948. Actual production could have begun even before that date for records suggest that it was completed some time in 1947. It remained the longest lens for the system until the release of the 250mm f4.0 Nikkor in early 1951. It was made only during the Occupation and its construction is typical of Nikkor optics of the period. In other words it is a very heavy chrome-on-brass lens although its physical dimensions are not large considering its weight.

Available until only March 1950. it was not produced in large numbers. Two totally different serial number types were used. The earliest lenses, of which the author has only seen three, begin with the prefix '611'. Two of these lenses are in the author's collection and are No. 61138 and No. 611171. The third is No. 611185 and is unique because it is in an Exacta mount and is the only 135/4.0 Nikkor recorded as such. These early lenses differ from the later type in several respects. The front rim is constructed differently and much larger screwheads are visible on the barrel. Also the engraving of both the identification ring and the depth of field scale appear almost 'crude' compared to later examples. There is the possibility that these '611' type lenses were actually a preproduction run made in November 1946, using Nikon's dating system, to test the feasibility of making the lens. They appear almost hand made and not mass-produced, and may only number about 200 units. To date none have been found in screw mount. The second type of number seen begins at No. 9041 and has been recorded as high as No. 904701 for a total of 701 lenses, thus the figure of 900 for a total production, although they may approach 1000. This second batch uses smaller screwheads, a different front rim and much higher quality engravings and diaphragm blades. Also many have been found in screw mount. Both types lack clickstops and have the MIOJ engraving on the underside of the barrel near the mounting ring. However, a few lenses in the second batch have been found where the MIOJ engraving is not external but on the side of the rangefinder cam at the rear of the lens. Examples of this are No. 90431, No. 90462, No. 904227 and No. 904675, so they are well dispersed. It is not known why this was done, but it makes for an interesting variation.

Both types used 40.5mm accessories and were supplied with a one-piece, unmarked slip-on shade that reversed for storage. The front cap was chrome with the word 'NIKKOR' in very large letters. The proper rear cap for this vintage is also chrome with some unmarked and others with the Nippon Kogaku logo engraved.

The 135mm f4.0 Nikkor-Q is one of the most difficult of the early MIOJ lenses to locate today and more variations may surface as more examples are discovered.

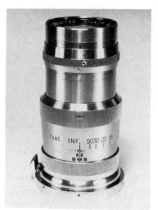

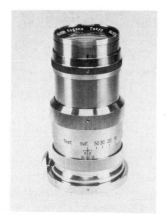

The earliest known 135mm f4.0 Nikkor No. 61138 (1946?)

Early example from the more common second type of 135mm f4.0 Nikkor is lens No. 90431 (1949)

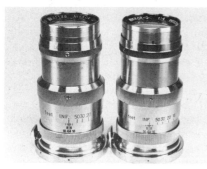

Comparison photo of a '611' and a '904' type lens. Note the differences in the front flange and the types of screws and engravings used.

Although no individual finder has been found marked MIOJ, this example is engraved 'Tokyo' and is from the proper period (1950?)

Two close-up views of the front rims of lens No. 61138 compared to that of lens No. 90454

135mm f3.5 NIKKOR-Q (OCCUPIED)

Introduced: March 1950
Apertures: f3.5–f16
Angle of View: 18 degrees
Elements: 4
Foc. range: 5ft to Inf.
Filter size: 43mm
Weight: 18 ounces
Original Price: Unknown
Quantity: Approx. 3000

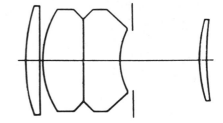

In March 1950 Nippon Kogaku replaced the 135mm f4.0 with a faster f3.5 lens, whose optical formula may have been almost identical. It was made in great numbers till the end of the rangefinder era, but this chapter will deal with those from the Occupation.

It is very similar in construction to the previous lens except that they added a tripod socket to this version. The earliest lenses begin at No. 500601 and range as high as No. 50060427, or about 500 lenses. This type of number resembles those used on the first versions of the 50mm f1.4 and 2.0 Nikkors discussed previously. They were followed by an entirely different type beginning at No. 253000 to a high of about lens No. 256000. Although the numbers changed the lenses were identical. They all lacked clickstops and only stopped down to f16. The front rim was not grooved like the f4.0 lens and the MIOJ engraving was on the rear cam and not external. The tripod socket is generally European thread and some have 'Japan' engraved on the collar. The barrel was heavy chrome on brass and would lose weight as time passed.

The second group of numbers from No. 253000 to No. 256000 suggests that 3000 lenses were made, but this is not quite true. More so than any other of the early lenses, the 135mm f3.5s from the Occupation are not clearly defined. There is a great deal of intermixing of occupied and unoccupied lenses. Within the author's own collection is lens No. 255053 that is not occupied and No. 255059 that is! Many other examples of this have been recorded. The two types do differ significantly and it is not known why the numbers are so inconsistent. There are also many screw mount lenses within this group, therefore the total amount in Nikon bayonet and marked MIOJ is appreciably below the 3000 figure, possibly as low as 2000 lenses. There are variations in the depth of field scale and some early lenses lack filter threads. All in all the 135mm f3.5 Nikkor-Q (Occupied) presents a challenge to the collector to find all of the variations, but the most interesting aspect is finding two lenses with very close serial numbers where one is occupied and the other is not.

All types used 43mm accessories which was becoming more the standard at Nikon. The proper shade for these lenses is still the slip-on type but it is now two-piece, doubling as a filter holder. It reverses for storage and the front cap is still chrome and usually embossed with the Nippon Kogaku logo. Sometimes they are found with the later screw-in shades, which do fit, but they are a mismatch.

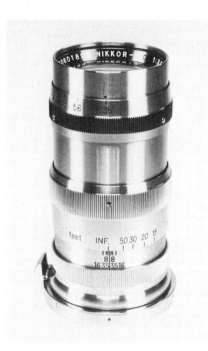
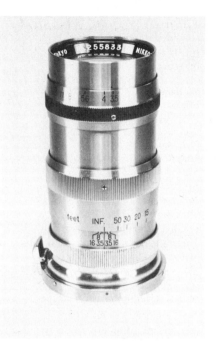

Early 135mm f3.5 MIOJ Nikkor
No. 50060189 from the first batch (1950)

Example of the second type is lens
No. 255833 which is MIOJ (1951)

MIOJ 135mm f3.5 Nikkor with proper
caps and slip-on shade

Lens No. 50060189 mounted on Nikon
M No. 6092241 with early chrome
optical finder (1950)

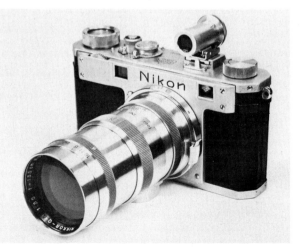

135mm f3.5 NIKKOR-Q

Introduced:	1953
Apertures:	f3.5–f32
Angle of View:	18 degrees
Elements:	4
Foc. range:	5ft to Inf.
Filter size:	43mm
Weight:	16.75 ounces
Original Price:	$135.00
Quantity:	Approx. 12,000

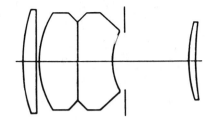

This second version of the 135mm f3.5 Nikkor-Q can be said to generally range from No. 256000 to a high of about No. 268000, or 12,000 lenses. However, as mentioned there is some intermixing with MIOJ lenses. Examples of lenses before No. 256000 that belong in this group are Nos. 253212, 255053, 255078, 255575 and 255814, which are bracketed by MIOJ marked units! Once the numbers get beyond No. 256022 no MIOJ lenses have been seen, although some examples are still engraved 'Tokyo' on the identification ring and lack clickstops, but are not marked MIOJ. Examples of this are lenses No. 256022 and No. 256220.

The second type differ in that they now stop down to f32 and have clickstops, the diaphragm ring is satin chrome and the word 'Japan' has replaced 'Tokyo' on the identification ring. The barrel would also lose weight, especially in the latter half of this batch. Within this group are four different mounts. In descending quantity they include Nikon, screw mount and Contax and Exacta mount. The Contax mount lenses appear identical to those in Nikon bayonet but have the letter 'C' engraved on the side of the barrel and differ because their rangefinder helix has a slightly different pitch. Those in Exacta mount will be discussed in their own chapter.

The majority of lenses in this group are chrome on brass but the first black 135mm Nikkors ever made appear. This occurred some time in late 1955. The black lenses in this category are actually different from those that followed, and are known amongst collectors as the 'original' mount black version. The first seen is No. 264583 which is still followed by some chrome lenses until about No. 265317, after which only black barrels have been recorded. Therefore, there is some intermixing of chrome and black lenses but not as much as some other lenses in the system. These black lenses are identical to those made in chrome, and are actually black paint over brass and weigh the same. They range from about No. 264583 to around No. 268214 after which an entirely new barrel is seen. These newer lenses will be covered in their own chapter. It appears that around 3500 of the Original mount black lenses were made, although some chrome mounts are still intermixed, and are an interesting variation to search for.

The proper shade for this second batch is now the screw-in type. They are two-piece and still reverse for storage. Those made for the chrome lenses are, of course, chrome and use a chrome screw-in front cap. The black version of this shade is identical except for finish and uses a black screw-in cap. By this time the rear cap is generally a thinner metal than the earlier type and now finished in black.

Although these are common lenses, and rather easy to find today, clean examples are difficult and the black version is still a challenge for the collector to locate, especially with the proper shade.

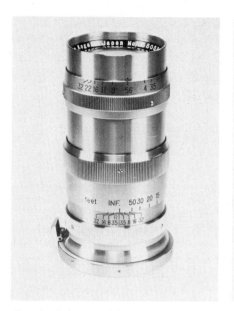

Standard chrome 135mm Nikkor lens
No. 255053 (1953)

Black version of the chrome barrel, lens
No. 265317 (1955)

MIOJ marked lenses can be found
during the early production of the
135mm lenses intermixed with non-
MIOJ types. Lens on left is MIOJ
No. 255059 while on the right is
non-MIOJ lens No. 255053! Note the
close serial numbers!

Comparison photo of the chrome and
black versions

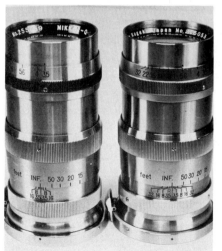

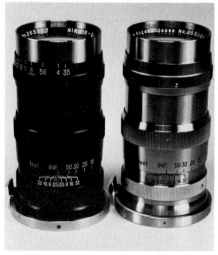

135mm f3.5 NIKKOR-Q (New)

Introduced:	July 1956
Apertures:	f3.5–f32
Angle of View:	18 degrees
Elements:	4
Foc. range:	5ft to Inf.
Filter size:	43mm
Weight:	14 ounces
Original Price:	$135.00
Quantity:	Approx. 14,000

In July 1956 Nippon Kogaku redesigned the barrel for the 135mm f3.5 Nikkor-Q, but did not change the optical formula. The new barrel utilized aluminium in place of brass for most of the exterior and some of the interior parts. At the same time they also changed the appearance of the barrel. Although only finished in black, it differed from those in the original black mount in other ways besides weight. The rear flange and mounting ring are finished in a satin chrome and the ribbing was changed to the style used on the 105mm f2.5 Nikkor. If viewed side by side the two lenses appear decidedly different, as the accompanying photo illustrates. This new barrel first appears at about No. 268000 and does slightly overlap the original black mount. Serial numbers for this new barrel have been recorded as high as No. 282507 for a production of around 14,000 lenses, and added to the previous types, a total of at least 30,000 of the 135mm f3.5 lenses were made. It is this version that was available until at least 1964, so it was made for almost eight years. The only variations seen are some differences in the focussing scale and the removal of the red 'C', for coated, on the identification ring at about No. 273000. Otherwise it was made unchanged throughout its production run. It was available in both Contax and screw mount, but none have been recorded in the Exacta type mount. It appears that Nikon abandoned the Exacta lenses even before the original black mount was made.

The shade for this version was changed to a snap-on, reversing, type that used a black plastic snap-on front cap. The shade was still metal but now aluminium instead of brass. There are at least three versions of the shade but they only vary in engravings and not configuration. Sometime during the production of this lens the metal rear cap was replaced by the plastic type. It is probable that this lens was generally used with the black bright line finder, instead of the chrome type, although both the Nikon SP and S3 had a built-in frame-line for this focal length.

Because of its large production and late vintage, it is rather easy to find this lens in extremely fine condition. Many are discovered in their original box and some have been found in new condition.

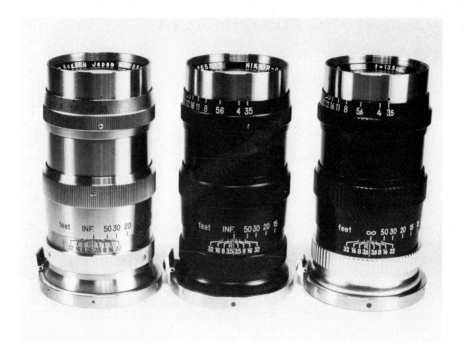

Comparison photo of all three types of post-occupation 135mm f3.5 Nikkors

Chrome and black shades for the old style barrel of the 135mm f3.5 Nikkor

Both chrome optical and black bright-line type finders were made for the 135mm lenses

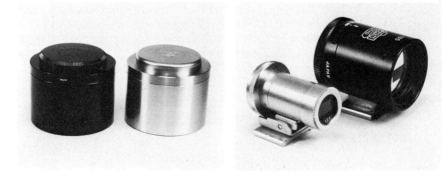

135mm f3.5 NIKKOR-Q (EXACTA)

Introduced: 1950?
Apertures: f3.5–f32
Angle of View: 18 degrees
Elements: 4
Foc. range: 5ft to Inf.
Filter size: 43mm
Weight: 16.75 ounces
Original Price: $135.00
Quantity: Unknown

Possibly as early as 1950 Nippon Kogaku made their 134mm f3.5 Nikkor-Q available in an Exacta mount, and it is the only lens for which they did this. Why it was made at all, and why only this focal length, is not known. Since the Exacta was the leading SLR of the period they may have thought that there was a market for such a lens, but why not do the same with the 85mm and 105mm lenses? Whatever the reasons the result is a true oddity, and a real collector's item.

Illustrated is an Exacta mount lens alongside one in a Nikon bayonet. Both barrels are identical from the mounting ring forward. The difference in physical length is due to the greater depth of the reflex body which allows for a shorter barrel. The author has recorded only four examples of this lens to date. All are in chrome mount, stop down to f32 with clicks and have 'Japan' and not 'Tokyo' on the identification ring. The serial numbers of the four lenses are Nos. 256192, 259759, 260742 and 261521. All belong to the second batch of lenses made after the end of the Occupation, therefore none are marked MIOJ. They also end well before the black lenses appear and none have been found in black to date. A fifth lens is known to the author and was mentioned in the chapter on the 135mm f4.0 Nikkor-Q. That lens is the only example of an f4.0 in an Exacta mount to surface, and also the only one marked MIOJ. The fact that an f4.0 lens exists would mean that Nippon Kogaku decided to make an Exacta mount quite early, yet none have been found with the f3.5 aperture made during the Occupation. Because of the very small, and dispersed, sampling available, it is impossible to determine just how many of these lenses were made. More examples need to be found to make a better estimate, but one thing is obvious. This lens was not made in any great quantity and may qualify as one of the rarest of all the Nikkors from this period.

The Exacta mount lens used the same 43mm accessories and was supplied with the two-piece, reversible, screw-in type shade with a chrome cap. The rear cap consisted of black-painted aluminium that is held on with friction.

The author believes that some lenses were probably made that are marked MIOJ and will eventually surface. Since they were listed in Nikon price sheets until July 1959, black lenses may exist, although it is possible that what are listed are actually lenses that were left over, and may still be chrome.

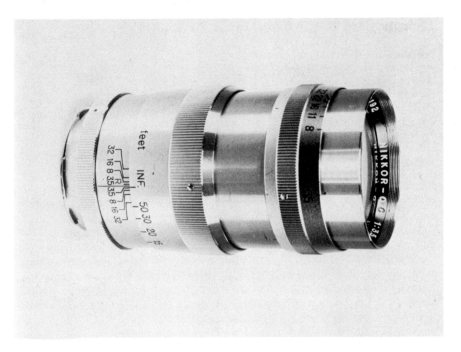

Rare Exacta mount 135mm f3.5 Nikkor
No. 256192

The Exacta version alongside a Nikon
mount 135mm Nikkor

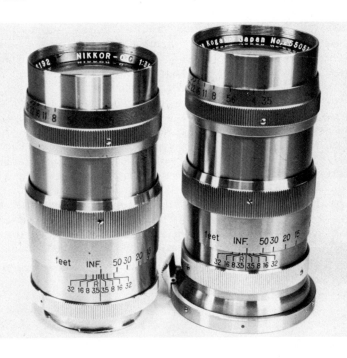

135mm f4.0 NIKKOR-Q (for BELLOWS)

Introduced:	May 1958
Apertures:	f4.0–f22
Angle of View:	18 degrees
Elements:	4
Foc. range:	1 : 1 (lifesize) to Inf.
Filter size:	43mm
Weight:	11.5 ounces
Original Price:	$120.00
Quantity:	Approx 1500

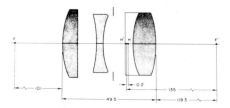

The only RF Nikkor made specifically for close-up work was the 135mm f4.0 Nikkor-Q Short Mount. Although it was listed in Nikon price sheets as early as May 1958, it may not have been actually marketed until January 1959.

It was designed for use in combination with the Nikon Reflex Housing and the Bellows Model I. It could also be used on their copy stands, especially the later versions that used a bellows instead of extension tubes. When used with the Housing and Bellows it could focus from infinity to 1 : 1 lifesize. Its simple four-element optical formula allowed for a very flat field and excellent sharpness out to the very edge. Because of its late introduction date this is a very modern lens. It was finished in satin black with a chrome mounting ring and a satin chrome front rim that doubled as the diaphragm scale. It also possessed a preset diaphragm similar to that used on the reflex housing lenses and the 105mm f4.0 Nikkor. This allowed the user maximum brightness on the focussing screen especially useful at very close distances. Possessing no focussing helix of its own allowed for a compact barrel. The rear element protrudes about one inch and that part of the barrel visible when mounted is no larger than the 85mm f2.0 Nikkor. It was supplied with a 43mm snap-on black plastic front cap but no shade was ever made since the front element is deeply recessed. No specific rear cap was ever listed although those made for the 21mm and 25mm lenses are deep set enough to fit. There is also a screw thread at the very rear of the lens which is used to mount it in its own plastic storage bubble.

One would think that such a special purpose lens that was released so late in the rangefinder era would not be made in any large numbers. The serial numbers range from No. 578000 to a recorded high of lens No. 579461, or about 1500 lenses, which is a significant quantity. The reason is that Nippon Kogaku made a special adapter ring called the B-F tube, later BR-1, that allowed this lens to be used on those bellows units made for the later Nikon F series. Close-up photography came into its own with the advent of the SLR because it was so much easier, and the 135mm f4.0 Nikkor-Q was the only bellows lens made for the reflex system in its first five years. Because of this, many of these lenses were sold after the rangefinders were gone and were used with the Nikon F system. It is listed in Nikon F literature until at least 1968 when it was replaced by a lens using the same optics but now in a direct reflex mount.

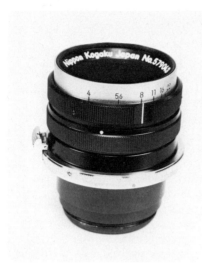

Bellows-Nikkor 135mm f4.0 No. 579043 (1958)

Bellows-Nikkor in its own special plastic bubble base which has a screw mount

Short mount Nikkor No. 579043 mounted on Bellows Model I No. 56035

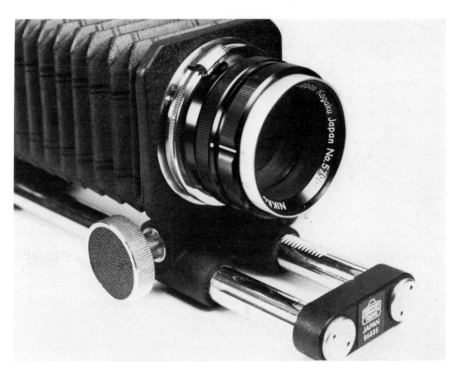

180mm f2.5 NIKKOR-H

Introduced:	November 1953
Apertures:	f2.5–f32
Angle of View:	13.5 degrees
Elements:	6
Foc. range:	7ft to Inf.
Filter size:	82mm (Series IX)
Weight:	60 ounces
Original Price:	$399.50
Quantity:	Approx 1200

One of the more exotic lenses for the Nikon rangefinder system was the 180mm f2.5 Nikor-H. An extremely fast lens for its time, its only peer was the famous 180mm f2.8 Sonnar for the Contax. Made up of six elements mounted in a very heavy short mount barrel, it was only usable on their reflex housing, and focusssed down to seven feet. Its optical formula was computed to make it highly usable at wider apertures making it a very good available light lens. It possessed a preset diaphragm mechanism and stopped down to f32. Finished only in a very handsome satin black barrel, it is possible that the very early examples had chrome tripod sockets, but the author has yet to record any. Although some aluminium was used for the barrel exterior, the lens is basically made up of heavy brass, especially the helix, and weighed a very substantial 60 ounces. However, because of the preset diaphragm and a heavily knurled focussing ring, it handles quite well.

First marketed in Novmember 1953, it was listed as late as 1963. It is possible that this lens enjoyed more popularity after the release of the Nikon F reflex, for Nippon Kogaku made an adapter, called the N-F tube, that allowed its use on the 'F'. Being such an extremely fast lens, and since no 'F' mount lens approaching its speed existed, it became a favourite of early Nikon F users.

Two distinct serial number types exist. The earliest lenses are numbered starting at No. 373500 and have been recorded as high as No. 373877. After this point a second type of number appears. It ranges from about No. 473500 to a high of No. 474176, and the total is approximately 1200 lenses. This is only an average of 120 lenses per year but makes sense when one realizes just how much $400.00 was in the late 'fifties. Also any potential user would need to purchase the Reflex Housing at an additional cost of $100.00, so it was not an item that would appeal to the mass market.

The 180mm f.2.5 Nikkor-H used 82mm screw-in accessories but was supplied with a two-piece, reversing, hood that allowed use of Series IX filters also. The hood has been seen in at least two versions which differ slightly in shape. When reversed it was topped by a black 82mm screw-in cap.

Variations seen in this lens include differences in the knurling of the focussing ring and the distance scale. Some examples are calibrated only in feet or metres while others have both scales. Besides these examples it remained basically unchanged throughout its ten-year run.

A very impressive and beautiful lens, the 180mm f2.5 Nikkor-H is not easily found today, especially one in fine condition. Being so large and heavy the black painted barrel is prone to wear and many examples seen by the author are in less than collectable condition. In addition, some are still being used today on the Nikon reflex cameras. The 180mm f2.5 Nikkor-H is an important addition to any Rangefinder collection.

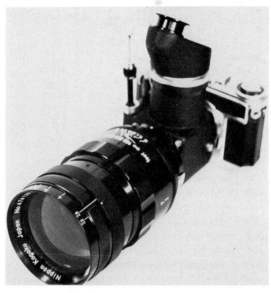

180mm f2.4 Nikkor No. 474133 (1956)

Lens No. 474133 on Nikon reflex housing mounted on an SP

Nikon SP with reflex housing and 180mm lens with shade

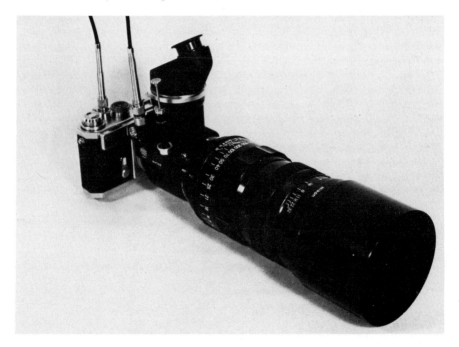

250mm f4.0 NIKKOR-Q (MANUAL)

Introduced:	January 1951
Apertures:	f4.0–f32
Angle of View:	10 degrees
Elements:	4
Foc. range:	10ft to Inf.
Filter size:	68mm (Series IX)
Weight:	40 ounces
Original Price:	$224.50
Quantity:	Approx 600

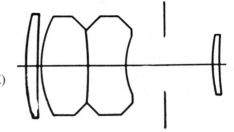

The 250mm f4.0 Nikkor-Q was the first lens that Nippon Kogaku developed for their reflex housing. This is significant in that this is less than three years after they released their very first camera, the Nikon I, and shows how feverishly they were designing new lenses for their new camera. This chapter will deal with the first version of this lens, which was released in January 1951 along with the Nikon S camera.

Its optical formula was similar to that used for the 135mm f3.5 Nikkor and retained its high accutance plus excellent speed for a lens of this focal length. Designed for use on the Nikon Reflex Housing, and the most commonly used focal length, it focussed down to 10ft. This first version of the 250mm f4.0 Nikkor-Q was made only in a manual mount and stopped down to f32. The serial number range seen to date is from No. 271800 to No. 272400, for a total of approximately 600 lenses. Made only in a black painted barrel, most of these early lenses used a chrome tripod socket instead of black.

It was supplied with a black, two-piece, reversing hood that would accommodate Series IX filters, but the lens also had a 68mm thread. The hood was made from heavy gauge aluminium and used a 68mm screw-in cap. This was a heavy lens, weighing in at 40 ounces, with some aluminium used for the exterior barrel but of mostly brass construction.

It was eventually redesigned and replaced by an easier-to-use lens that will be covered in the next chapter. It appears that this version was made until mid-1956, so the yearly production was around 100 lenses. This is not a very large quantity, and fine condition examples of these early lenses are not easy to come by today. Because it lacked an important feature available on the 180mm f2.5 lens, this version of the 250mm f4.0 Nikkor-Q was replaced in late 1956 by the version that proved to be much more popular. The manual 250mm f4.0 Nikkor-Q is significant because it was the first lens for a reflex housing that Nikon ever made, and marked the beginning of what was to become one of the most extensive telephoto systems ever designed for a rangefinder camera.

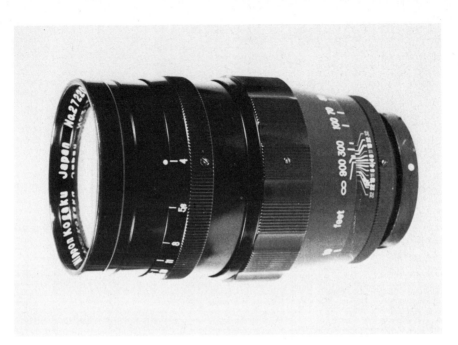

Manual 250mm f4.0 Nikkor No. 272200 (1951)

Lens No. 272276 with early version of the shade (1951)

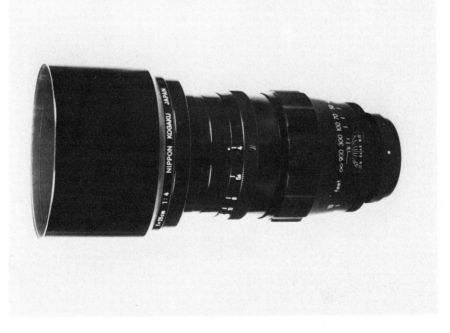

250mm f4.0 NIKKOR-Q (PRESET)

Introduced:	1956
Apertures:	f4.0–f32
Angle of View:	10 degrees
Elements:	4
Foc. range:	10ft to Inf.
Filter size:	68mm (Series IX)
Weight:	36.5 ounces
Original Price:	$224.50
Quantity:	Approx 1700

Sometime in 1956 Nippon Kogaku decided to redesign and update the 250mm f4.0 Nikkor-Q. Although the optical formula remained the same, the result was a completely new barrel. This change was brought on by the adoption of a preset diaphragm mechanism similar to that used on the 180mm Nikkor. Since the 180mm lens was released in 1953, and was preset from the very beginning, it is surprising that Nikon waited so long to add this feature to the 250mm Nikkor. In the meantime the longer 500mm f5.0 Nikkor had also been released with a preset diaphragm. Whatever the reasons, the 250mm f4.0 Nikkor-Q was finally redesigned to more modern specifications.

The barrel of this new version differs significantly as the accompanying illustration shows. It is now much slimmer and has lost some weight. The addition of the preset diaphragm made for a much easier-to-use lens, and it would remain unchanged until the end. It was listed in Nikon price sheets as late as 1962 and probably saw use on the Nikon F camera, as did the 180mm lens.

Two types of serial numbers are encountered when collecting the preset 250mm Nikkor. The first type picks up where the manual lens leaves off and begins at about No. 272400. They have been recorded as high as No. 273769 for a total of about 1400 lenses. At this point a new serial number was adopted which begins at No. 277400 and runs as high as No. 277668 for an additional 300 units. The total production of the preset 250mm Nikkor is therefore approximately 1700 lenses. When added to the 600 manual lenses the total production of all types of the 250mm f4.0 Nikkor-Q can run as high as 2300 lenses, which makes it the most popular lens made for the reflex housing.

This new lens came equipped with a slightly different hood. It was still made from heavy gauge aluminium but now had a different shape, yet it still reversed for storage and was of two-piece construction. Fine examples of this later 250mm f4.0 Nikkor-Q are much less difficult to acquire than the earlier manual lens. As late as 1980 the author was able to unearth brand new examples of this lens still in their original boxes along with the warranty cards!

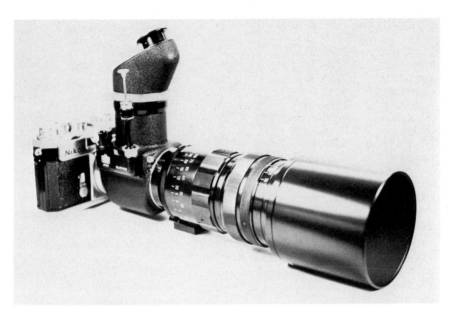

Preset 250mm Nikkor with shade mounted on the reflex housing and a Nikon SP

View of lens No. 277646

Two views of the manual and preset 250mm Nikkors showing the differences in the barrels and tripod sockets

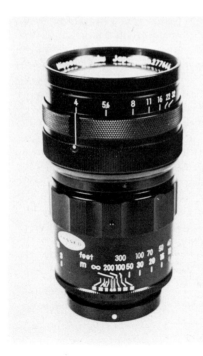

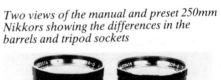

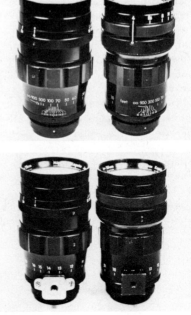

350mm f4.5 NIKKOR-T

Introduced:	June 1959
Apertures:	f4.5–f22
Angle of View:	7 degrees
Elements:	3
Foc. range:	13ft to Inf.
Filter size:	82mm (Series IX)
Weight:	59 ounces
Original Price:	$398.00
Quantity:	Approx 650

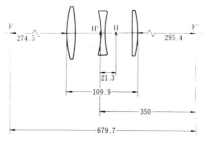

The most modern lens made for the Nikon reflex Housing was the 350mm f4.5 Nikkor-T. First announced in June 1959 at the same show that saw the introduction of the Nikon F, it was not actually marketed until January 1960. A lightweight lens for its size, its major claim to fame is that it was the first, and only, RF Nikkor ever made with a semi-automatic diaphragm mechanism. This unique feature made this lens the easiest to use on the Nikon Reflex Housing. Near the mid-point of the barrel was a clickstopped diaphragm ring that stopped down to f22. To its rear was another ring with a lever attached and an arrow engraved pointing to the left. Near this second ring was a cable release button similar to those found on many cameras. The method of operating the semi-automatic diaphragm was as follows: the lens would be mounted to the reflex housing and a double cable release attached with one cable going to the shutter release on the camera and the other to the socket on the lens; the user would move the first ring to the chosen aperture; upon depressing the cable release the diaphragm would stop down to the chosen aperture, the mirror would rise and the shutter would release, all in sequence; the user would then rotate the second ring, using the attached lever, in the direction of the arrow which would automatically reopen the diaphragm to maximum aperture for easy focussing; further pressure on the cable release would again stop the lens down to the same aperture until the user changed it. The result was a semi-automatic diaphragm that an experienced user could operate much more quickly than can be described in words!

The 350mm f4.5 Nikkor-T consisted of three elements mounted in a lightweight barrel made primarily of aluminium. The serial numbers range from No. 354500 to a high of No. 355116 for a total of about 650 lenses. Only one version was made unless the lens shown in some literature exists. This lens has a black aperture scale instead of chrome and a slightly different lever, but none have been reported to the author. It was listed in the Nikon price sheets until 1964 and many were probably used on the Nikon F with the N-F adapter.

It was supplied with a screw-in shade that reversed for storage. It mounted using the 82mm thread on the lens and had a black metal cap. Two versions of the shade exist. One is painted a satin black but the second type is finished in a grey crinkle paint. It is probable that the black version is the earlier of the two.

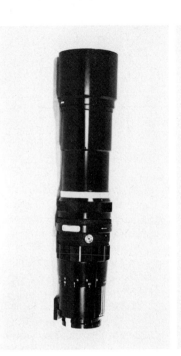

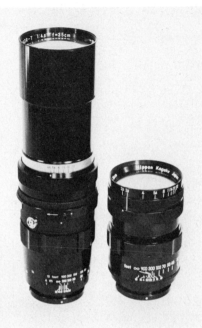

The 350mm f4.5 Nikkor No. 354735 (1959)

Comparison photo showing relative sizes of the 350mm Nikkor on the left and the 180mm lens on the right

Both types of shades made for the 350mm Nikkor. On the left the crinkle finished type with the gloss type on the right

500mm f5.0 NIKKOR-T

Introduced:	September 1952
Apertures:	f5.0–f45
Angle of View:	5 degrees
Elements:	3
Foc. range:	25ft to Inf.
Filter size:	110mm
Weight:	19 pounds
Original Price:	$550.00
Quantity:	Approx 300

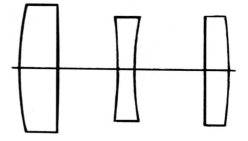

In September 1952 Nikon announced the second lens made for their reflex housing. They doubled the focal length of the 250mm lens and came up with the truly massive 500mm f5.0 Nikkor-T. This cannon weighed 19 pounds and, with hood attached, measured nearly three feet long, and would reign as the largest RF Nikkor until the release of the 1000mm f6.3 Mirror lens in 1960.

Because of its size, limited use, and very high price for the times, it would remain a low production item and was listed in Nikon price sheets until at least 1961. The barrel was finished in gloss black with a huge, centrally mounted, tripod collar finished in black crinkle paint. The base of the tripod socket was almost four inches across. At the top was a locking clamp that, when loosened, allowed the entire lens along with the housing and camera, to rotate through 360 degrees. The barrel consisted of some aluminium and a great deal of brass, and even the shade weighed nearly a pound. The front lens cap was made of a very heavy gauge aluminium that appears almost one-eighth inch thick! So massive was this lens that it was supplied with its own custom hardwood box with two keylocks and a large carrying handle, all of which added up to a total weight of nearly thirty pounds!

Supposedly the earliest examples had a manual diaphragm, but the author has not been able to locate any. All literature as early as 1954 list it as having a preset diaphragm mechanism, so the existence of a manual lens is doubtful. The preset mechanism was the same as that used on the 180mm Nikkor and stopped down all the way to f45. It focussed to 25ft and was so massive that the camera plus housing, and not the lens, would move while focussing. Serial numbers recorded to date range from No. 647000 to a high of No. 647248, for a production of about 300 lenses. However, if the manual version does exist it would have a different type of number, although it would not add very much to the total produced. Since it was made for nearly ten years, its average yearly production would be in the area of 40–50 lenses!

It was supplied with a two-piece, reversible, shade and slip-on front cap. There is room within the hardwood box for two filters but it is not known if they were supplied as standard equipment.

A unique example of this lens is No. 647043 illustrated here. This lens is from the author's collection and has nearly three-quarters of the barrel, plus the shade, finished in the same crinkle paint as the tripod collar. On close examination it is obvious that this finish was applied after the lens was originally constructed. However, because of the excellent quality of the paint, and the fact that it matches the tripod collar perfectly, it is possible that it was done by the factory on special request. This finish is much less prone to scratches and abrasions than the gloss black and makes more sense in a lens of this size.

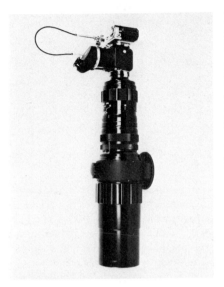

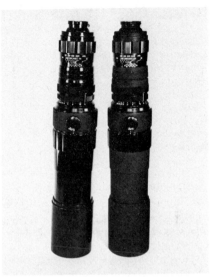

500mm f5.0 Nikkor No. 647104 mounted on Nikon SP with reflex housing (1955)

Two 500mm Nikkors! On the left is lens No. 647104 which has the standard gloss black finish. On the right is lens No. 647043 which is mostly finished in crinkle type paint. It is not known if this was a factory-installed option.

The 500mm Nikkor was supplied with its own hardwood carrying case which included room for two optional filters

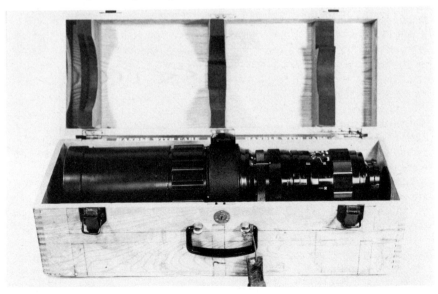

151

1000mm f6.3 REFLEX-NIKKOR

Introduced: June 1959
Apertures: f6.3–f22 (obtained through the use of neutral density filters)
Angle of View: 2.5 degrees
Elements: 3
Foc. range: 100ft to Inf.
Filter size: 52mm (built-in)
Weight: 22 pounds
Original Price: $1650.00
Quantity: Unknown

The longest focal length lens for the Nikon, or any other, rangefinder system was the 1000mm f6.3 Reflex-Nikkor. First shown in June 1959, it was actually marketed in January 1960. One of only two 1000mm lenses available for a rangefinder camera, it was the only one to be designed as a mirror optic. Actually the 1000mm Nikkor was the first production mirror lens made by a major manufacturer for a 35mm camera, and the first of many to come from Nikon. A unique feature was a built-in filter wheel that used neutral density filters to give equivalent stops down to f22. Although this did not change the depth of field, it was the first mirror optic to allow the user some control of the exposure besides the shutter speeds.

A truly massive lens that weighed 22 pounds and measured two feet long and nearly nine inches across, the 1000mm Nikkor originally sold for $1650.00 in 1960. Add to that the cost of the reflex housing and one can imagine that this was a low production item. Serial numbers appear to begin at No. 100600 but the author has examined only one, No. 100648, and has been unable to determine just how many were made. The earliest version has a black crinkle finished barrel and lacks a carrying handle. The version illustrated here is the second which has a grey crinkle finish and does possess the carrying handles. It came with a slip-on, reversing, lens shade approximately six inches deep and a slip-on front cap. The rear cap is unique in that it locks to the edges of the barrel and covers the entire rear of the lens. It measures nearly ten inches across and six inches deep. This lens has a built-in bellows focussing mechanism operated by a thumb-wheel which allowed for very smooth, and light, focussing. It came with a grey metal carrying case and the entire outfit weighs nearly 30 pounds!

Little is known about the 1000mm f6.3 Reflex-Nikkor. It came out near the end of the rangefinder era at Nikon and was made in very small numbers. A later version looks exactly the same as the one illustrated but it has a direct Nikon F mount and is not usable with the rangefinder cameras. Of course the RF version can be used with the Nikon F by mounting the N-F tube.

Truly a fascinating lens, the 1000mm f6.3 Reflex-Nikkor was the crowning achievement of the Nikon optical engineers. Years ahead of its time, it helped make the Nikon telephoto system the most complete available during the era of the rangefinder '35'.

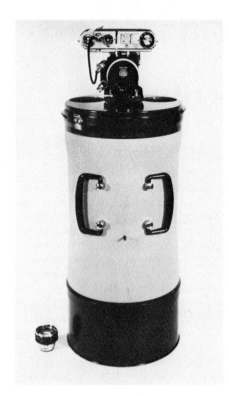

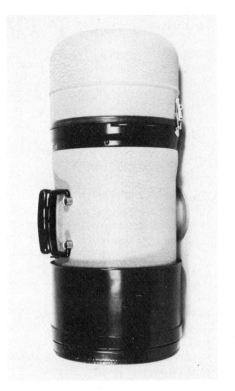

Comparison of 1000mm Nikkor alongside the 50mm f1.4 lens

1000mm Reflex-Nikkor with proper caps

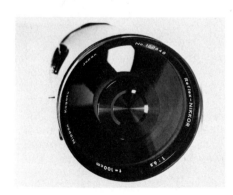

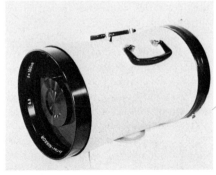

Front view of 1000mm Reflex-Nikkor No. 100648

The 1000mm f6.3 Reflex Nikkor (1959)

PART III

ACCESSORIES

THE S36 ELECTRIC MOTOR DRIVE

Probably the most fascinating, and famous, accessory ever made for the Nikon rangefinder system was the Nikon Electric Motor Drive. As stated in Book I, the Nikon motor was actually first produced for the Nikon S2 in March of 1957. However, because it was first publicized at the introduction of the Nikon SP in September 1957, most people equate it with that model. Actually this is fine because the SP was the first Nikon to be designed from the ground up to use the motor drive. The Nikon S2E, as it was called, was not and was actually a trial run to test both the idea of a motor and the market for such an item. The enthusiastic reception it received prompted Nippon Kogaku to continue development of the motor. Since the SP was almost ready for the market they decided that it would be a better candidate for such an accessory, and thus the camera and its motor were announced at the same time. This marked a new era for Nikon. Not only had they introduced the finest example of a rangefinder '35' they would ever make, they also began a new era of motorized photography over which they would dominate, even to this day. Motorized cameras are extremerly popular today, yet in 1957 the electric motor for the Nikon SP was unique. Previously only spring-wound motors were available, such as the famous Leica Mooly and the Bell and Howell Foton. The only electric motor made for a general purpose camera was the rare Leica 250 motor from World War II which had long been discontinued. The Nikon S36 motor opened up a new era in 35mm photography by allowing any off-the-shelf Nikon SP, S3, S3M, and possibly the S4, to be motorized without major modification. Every Nikon rangefinder made after the SP, including the S4, could be motorized, for their basic design included provision for this option.

The basic design of the motor was simplicity itself. Since the Nikon had a removable back the motor was designed to replace it and was built with its own back attached. It mounted to the camera in exactly the same way as the standard back and added a little more than one inch to the height of the camera. Made along the same lines as the camera body, the result was a beautifully integrated accessory hardly noticeable when mounted. Since the batteries were contained in a separate pack, the motor itself only added 8.2 ounces to the normal weight of the camera. It consisted of a DC motor requiring nine volts for proper operation. The only modification needed was the replacement of the plate that covered the bottom of the camera chassis with one that had two holes plus a lever installed. This allowed for mechanical connection between the motor and the camera which was supplemented by a revolving cog on the motor that engaged a matching gear on the bottom of the take-up spool of the camera. This take-up spool was supplied with every Nikon SP, S3 and S3M ever made and could be added to the S4. The shutter used in all these models, including

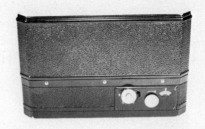

Front and rear aspects of black S36 Motor Drive No. 94039 (1957)

the S4, was the same and was designed for motorized use. This exact method was used on the F36 motor for the Nikon F that was made up to 1974, and in huge numbers, which attests to the beauty of this basic design that dates back to 1957. Once mounted the user would simply plug the power cord from the battery pack into a receptacle on the motor, set the frame counter to the maximum film load being used, choose a shutter speed and fire away. A control panel on the rear face of the motor contained the thumbwheel for setting the frame counter and a three-position shutter release button marked for single exposure, continuous and lock. When set on continuous the motor would advance and fire until pressure on the button was released or until the frame counter registered zero. If the user had less film in the camera than set on the counter a slip clutch was built in to prevent tearing the film off the cartridge. When set on single exposure the motor would fire only as fast as the user would apply and release pressure on the button. In continuous mode shutter speeds of 1/30 sec. and higher were required and a top speed of three frames per second was possible. On single mode any shutter speed could be used, except bulb and time, since the motor would not cycle until the user released pressure. However, at very slow speeds the user had to keep pressure applied until the shutter had completed the exposure, or else the motor would cycle before the curtains had come to a stop. In actual use this was all very simple and only required a little practice, and

Front and rear aspects of chrome S36 Motor Drive No. 94916 (1959).
Note missing front decorative button on left side

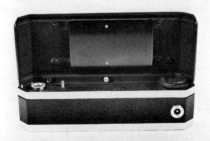
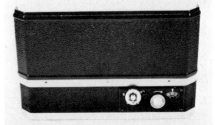

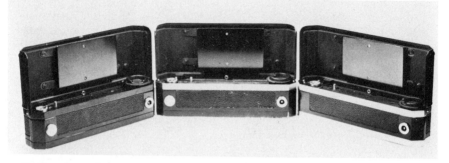

Group photo showing very unusual motor No. 94202 with chrome intermediate plate and black baseplate flanked by standard black and chrome versions

common sense, to perfect. One feature that the SP motor had that the reflex version lacked was that the shutter release on the camera could be used exactly as the one on the motor. This was handy because in the horizontal position the camera release was easier to reach, while in the vertical mode the motor release was better. Anyone who has ever used a motor on the Nikon F will notice that the SP version is quite similar, which it should be since the reflex version was simply a derivative. The only drawbacks to the SP motor, when compared to the F motor, were that it had only one framing speed and could only be used with a separate battery pack. The F motor had variable speeds and was eventually usable with a cordless pack for better portability. However, it was the SP motor that laid the groundwork for a line of motors that would become standard equipment for professional photographers

The Nikon S36 Motor was listed from September 1957 up to October 1964, and sold for $199.50, which included the battery pack and a one-metre cord. A charge of $20 was made to have the motor adapted by Nikon to a particular body and this procedure was also used for the F version. Nikon stated that once a motor was adapted use on a different body was not recommended without it being readapted. However, from experience, the author has found that in some cases this is not required, for some motors will work on more than one body.

At least seven versions of the S36 motor exist, although some are simply cosmetic. The author has not been able to examine the first version, but from available photographs it can be described. This is the motor that was first shown on the Nikon S2E in March 1957. It differs from the standard production model in the following ways. Except for the baseplate and the rear control panel, it is entirely covered with the same leatherette as the camera and does not have the painted surfaces like the later types. The power outlet is at the left rear end of the motor instead of on the front, and the baseplate is chrome. An interesting point is that this same motor is seen in the original test report on the Nikon SP in the November 1957 issues of both Modern and Popular Photography, and this is the best source of photos of this version. No serial numbers have been recorded so the author has, at this point, no idea as to how many were made or how they were numbered. The second version is also a mystery of sorts. The original literature released by Nikon shows a version that has also eluded the author. This version can be seen in books and advertisements from 1957 and 1958 and shows a motor that now has the more common painted

surfaces at each end, a front mounted power outlet with a decorative button at the opposite end to balance the design, and a chrome baseplate. The intermediate plate, which corresponds to the baseplate of the standard back, is black. No motor with this configuration has come to the attention of the author. The third type is that which is more commonly seen, although two versions do exist. This third type is the same as the second except that the baseplate is also black, and not chrome. This black motor is the most common type seen. Serial numbers begin at No. 94001 and it is the first type for which any serial numbers have been recorded. They range up to a high of No. 94199 and differ from the next version in that they have the letter 'K' engraved on the control panel to denote continuous. It is not known why the 'K' was used instead of a 'C'. The fourth version is identical to the third except that now a 'C' has replaced the 'K' on the panel. These motors run from about No. 94200 to a high of No. 94663, or a little over 500 units. Up to this point all recorded numbers, with one exception, are for black motors with front mounted power outlets and a decorative button. No motor with the chrome baseplate like that shown in the early literature has been found, even though these black motors had to be made at a later date. A fifth type has recently been found that differs in that the baseplate is black but the intermediate plate is chrome! This is just the opposite of the second type and its serial number is No. 94202 and it has the 'C' engraving. More examples need to be found to determine if this example is part of a batch made just after the end of the 'K' motors.

At around No. 94700 another cosmetic change is seen. Motors from this point up to about No. 95000 are the sixth type and differ in that both the intermediate and baseplates are chrome! Also the front decorative button has been deleted. This sixth type is referred to as the chrome-on-chrome version. Another change seen on this type is that the sequence of engravings on the control panel have been changed. As viewed from the top to the bottom, the previous motors were engraved K-.-L, and then C-.-L. This sixth type is engraved S-L-C, therefore, the sequence of the switches has been changed and this type would be seen on the yet to be made Nikon F motor. The seventh type is still the chrome-on-chrome variety, but it is now called the S72 motor because it was used on the Nikon S3M! This motor appears to be identical except that the frame counter is calibrated up to 72 exposures. Recorded numbers seen to date range from No. 95041 to a high of No. 95101, which is also the highest number seen for any motor! It appears that the S72 was made at the end and that possibly the S36 was discontinued by then. Taken as a whole those motor types for which numbers have been seen run from No. 94001 to No. 95101 for a total of 1100 units. The first two types could not have been made in any quantity so an upper figure of as many as 1200 motors may have been made. Considering that it was made for at least six years this is not a large number, which accounts for the fact that motors are difficult to find today.

A few accessories were made for the motor. The first type of battery pack was a small, grey metal, flat pack that resembled hearing aid packs of the day and used six penlight batteries. It had a remote button that allowed firing the camera from the pack. This was replaced rather early by a brown leather, oblong, pack that used six type 'C' batteries. This is the type most collectors are familiar with for it continued into the reflex era. It also had a remote button at its top. This pack was changed to a grey vinyl type at about the same time the chrome-on-chrome motors were made, and this is the last version. Nikon also made a voltage meter for the pack that measured the available voltage by simply inserting it into the cord receptacle on the

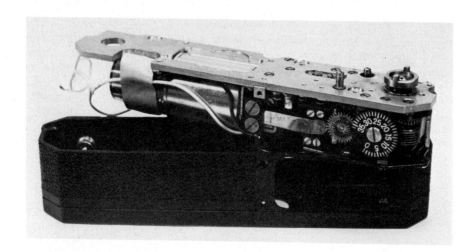

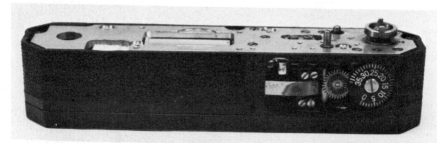

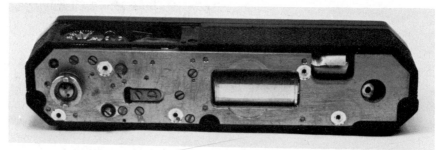

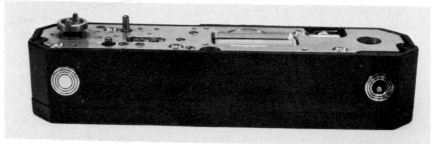

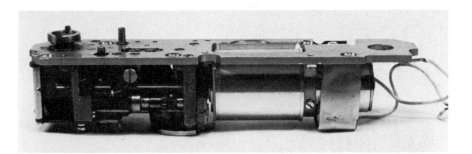

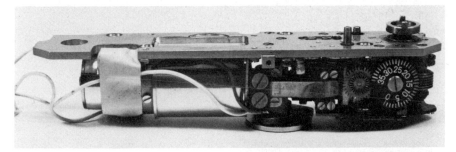

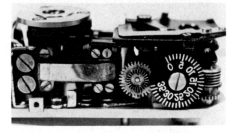

Series of photos showing interior of S36 Motor Drive both assembled and dissembled

pack. This meter was made in a few varieties but any found that read up to 12V were made for the Nikon F motor. That for the SP motor only reads up to 9V. An unusual pack was not made by Nikon but marketed by Jacobsen Products in California. It is identical to the Remopak they made for the Nikon F motor but will only fit the SP type. It is the only cordless battery pack ever made for the rangefinders and is rather difficult to find today. A special microswitch cord was also made. This was used when shooting with the reflex housing and the motor. By attaching it to both the motor and the housing the proper sequence was maintained. As the mirror would rise the built-in switch would trigger the motor at the proper time. One last accessory was the elusive periscope attachment. This consists of a collapsible pole with a bracket that held the motorized camera. The battery pack was attached to the pole and a mirror was positioned above the camera. The user would raise the entire rig up over a crowd and see the view of the 50mm lens reflected in the mirror. He could then fire the motor from the battery pack which made for a very interesting accessory indeed.

One other item of interest is the 250 shot motor for the rangefinders. Not much is known about this item but the author has seen photos of two such motors. They differ markedly from the one that was made for the Nikon F and may only have been made

as an experiment, although they do exist. No serial numbers are available at this time for more research needs to be done on this motor.

Obviously any motor would be a fine addition to a Nikon collection, but there are enough variations to keep the collector busy for years. Following is a short summation of the types of motors for easier identification to aid the collector.

VARIATIONS OF THE S36 MOTOR DRIVE

TYPE ONE: Completely leatherette covered; power outlet at left rear of motor; chrome baseplate; serial numbers unknown.

TYPE TWO: Partial leatherette covering with painted surfaces at both ends of motor; power outlet at right front of motor; decorative chrome button at left front; black intermediate plate; chrome baseplate; serial numbers unknown.

TYPE THREE: Same as Type Two except that both the baseplate and intermediate plate are black; 'K' used for continuous with the sequence K-.-L: Numbered from 94000 to about 94199.

TYPE FOUR: Identical to Type Three except that a 'C' is used in place of the 'K' with the sequence C-.-L: Numbered from about 94200 to a high of 94663.

TYPE FIVE: Identical to Type Four except that the intermediate plate is chrome and the baseplate is black which is just the opposite of Type Two; only known example is No. 94202.

TYPE SIX: Both plates are now chrome and the front decorative button has been deleted; new sequence of switches reads S-L-C; numbered from about 94700 to a high of 95000.

TYPE SEVEN: Identical to Type Six except that the frame counter is calibrated up to 72 exposures and was made for the Nikon S3M half-frame camera; numbered from about 95000 to a recorded high of 95101.

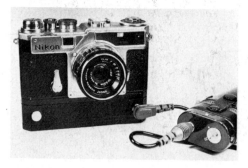

Chrome SP on black S36 Motor with battery pack and cord (1957)

THE NIKON EXPOSURE METER

Nippon Kogaku made only one exposure meter for their rangefinder system. It was announced in September 1957 along with their new camera, the Nikon SP. One may wonder why they waited nine years to design a coupled meter, yet the word 'coupled' is the key. The Nikon SP was the first camera in the series to have a non-rotating shutter speed dial. The previous models I, M, S and S2 used the older style rotating dial which precluded any chance of physically coupling a meter. In addition these early cameras had the slow speeds on a separate dial under the fast speeds which made coupling even more difficult. The Nikon SP, as well as the models that followed, had all the speeds on a single stationary dial. This allowed a meter to be designed that could couple easily and the result was Nikon's first meter.

The user would insert the meter into the camera accessory shoe from the front, instead of the rear, making sure that a gear on the side of the meter engaged the teeth around the shutter speed dial. Then set both the meter and the shutter dial to the same speed and rotate the ASA dial on the top of the meter to the proper film speed and the Nikon Exposure Meter would be properly mounted. To calculate exposures the user would rotate the shutter speed dial until the chosen f-stop would line up with the indicator needle. When the cover was closed in bright light the black f-stop scale was used. In dim light the user would open the cover and use the red f-stop scale. If the user chose a particular shutter speed first then the diaphragm on the lens could be moved to the f-stop indicated by the needle. A 4X booster was available that mounted to the side of the meter. With this in place the red f-stop scale was used but

Both early grey-topped and later black-topped meters. Note ASA range of early meter only goes up to '800'

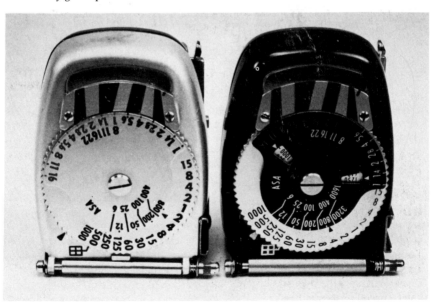

Underside of same two meters. early meter is No. 950095. Later version has the unusual seven digit No. 9626927 of which only a small quantity have been recorded

the shutter speed was read opposite a special square mark instead of the usual arrow. The result was that the meter could be used by either choosing the shutter speed or f-stop, whichever the user preferred, and all of the above could be done much faster than can be described on paper!

The 'Nikon Exposure Meter could be used on all the models that followed the Nikon SP, including the S3, S4 and S3M. It was made in two distinct versions, one of which is rarely seen. When first released the meter was finished with a black underside and a grey top plate. The ASA dial on this version was calibrated from ASA 6-800. The serial numbers used begin at meter No. 950001 and the grey-topped version has been recorded as high as No. 950480 for a possible total of only 500 units. The exact number is not known but the total is definitely below 800. The second version differs in two respects. This version is now finished completely in black, except for the front cover which was always chrome, and is calibrated from ASA 6-1600. The serial numbers continue where the grey-topped version leaves off and the earliest recorded by the author is No. 950809. To determine the number produced is difficult for it appears that Nikon used at least two different types of serial numbers. Recorded numbers run up through No. 963824 which would suggest a total of almost 14,000 units! After this point a new seven digit serial number is seen and ranges from No. 9626900 to No. 9630317 for another 3000 units. Why Nikon changed the numbers is not known, for there seems to be no difference in the meter itself. Whatever the reasons, a production of at least 17,000 meters is suggested by the recorded serial numbers.

NIKON REFLEX HOUSING – TYPE ONE

The first long telephoto marketed by Nippon Kogaku was the 250mm f4.0 Nikkor-Q. This occurred in January 1951 and it was released along with Nikon's first reflex housing. This original housing was the first of two types made, and it was listed until at least November 1955. Its replacement is first seen in Nikon price sheets in May 1956, so the changeover to the new type occurred some time in early 1956. The second version is listed as late as October 1964 so it was made for eight years while the first version was available for only five. The Nikon Reflex Housing was made in only these two basic configurations which do differ significantly.

The main body of the early version is basically a box, with its sharp corners and squarish appearance. The housing for the focussing screen rises in a straight vertical and is topped by a removeable magnifying eyepiece that is also orientated vertically. The entire housing is finished in a gloss black paint except for the face, which is chrome. As far as is known no accessory finders were made for this version so the user was only able to focus by looking straight down into the eyepiece as one would do with a waist-level SLR such as the Hasselblad. The finder was removed using a bayonet mount and the focussing screen could also be lifted out. The finder has a focussing eyepiece and is topped by a rubber eyecup. In this version the screen did

Original Nikon Reflex Housing No. 371190 with the prism detached (1951?)

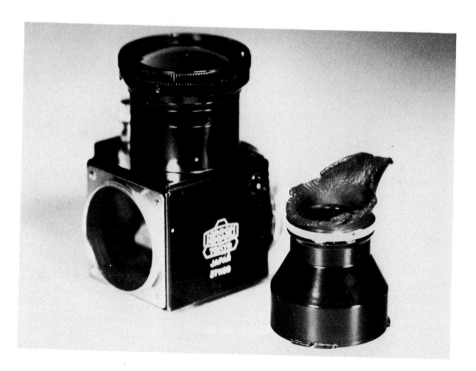

 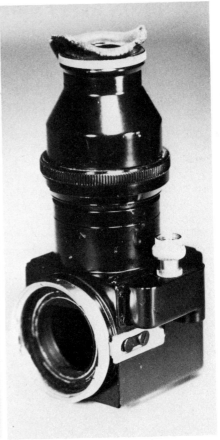

Three-quarter front of housing with prism attached. Note that prism is at ninety degrees and boxy shape of housing body

Three-quarter rear view. Chrome slide is used to rotate camera to vertical mode. Protrusion is the mounting platform for the cables

not rotate when shooting in the vertical mode but there are etched lines to give the photographer some idea of what was covered. The only serial number used on these early housings is on the side of the main body and the finder is not numbered. The serial number range seen to date is from about No. 371000 to a high of No. 371190, which is illustrated here.

On the right side of the main body are the controls. A chrome slide is used to unlock the camera mounting ring to allow the user to rotate the body to the vertical mode if needed. On the later version this would be replaced with a button which was much more secure. Above this slide is a protruding platform with two receptacles for the cables. Unlike the later version, which has both fittings on the top of the platform, this first type has one on the top and one of the bottom. In use the cable that went to the shutter release of the camera was mounted to the bottom fitting.

These early housings do not appear to have been made in very large numbers.

NIKON REFLEX HOUSING – TYPE TWO

By May of 1956 a newer type reflex housing was introduced at the price of $129.50. This much more modern unit was the final type made by Nippon Kogaku and was listed until at least October 1964. Externally it differed significantly from Type One in that Nikon changed the finish from the previous gloss black to a crinkle type paint. This finish was used on the body of the housing as well as the interchangeable prism finders. Also gone is the boxy shape with sharp corners that have been replaced by a more elegantly sculptured body with softened contours. This made the unit feel more comfortable in one's hands as well as appear more compact. The standard prism supplied with this unit was now angled at 45 degrees, as opposed to a vertical orientation, which was much more comfortable in actual use. It also incorporated a 4.3X focussing eyepiece with diopter correction to add to its ease of use. This prism was removable by a simple bayonet mounting system and could be interchanged with an optional 90-degree prism. This second prism was first available some time in late 1959 and sold for $42.00 and was also fitted with a focussing eyepiece.

On one side of the housing was a button that, when depressed, allowed the user to rotate the camera body to the vertical position. As this was being done a coupling gear within the housing also rotated the finder screen into the vertical mode. On the opposite side was located a protruding panel that housed two receptacles. To one was mounted the removable fingertip release which stood approximately two inches high, and was supplied as standard equipment. This fingertip release was very easy to use, because of its height, and was coupled to the second receptacle into which a cable was attached that ran to the camera shutter release. Pressure on the fingertip release caused the mirror to begin to rise and then transferred its motion to the cable which would trip the shutter at the proper time. All of this could be adjusted by a ring on the second receptacle to time the release of the shutter with the uppermost

*Housing No. 471422 with prism
No. 67340 removed*

*Nikkor 250mm lens and SP on Reflex
Housing with optional 90-degree prism
finder*

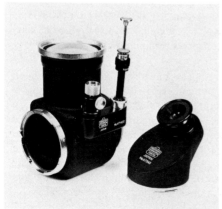
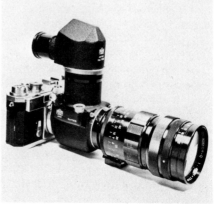

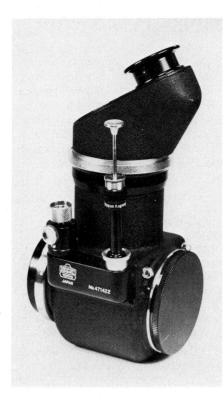

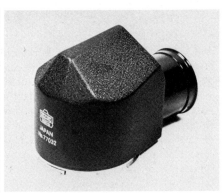

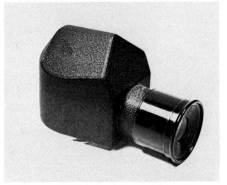

New style Nikon Reflex Housing No. 471422 (1956)

Two views of the very rare 90-degree prism for the Nikon Reflex Housing, No. 77032 (1959?)

position of the mirror to prevent any image cut-off and also reduced the delay time to such a point that the housing worked as precisely as a modern single lens reflex. The fingertip release could be removed and replaced by a standard cable release for times when speed was not needed, such as copying and close-up work, and this cable was also supplied as standard equipment. As mentioned in the chapter on the Nikon motor, an accessory micro-switch cable was also available. Pressure on the fingertip release would close the switch when the mirror was completely raised and then fire the motor, all in proper sequence.

The serial numbers used on this newer housing began at No. 471000 and have been recorded as high as No. 471763. A second number was used on the interchangeable prisms. The standard 45-degree prism began at No. 67000 and have been seen as high as No. 67628. These prism numbers do not run in exactly the same order as the housing numbers. It is possible to have two housings where the later one has an earlier number on its prism. It appears that the two items were made on separate lines and when being readied for shipping were joined together randomly. The 90-degree prism began at No. 77000 and the highest number seen is the one pictured here, which is No. 77032. It appears that not many were made and that it was a seldomly used accessory.

BELLOWS MODEL ONE

In May 1958 Nikon announced both the 135mm f4.0 Nikkor-Q short mount lens and the bellows unit for which it was designed. This is the first, and only, bellows focussing attachment ever made for the Nikon rangefinder series. Although the one pictured in Nikon literature varies slightly from those seen by the author, it may only be a prototype and not have actually been produced. Therefore, it appears that only one type was ever made. First listed in Nikon price sheets in May 1958, it is last found in one dated October 1961, although it may have been available slightly later. It sold for $49.50 which included two reversing rings for the 50mm f1.4 and 2.0 Nikkor

Very scarce Nikon Bellows Model One in extended position *Bellows No. 56035 partially retracted*

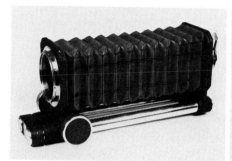
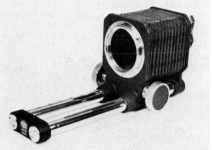

lenses. It was mounted on a bi-post track and was designed to be used between the Nikon Reflex Housing and various Nikkors. It allowed direct image magnification from 0.8X to 4.8X depending on the lens used. When using the special 135mm f4.0 Nikkor-Q a full range of focus from infinity to life-size was possible. The new type reflex housing was available by this time and its improvements over the older type made actual picture situations very pleasant. The 45-degree finder, with its 4X magnification and bright focussing screen, made close-up photography with the rangefinder Nikons nearly as simple as it would be with the later Nikon F SLR, although the equipment was bulkier.

It is not known at this time how many units were manufactured, but the total production could not have been very large. It came out very late in the rangefinder era and preceded the Nikon F by only one year. With the introduction of the 'F' and its own bellows units, which could use the same 135mm f4.0 Nikkor-Q with an adapter, the resulting set-up was more compact and easier to use. Because of this the use of the rangefinder cameras for close-up work declined significantly after late 1959, so the market for the Bellows Model One lasted for only a little over one year. The serial numbers begin at No. 56000 and have been recorded as high as No. 56135. This suggests a production of well under 200 units, although it is possible that more were made. However, the author feels that, because of its short life-span and limited use, the Nikon Bellows Model One could very well have been made in quantities of less than than 200! This could account for the fact that today they are very difficult to acquire and qualify as one of the more elusive Nikon accessories for the rangefinder system.

NIKON COPY OUTFITS

NIKON REPRO COPY OUTFIT 'S': This unit was the first copy outfit made by Nikon for their rangefinder cameras. It was available at least as early as 1954 and made in this configuration until early 1957. It originally sold for $89.50 which included a hardwood instrument case, a set of five plastic frames corresponding to reductions of 1:1 to 1:4, three extension tubes of different lengths, an anti-reflection ring, and a focussing eyepiece. This unit can be considered portable for it could be used horizontally, mounted on a tripod or hand held.

The Nikon Reflex Housing could be inserted between the camera and the bracket which adds an extension of 74mm and increased the image size to greater than 1:1 on the negative. The resulting image would be right side up and unreversed, and showed the exact area covered. The limits of this first unit were from life-size (or greater with the housing) down to 1:4. In early 1957 it was modified and made even easier to use, as well as more versatile.

Nikon Copy Outfit Model 'S' No. 4904

Accessories included extension tubes, focussing eyepiece, rods for setting magnifications and corresponding plastic frames

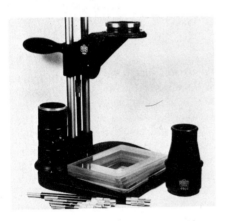

NIKON REPRO COPY OUTFIT 'SA': The 'SA', or advanced, version, was made available in early 1957 at a price increase of only $10.00. With this small investment the user acquired a much more versatile unit.

The extension tubes on the first model allowed only for a series of fixed reproduction ratios from life-size down to 1:4. On the newer 'SA' model the tubes were replaced by a built-in bellows unit, for greater flexibility, that allowed an infinite number of ratios from life-size down to 1:5, plus a supplementary lens which extended this down to 1:20! The plastic frames that were inserted in the base were no

longer needed and were deleted. Only one upright post was used since the previous rods that adjusted the image ratios were also no longer required. The user would simply slide the focussing stage with its bellows unit onto the upright and lock it in place. The same three Nikkor lenses could be used and a focussing eyepiece was still supplied. Adjusting for different image ratios was accomplished by racking out the bellows until it lined up with a scale engraved on its track. All in all this second unit

Nikon Copy Outfit Model 'SA' No. 11290. This is the improved version which used a focussing bellows instead of fixed length extension tubes for more versatility

Model 'S' with Nikon S4 No. 6307278 mounted

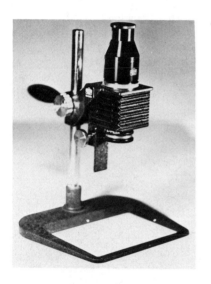
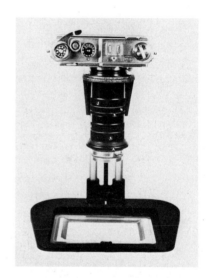

was a great improvement over the first and, at $10.00 additional, a real bargain. The reflex housing could also be used with this unit for even greater magnification. The Nikon Repro Copy Outfit 'SA' was listed as late as 1962.

NIKON MACRO COPY OUTFIT 'P': In early 1955 Nikon introduced a new, more advanced, copying outfit called the Macro Copy 'P'. It sold for $175.00 which is nearly double the price of the simpler 'S' and 'SA' models. This unit was a much more substantial item that was intended for permanent copying set-ups as opposed to being portable. The purchase price included the following: an auto-positioning, sliding, fold-over camera and focussing screen bracket; detachable focussing

magnifier; three extension tubes; micrometer focussing lens mount; adjustable supporting arm that rode on a two-piece, chrome upright; auxiliary lens attachment for the 50mm f1.4 and 2.0 Nikkors; a cable release and a fitted hardwood case which formed the working platform for the entire outfit. The case is fitted with padded wooden blocks to hold the parts of the disassembled unit so that none can be dislodged when carrying it. There is also room within the box for the camera body and one normal lens, if the user desired this. This sturdy wooden case formed the baseboard and working surface of the unit itself and the chrome upright was securely clamped to it. A metal sliding arm was attached to the upright and in turn the combined camera holder and focussing stage was attached to this arm. The Nikon body was held in this bracket and the normal lens was inserted into the bayonet mount of the micrometer focussing ring under the stage. There was a 5.5X eyepiece supplied for viewing the image on the ground-glass. The mount for this eyepiece was coupled to the bracket holding the camera in such a way that, as one is swung into position the other is swung away. This was accomplished by means of a curved, toothed arm which engaged a gear ensuring a positive precision shift from focussing to exposure position in a single motion. The camera and focussing stage can be swung sideways for copying of large documents if required.

NIKON MACRO COPY OUTFIT 'PA': By May 1958 the Nikon Macro Copy was modified and replaced by the new 'PA' version, which sold for $199.50. The major improvement was that the previous extension tubes were replaced by a built-in bellows focussing unit as was done for the Repro Copy 'SA'. This allowed for an

Front and side views of Model 'PA' Copy Outfit with focussing eyepiece in position and camera body in 'standby' position

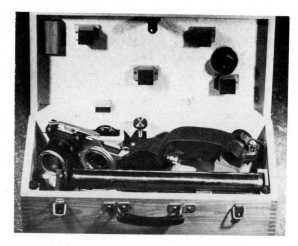

The Model 'PA' Copy Outfit was supplied with a hardwood instrument case that also doubled as the baseboard for the entire outfit. The Model 'P' is similar but uses extension tubes instead of the bellows attachment

infinite number of copying ratios instead of fixed reductions possible with the tubes. Besides this the unit remained basically the same as the previous version but was now much easier to use and a great deal more versatile. In this final configuration it was listed in Nikon price sheets as late as 1962.

Front and side views of Model 'PA' Copy Outfit with camera body in shooting position and focussing eyepiece slid out of the light path

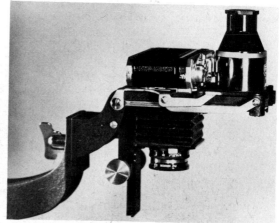

MICROFLEX PRISM-REFLEX MICROSCOPE ATTACHMENT

More than just a simple microscope attachment, the Nikon Microflex unit is actually the basis of a complete photomicrographic system. It was available at least as early as January 1955 and listed in Nikon price sheets until late 1964. Its original price was $145.00 which eventually rose to $180.00 by the time it was discontinued, although an almost identical version was made for the Nikon F for many years. It was supplied with a fitted hardwood case which held all the necessary parts save the camera body.

The basic module mounted directly to any standard microscope and contained both the built-in leaf shutter and movable prism along with the camera and viewing ocular mounting rings. The shutter was calibrated from 1 sec. to 1/300 sec. and included 'T' and 'B' settings and was fitted with a cable release socket. Any Nikon rangefinder camera body was mounted directly at the top of this module and the focussing eyepiece at the side. The standard focussing-viewing ocular was diopter corrected from zero to plus or minus '2' and was designed to be used by one person. A second ocular was interchangeable and featured a large, fine-grain viewing screen that allowed simultaneous viewing by several people at once.

With the shutter closed and the prism in position the photographer could focus and view the image in either of these side-mounted oculars. Once proper focus was determined and the correct shutter speed calculated, pressure on the cable release caused the prism to swing out of the light path and the shutter to trip, all in proper

Basic components of the Nikon Microflex unit, No. 31323

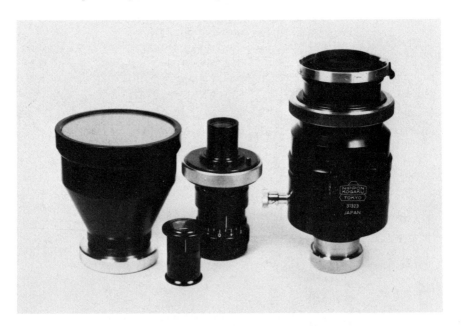

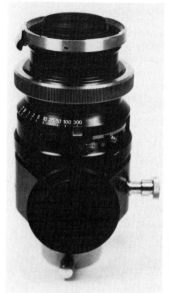 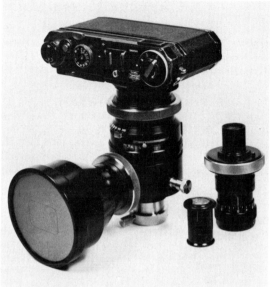

The shutter module No. 31323. To this is attached the camera microscope and the selected eyepiece

Black SP mounted on Microflex with optional viewing screen. Standard oculars are to the right

sequence. The shutter within the camera body was left open on the 'T' setting and only the shutter in the Microflex was used. The result was a perfectly focussed image on the film plane of the attached camera body. The user would then advance the film, unless a motorized Nikon was being used, cock the leaf shutter and turn a lever to reposition the prism, to be ready for the next exposure. All of this worked flawlessly for the Nikon Microflex Unit was constructed to extremely high standards and finished in beautiful satin black and chrome.

The side mounted oculars eliminated the need for a reflex housing, which would have made this item extremely ungainly and allowed the resulting set-up to be as compact as the later Nikon F version. It simplified microscope photography immensely and proved to be such a fine design that it survived into the reflex age basically unchanged.

It is not known how many Microflex units were manufactured. Although it was listed for nine years, it was a special purpose item that did not see very wide use. It is possible that many are still in use today in laboratories and have not yet come onto the used market-place. The serial number of the example used here is No. 31323 but more numbers need to be recorded to determine the range and possible quantity produced.

CLOSE-UP ATTACHMENTS

Nippon Kogaku produced auxiliary close-up attachments for their rangefinder cameras from at least 1953 on, and none appears to have been made during the Occupation.Three distinct types were made which vary in construction because of the camera model they were designed to be used on. However, the basic idea of all three types was the same and they shared the following characteristics. Each consisted of a metal bracket that slipped into the accessory shoe from the front instead of the back. This bracket contained the optics that were positioned in front of the viewfinder and rangefinder windows of the camera. These optics corrected the rangefinder of the camera to allow focussing from 1.5ft–2.5ft (18–30 inches), which was much closer than the standard 3ft minimum. A close-up lens was supplied which screwed onto the front of the normal lens, and was made in sizes for either the 50mm f1.4 or 2.0 lens. Therefore, there are two versions of each close-up attachment which consists of the exact same bracket, but either the 1.4 or 2.0 close-up lens. No serial numbers were used on the brackets themselves, but the close-up lenses were numbered. A leather case that held both the bracket and lens was supplied with each version, which will now be described by camera type.

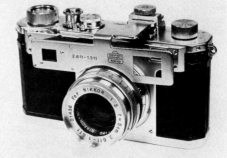

Model 'S' unit alone and mounted on camera with 50mm f2.0 lens

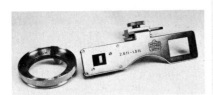

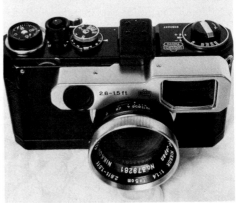

Model 'S2' unit alone and mounted on camera with 50mm f2.0 lens

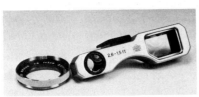

Model 'SP/S3' unit alone and mounted
on a Nikon SP with 50mm f1.4 lens.
Note cut-out for frosted window needed
when using the SP

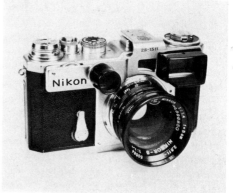

TYPE ONE – NIKON S: Although marketed after the introduction of the Nikon S, this version can be used on the earlier I and M models because the rangefinder windows and accessory shoe are in the same position. The bracket consists of a heavy gauge of chromed brass and has a locking screw to attach it firmly to the accessory shoe of the camera. There are no optics on the viewfinder side, but only the rangefinder port, which are mounted to the backside of the bracket. The cut-out on the viewfinder side simply acted as a framing device on this version. The bracket is completely chrome finished except for the backside which is painted black to reduce flare. The close-up lenses for this version are chrome finished. Around their face is engraved 'For Nikkor 1:1.4 f = 5cm 2.6ft – 1.5ft. No. xxxxx'. The 2.0 version is identical except for the marked f–stop.

TYPE TWO – NIKON S2: The version made for the Nikon S2 differed markedly. The bracket consists of a lighter weight chrome on brass, has a black crinkle finished mounting piece and was more than one-half inch thick. This thickness was caused by the fact that the optics are now built-in the bracket itself and do not protrude as they did on the 'S' version. There are now optics for the viewfinder as well as the rangefinder, and the locking screw has been deleted. This version is actually lighter than its massive appearance would lead one to believe. The screw-in close-up lenses for the S2 version were first the same as those for the 'S' type. However, very early on these were changed slightly. The outside rim is still chrome but the face of the lens, with the engravings, is now painted black. This black surface allowed easier reading of the engravings but also reduced flare significantly.

TYPE THREE – NIKON SP, S3, S4 and S3M: The last version was designed to fit all the cameras made after the Nikon S2. This was possible because they all were of the same basic construction and had their windows and accessory shoes in the same position. Nikon again changed the design of the bracket significantly. They reverted back to the 'S' type and made the bracket along similar lines. It is again constructed from a heavy gauge chromed brass but now the optics are mounted to the face, and not the back, of the bracket. The optics for the rangefinder window are housed in a black circular fitting and those for the viewfinder in a large rectangular housing.

FINDERS

Over the years Nippon Kogaku made a large variety of accessory finders for the rangefinder system. The individual finders, those made for a particular focal length, have been covered under their respective lenses and will only be mentioned briefly in this chapter. The emphasis in this section will be on the multi-purpose type finders such as the Variframe (imarect type) and the Varifocal (zoom type), along with some special purpose types such as the Sportsfinder.

INDIVIDUAL FINDERS: There are two basic types of individual finders. The earliest were simple optical finders generally mounted in a chrome on brass housing and lacking any framelines. Most possessed a device for adjusting to parallax, although two types lacked this and were made only in black. The second type is the more modern black bright-line variety which replaced the simpler optical units. These are generally larger, with one exception, and provided an extremly bright image along with an etched frameline to ease composition, and also had provision for parallax correction. Following is a listing of finders by focal length and type to be used as a guide by the collector.

21mm: Made only in a black housing with a chrome rectangular face, this is an optical finder and lacks a frameline. Because of the extreme angle of view no parallax adjustment was provided, nor needed. Relatively difficult to find today, it is identical to those made for the Nikon F lens but are not interchangeable due to a difference in the type of mounting shoe used. The housing is rectangular and plastic and five elements were used to obtain the wide coverage. One of only two individual finders known to be serial numbered, they range from No. 600100 to a recorded high of No. 600402. The Nikon F version is also numbered but a different series was used.

25mm: This is also an optical finder without a frameline or parallax adjustment. Only one type seems to have been made. It consists of a black metal housing with a chrome

Nikon 21mm Finder (1959) Nikon 25mm Finder (1953) Nikon 28mm Finder (1952). Made only in chrome

 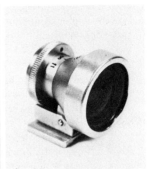

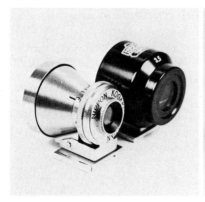 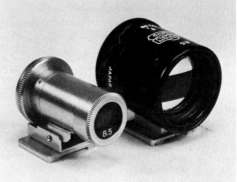

Nikon 35mm Finder. Chrome (1949?)
and black Bright-line (1956)

Nikon 85mm Finder. Chrome (1949?)
and black Bright-line (1956)

face which is round and uses a rectangular mask. None have been seen with serial numbers.

28mm: The 28mm finder is optical and was never made in the bright-line type. Available only in chrome on brass, it consists of a flared round tube with a rectangular front mask. A parallax adjusting dial was provided around the eyepiece and none have been seen with serial numbers.

35mm: Two versions of the 35mm finder were made. The earliest is very similar to the 28mm type for it was chrome on brass and flared in the same manner. It also had a parallax dial around the eyepiece and none have been seen with serial numbers. It is possible that some were made during the Occupation, but the author has yet to see one. Nippon Kogaku Japan is engraved around the eyepiece so if an MIOJ version exists it would probably be marked 'Tokyo' instead of 'Japan'. The author does possess such a finder in the 85mm focal length with the 'Tokyo' engraving but no MIOJ markings are present. By 1956 this type was replaced by the more modern black bright-line version. In the case of the 35mm this new type is actually more compact than the chrome one it replaced. Consisting of a black painted aluminium housing, it does not have a parallax dial. Instead it uses parallax markings within the frameline. An additional feature of all the bright-line finders was that the image is now life-size which is a great improvement over the previous type. None have been seen with serial numbers.

35mm STEREO: The finder for the Stereo-Nikkor is of the black bright-line type and appears identical to that made for the standard lenses. The word 'Stereo' is engraved on the housing and the proper vertical frameline is etched. None have been seen with serial numbers.

50mm: A 50mm finder was made by Nikon but not for their system! It was never listed in any of their price sheets and is virtually unknown to most collectors. It was

supplied with the screw mount version of the 50mm f1.1 Nikkor and is of the black bright-line type. It is possible that, because of design differences, the viewfinder of either the Leica or Canon would be partially blocked by the very large f1.1 lens and Nikon felt a separate finder was needed for proper framing.

85mm: The original 85mm finder was the chrome-on-brass optical type consisting of a thin tube over one inch long. This same tube was sufficient for the 105mm and 135mm focal lengths and was used for those finders. The image was less than life-size and a parallax dial was mounted around the eyepiece. Some were made during the Occupation but are not marked MIOJ. The way to determine these is that Nippon Kogaku Tokyo is engraved around the eyepiece. The 85mm finder was also upgraded to the new bright-line type by 1956. This new type is slightly shorter but a much wider housing was used. There are parallax markings within the framelines but an additional dial was mounted at the rear. None have been seen with serial numbers.

105mm: The 105mm finder was also made in both basic types. The early chrome-on-brass version is quite similar to the 85mm but none would have been made during the Occupation. The later black version is identical to the 85mm type in size and shape. It also has built-in parallax markings as well as a rear-mounted dial. None have been seen with serial numbers.

135mm: This finder was also made as far back as the Occupation. The chrome on brass optical version is quite similar to those made in the 85mm and 105mm focal lengths and early ones are probably engraved with the 'Tokyo' markings. They were also replaced by a life-size, black, bright-line version by 1956. However, the black 135mm finder is unique in two respects. First it is physically the largest of the individual finders Nikon made. Although it is the same length as the chrome one it replaced, the body tube is much wider. Secondly this version was the only other type, besides the 21mm, that was serial numbered, but not all of them! The numbers appear to start at No. 136000 and have been recorded as high as No. 136676. Those that are numbered appear identical to those that are not except that the finish on the barrel is not as glossy. All other characteristics are the same and the author feels that

The Nikon 135mm Bright-line finder can be found with and without a serial number. Besides the 21mm type this is the only other individual finder to be found with serial numbers (1956)

Nikon 105mm Finder. Chrome (1954) and black Bright-line (1956)

Nikon 135mm Finder. Chrome (1949?) and black Bright-line (1956)

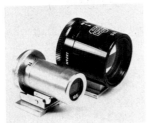
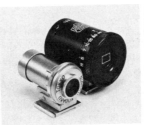
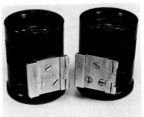

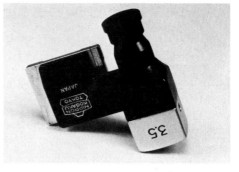

No leather case was made but the Mini-Finder was supplied in its own plush-lined box

The unique Nikon 35mm Mini-Finder

the numbered finders were of later vintage, because they are lighter in weight. It is not known why numbers were added, but it is possible that the latest versions of the other black bright-line finders are, but have yet to be seen.

35mm Mini-Finder: This little known finder is unique to the Nikon system, for no other manufacturer produced anything quite like it. First listed in Nikon price sheets in late 1956, it sold for $11.75, and was still available as late as October 1964. Nikon literature always mentioned that it was for the Nikon S2 only, which is curious, since it will also fit the later SP, S3, S4 and S3M models. It was the only accessory finder Nikon made that could be left on the camera and still allow the standard ever-ready case to close properly. This was its primary reason for existing and it fulfilled this criteria perfectly.

It departed from the standard design used for accessory finders in that the mounting shoe was placed to the side, as opposed to under, the optical tube. This lowered its profile significantly along with the fact that the housing itself was greatly reduced

Nikon SP with 85mm f2.0 Nikkor No. 404382 and Nikon Sportsfinder

The Nikon Sportsfinder had framelines for 35, 50, 85 and 135mm

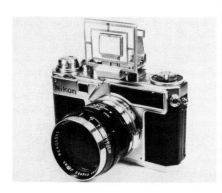

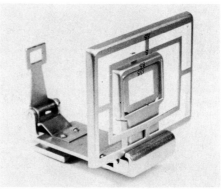

in size. The near life-size image of the regular 35mm finder was sacrificed to obtain this compact shape, but this is offset by its extreme portability. It could actually be left on the camera on a permanent basis, unless the user decided to use a flash attachment.

Primarily of black aluminium construction, the housing is rectangular with a chrome front rim upon which the '3.5' marking is engraved. There is no provision for parallax adjustment, but this is of less importance here. Not only is it much lower than the standard type finders, its optical centre is very close to that of the view-finder of the camera. This lessened the chance of parallax error, although it did not completely eliminate it. It was an extremely light item and weighed in at 10.4gms, and was hardly noticeable when mounted. This finder does not have a serial number so the quantity produced is impossible to determine at this time. However, they are rather difficult to find today and may not have been made in large numbers.

Because it is so unique, the Mini-35 finder is one of those items that every Nikon collector seems to fall in love with on first sight. Not many seem to change hands, for those that have one do not want to part with it. No leather case was ever made since it was meant to be left on the camera, but it was supplied in its own velvet-lined grey box which is illustrated here.

SPORTSFINDER: Possibly available as early as 1954, the Nikon Sports Frame Finder, or Sportsfinder, was listed as late as mid-1959, and sold for $10.85 including a leather case. Nikon chose not to serial number this item and a determination of the quantity produced is very difficult. Because of its relative scarcity today, it can be assumed that it was not made in any large numbers, despite its low cost. An item such as a Sportsfinder is not an often used accessory, and its utility declined after the arrival of the Nikon SP in 1957. Cameras like the SP and the models that followed, had a minimum of two framelines, and as many as six, built-in, and the viewfinders were designed to allow the user to see a certain amount of the scene outside the

The classic Imarect-type Nikon Variframe Finder No. M901123. This is the proper vintage for the Nikon M cameras (1949)

The Nikon Variframe flanked by a Leitz Vidom (left) and a Leitz Viooh (right). The Nikon finder has the shape of the Vidom but is laterally corrected like the Viooh, thus the author's use of the term 'Nikon Imarect-type Finder'

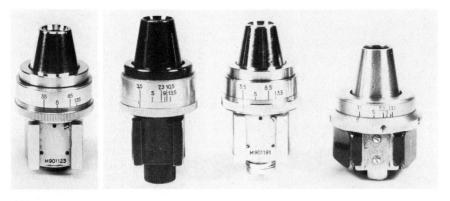

frameline. All of this reduced the need for an already limited use item, like the Sportsfinder, and production could not have been very large.

At least two versions of the Nikon Sportsfinder are known to exist. Both types have the same focal length frames (35, 50, 85 and 135) built in and none have been seen with a 105mm frame. There is actually very little space available to include the 105mm frame and it is doubtful it was ever made. The first version had the focal length markings engraved in such a way that they could be read right-side up when viewing the finder from the front. This version is also completely chrome finished. The second type seen differs in two respects. When viewing the finder from the front the focal length markings now appear upside down. However, when any frame was folded down in the stored position the photographer could now read these markings correctly, for they were now orientated for his point of view. Secondly this version has the inside surface of the frames painted yellow. When using the finder this yellow surface would be visible to the user and this was much easier to see than the previous chrome finish. Besides these two points both versions appear identical.

VARIFRAME: The earliest multi-purpose finder made by Nikon was very similar to the Leitz Vidom type except that the image was corrected, and the author has chosen to call it the imarect-type finder. Its shape was similar, with a rounded main body tube, and an accessory shoe on top along with a tapered nose-piece. Although the popularity of this finder would decline with the introduction of the Varifocal, or zoom, finder, the Variframe qualifies as one of the longest-running accessory finders made for the Nikon rangefinder system.

An item in production as long as the Variframe, from 1948 to at least 1957, would be made in many variations.. One thing to remember is that almost every version was also made with markings for the Leica-type cameras and were intermixed with those for the Nikon. Nippon Kogaku differentiated those for their cameras by engraving the word 'NIKON' around the eyepiece, along with Nippon Kogaku Tokyo, and later Japan. Those for the Leica-type cameras lacked this and were calibrated in focal lengths never made by Nikon, such as 73mm, 90mm and 120mm. In the early years it appears that as many were made for the Leica-type cameras as for the Nikon, and can be found quite readily.

The very scarce 28mm attachments. on the left is the slip-on type made for the Varifocal Finder. The one on the right is for the black Variframe Finder and may exist in chrome. – (T. Konno)

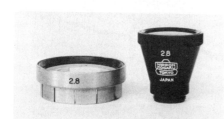

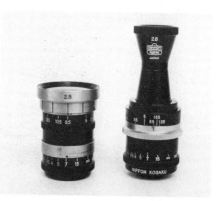

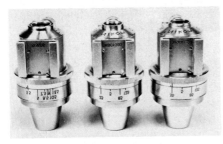
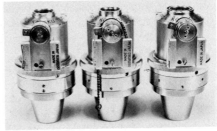

Three early Variframe finders. The two on the left are for the Nikon M and so engraved while the one on the right is for the Leica-type cameras and was made after the Occupation

During the Occupation years a great many variations are seen. The earliest finders were made for the Nikon I and are very difficult to find today. They were very heavy chrome on brass and are marked MIOJ on the base of the mounting shoe. On one side of the main housing is engraved '24 × 32' which was the frame size of the Nikon I. Serial numbers begin at No. 70500, but the quantity produced is hard to determine because so few have been seen. The number is engraved on the top mounted accessory shoe and one example would be finder No. 70527. The calibrations on these early finders would be 35, 50, 85 and 135 only. Some, but not all, have a small eyepiece attached by a fine chain that slipped over the eyepiece of the camera and increased the image seen to lifesize. The nose-piece is not threaded, for no 28mm attachment was made at this time, and all possessed a lever near the base which was used to correct for parallax, and was calibrated down to three feet. Another group of early finders with similar numbers are No. 71224 and 71250 which appear identical except that they were made for the Leica-type and are marked '24 × 36' and include such focal lengths as 73mm and 90mm.

The third type are those made for the Nikon M. These are unique in that the letter 'M' precedes the serial number, just like the camera, and no frame size engraving is used, although they may exist. Serial numbers seen range from No. M901100 to a

The black Variframe. This example is No. 543603 and is engraved 'Nikon' on the side denoting use on their own cameras. – (T. Konno)

The very last version of the Nikon Variframe Finder. Note that the accessory shoe has been removed. (1959?) – (A. Tamla)

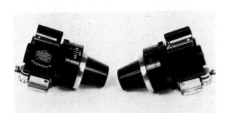

recorded high of No. M901465. All those seen within this group have the 'NIKON' engraving, lack the front thread and come with the eyepiece and chain. MIOJ is engraved on the base of the mounting shoe and the same heavy chrome on brass construction is used.

Another group of finders ranging in number from No. 9021 to as high as No. 902899 are identical except that they were made for the Leica-type cameras and have the '24 × 36' engraving, and are still marked MIOJ. Most of those within this group do not have the eyepiece and chain, for it appears that Nikon added this to only those finders made for their cameras.

The fifth type seen uses the serial numbers ranging from about No. 313000 to a recorded high of No. 313739. This group was also for the Leica-type cameras and lacked the eyepiece and were engraved '24 × 36'. An interesting point about this group is that they are not marked MIOJ even though they are followed, in serial number, by a group that is. They were probably made at a later date and Nippon Kogaku simply chose a type of number that would seem to make them earlier.

The last group of chrome on brass finders begins at No. 364000 and has been seen as high as No. 364785. This is the first type seen where non-MIOJ specimens appear within the same serial number block as those that are so marked. MIOJ finders have been recorded as high as No. 364160 but by finder No. 364372 they are no longer Occupied. All those recorded by the author within this group are for the Nikon and lack any frame size engravings, have the eyepiece and chain and finally possess a front thread for the 28mm attachment. This is also the first time that the 105mm focal length is engraved on a finder intended for use on the Nikon. Leica-type finders may be intermixed but none have come to the author's attention.

All versions seen to this point are chrome on brass. The majority were made during the Occupation and have Leica-type versions intermixed. All have the top mounted accessory shoe and the lever to adjust for parallax. At least six distinct serial number types are seen and, although they look identical, some improvements have been added such as the front thread. Some time in 1956 a new type was released.

Two views of the Type One Nikon Varifocal Finder No. 330148 *The later Type Two Varifocal Finder No. 359836*

Two very early Variframe finders intended for use on Leica-type cameras. Note markings for 73mm and 90mm lenses

VARIFRAME (New Type): During the last half of the Nikon S2 production, and before the SP was introduced, the Variframe finder was redesigned. They now appear in a lighter weight black housing that used a higher proportion of aluminium and less brass. The chrome versions, especially the early ones, were so heavy that with only a wide-angle lens mounted the camera was top-heavy and would not sit upright on a flat surface. Some of the later chrome finders were lighter but the black version was more usable. Two distinct types exist within the black Variframes. The first version appears similar to the chrome type in that the top mounted accessory shoe was retained, as well as the parallax lever and front thread. The word 'Nikon' is now engraved on the side of the main housing instead of around the eyepiece, and Leica-type versions were also made. Serial numbers appear to begin at about No. 543000 and have been seen as high as No. 545270.

The final version of the black Variframe finder is distinctly different. They again redesigned the housing and chose to eliminate the top mounted accessory shoe. Another change was that the base mounted parallax lever was deleted and replaced by a rear mounted dial similar to that used on the black bright-line individual finders. Therefore, this version is lighter still and much more compact. The serial numbers begin at No. 561000 and have been recorded up to No. 562148. It is not known whether or not this final version was made with Leica-type markings, for none have been seen, but they may exist. Even though the Variframe finders are listed in Nikon price sheets as late as 1957, their use dropped off after the introduction of the Nikon SP for the same reasons as the individual finders. The later black versions are not as easy to locate as the chrome types for it is possible that they were made for less than two years.

The only accessory made for the Variframe finders, besides the case, was the 28mm attachment. This screwed into the thread at the front. It was made in both chrome and black to match the finish of the finders themselves.

VARIFRAME FINDER VARIATIONS

TYPE ONE: Heavy chrome on brass construction; 24 × 32 engraved on side; base mounted parallax lever; has eyepiece and chain; MIOJ on base of mounting shoe; no threads; calibrated for 35, 50, 85 and 135mm lenses; word 'NIKON' around eyepiece; serial numbers begin at No. 70500; made for Nikon I.

TYPE TWO: Similar to Type One except it lacks the eyepiece and chain; 24 × 36 engraved on side; base mounted parallax lever; MIOJ on base of mounting shoe; no threads; additional calibrations for 73 and 90mm lenses; serial numbers begin at No. 71200; made for Leica-type cameras.

TYPE THREE: Similar to Type One; no frame size engraved; base mounted parallax lever; MIOJ on base of mounting shoe; no threads; calibrated for 35, 50, 85 and 135mm lenses; word 'NIKON' around eyepiece; serial numbers begin at No. M901100; made for Nikon M.

TYPE FOUR: Similar to Type Three; 24 × 36 engraved on side; base mounted parallax lever; lacks eyepiece and chain; MIOJ on base of mounting shoe; no threads; additional calibrations for 73, 90 and 105mm lenses; no 'NIKON' engraving; serial numbers begin at No. 90200; made for Leica-type cameras.

TYPE FIVE: Similar to Type Four; 24 × 36 engraved on side; base mounted parallax lever; lacks eyepiece and chain; not MIOJ!!; some may have threads; additional calibrations for 73, 90 and 105mm lenses; no 'NIKON' engraving; serial numbers begin at No. 313000; made for Leica-type cameras.

TYPE SIX: Similar to Type Three; no frame size engraved; base mounted parallax lever; has eyepiece and chain; marked MIOJ up to at least No. 364160; has threads; calibrated for 35, 50, 85, 105 and 135mm lenses; word 'NIKON' around eyepiece; serial numbers begin at No. 364000; made for early Nikon S.

TYPE SEVEN: Chrome replaced by black paint; no frame size engraved; base mounted parallax lever; lacks eyepiece and chain; no MIOJ; has threads; calibrated for 35, 50, 85, 105 and 135mm lenses; word 'NIKON' on side; serial numbers begin at No. 543600; made for Nikon S2.

TYPE EIGHT: Identical to Type Seven except has additional calibrations for 73 and 90mm lenses; serial numbers intermixed with Type Seven; made for Leica-type cameras.

TYPE NINE: New style black housing; top mounted accessory shoe deleted; parallax dial at rear; has threads; calibrated for 35, 50, 85, 105 and 135mm lenses; serial numbers begin at No. 562000; made for late Nikon S2.

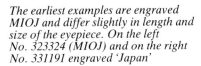

The earliest examples are engraved MIOJ and differ slightly in length and size of the eyepiece. On the left No. 323324 (MIOJ) and on the right No. 331191 engraved 'Japan'

Comparison photo of Type One and Two Varifocal finders

VARIFOCAL: The most popular multi-purpose finder made by Nikon was the Varifocal, or zoom, finder. More practical than the Variframe type, it enjoyed the longest production run of any special-purpose finder. The earliest examples are from the Occupation and it was still listed as late as October 1964. The Nikon Varifocal was a true zoom finder which maintained the same frame size but changed the magnification and coverage to correspond to the chosen focal length. The image was bright and sharp to the edges, all of which made this a very useful accessory. It was more compact and much lighter than the Variframe finder and was better balanced when mounted on the camera. It was not much larger than the 135mm black bright-line finder and very similar in shape. This finder was never made in chrome but consisted of a largely black barrel. It was made in three variations, two of which are significantly different.

As mentioned the Varifocal does date back to the Occupation, although this was not verified until just a few years ago. Since then two examples have been recorded by the author. The serial numbers appear to begin at No. 323000 and the two recorded examples are Nos. 323302 and 323324. It is not known how many were made but by finder No. 323470 they are no longer marked MIOJ. Those from the Occupation appear to be identical except for the MIOJ engraving on the mounting shoe, and a slightly shallower eyepiece. After No. 323470 none have been seen marked MIOJ and the numbers have been recorded up to No. 342157. This suggests a production of nearly 20,000 units which is possible since this was a very popular accessory. Those made after the Occupation have an eyepiece that protrudes slightly more, otherwise they appear identical. This first version has a parallax lever at its base near the mounting shoe calibrated down to three feet. A knurled ring approximately midway down the barrel was rotated to change the focal length and was calibrated for 35, 50, 85 and 135mm lenses. After the introduction of the 105mm f2.5 Nikkor this focal length was added. The rim is clickstopped and its index mark is on the chrome finished rear edge of the finder.

The second version, although very similar in size, was a totally redesigned item, as illustrated here. The parallax lever was replaced by a built-in dial at the rear as was

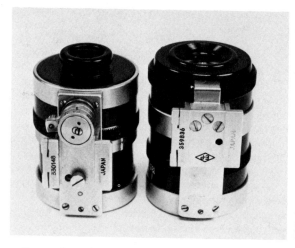
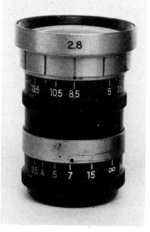

Comparison photo of above two finders showing marked differences in the mounting shoes

Type Two Nikon Varifocal finder with the very illusive 28mm attachment (T. Konno)

done on the last version of the Variframe finder. Since this dial displaced the focal length selector ring on the first type, this has now been moved forward to the leading edge of the finder. The index mark is now on the front rim instead of the rear, yet this rim is still chrome and carries the Nippon Kogaku logo. The protruding eyepiece is gone and is now recessed into the rear face but the total length of both are nearly identical. Now that the parallax lever is gone the mounting shoe is totally different. The serial numbers begin at No. 350000 and have been recorded as high as No. 359836, pictured here. This suggests approximately 10,000 having been made which is probable since it was made for a slightly shorter time. Also its popularity would decline with the advent of the more modern Nikons, such as the SP and S3, with their built-in framelines. The first version was much more popular because the finders on the Nikon M, S and S2 could not compare with the image the Varifocal provided. Those made for the Leica-type cameras are intermixed throughout the production of both types and do not have separate serial numbers. These would have additional calibrations such as 73 and 90mm, otherwise they are identical. A slip-on 28mm attachment was made and was first listed in early 1956. It was held on with friction and is marked 2.8cm. Many have been lost over the years and it is a rather difficult item to find today.

MISCELLANEOUS ACCESSORIES

This chapter will briefly describe certain accessories made for the rangefinder Nikons that do not quite fit into any previously discussed category.

DIOPTER CORRECTOR EYEPIECE: This virtually unknown, and rarely seen, accessory was made only during the early years. Its actual dates of production are unknown, but certain facts stand out. The author has not been able to find any listing, in any literature, for this item. No mention of it can be found dating back as far as 1948! The author possesses the original instruction books for the Nikon I and M, which date back to 1948 and 1949, and still no mention of this accessory is made. From its configuration it obviously would fit only the Nikon I, M and S cameras. The Nippon Kogaku logo is engraved but no serial number is used nor any MIOJ markings. From the type of chrome used it appears to predate the Nikon S model, which had a bright chrome finish, and looks similar to the dull finish used on both the Nikon I amd M models, but not exactly. Besides the one in the author's collection, he is aware of at least three more examples, all of which are identical and lack any serial numbers and the MIOJ engraving. It was designed to slip into the accessory shoe on the camera which placed its eyepiece directly in line with that built into the camera. It contains its own accessory shoe and allowed the user to mount an additional item if desired. The eyepiece has two functions. The most obvious is that it increases the magnification of the camera's viewfinder from the standard .75X to life-size! This makes it similar to the eyepiece that was attached by a chain to the Variframe finders of the period. Secondly, it can be revolved to change diopters and adjust the focus to the user's eyesight! No diopter correction was ever built into any Nikon rangefinder. Later models, from the S2 on, had correction eyepieces available that mounted to the eyepiece of the camera, but they were one strength only and not adjustable. Therefore, this very early finder was the only adjustable diopter correction eyepiece ever made for the series and it had the additional feature of magnifying the viewfinder image to life-size.

Nikon Eyepiece Diopter Corrector on a Nikon M (1949?)

The Eyepiece had its own accessory shoe, to replace the one on the camera to allow an additional item to be mounted, such as a flash unit or finder

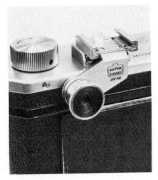
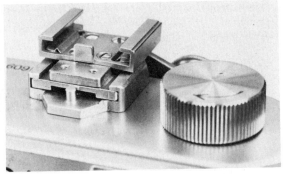

Two views of the uncommon Nikon Rangefinder Illuminator (1957)

RANGEFINDER FIELD ILLUMINATOR: An accessory that is unique to the Nikon rangefinder system was made specifically for the Nikon SP, and was first listed in May 1958. It was called the Nikon Rangefinder Field Illuminator and qualifies as one of the more esoteric accessories for the system. It was available until at least 1963 and sold for $18.75, including a leather case. It consisted of a mostly black plastic housing that slipped into the accessory shoe of the camera from the front. It maintained the cordless contact for the BC flash units by incorporating its own accessory shoe, which allowed any additional item to be mounted. Forward of this shoe was a cylindrical housing that protruded, and slightly overhung, the viewfinder window of the SP. This housing held a single penlight battery that powered a small grain-of-wheat bulb mounted to the underside. Next to this bulb was an on-and-off switch that was stepless, allowing the user to regulate the brightness produced. The purpose of this accessory was to illuminate the rangefinder frame-lines of the

Nikon SP with 50mm f1.1 Nikkor No. 141560 and Rangefinder illuminator. This would be the classic available light set-up

Top view of Nikon SP No. 6208961 and 50mm f1.1 Nikkor with Rangefinder Illuminator. Note accessory shoe and cordless flash stud are retained with this design

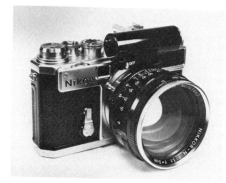

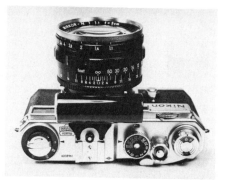

189

Nikon SP viewfinder when using the camera under very poor lighting conditions, which could reduce the visibility of the lines significantly. The bulb was placed directly in front of the frosted glass that usually provided illumination to these lines under normal lighting conditions. As far as the author is able to determine, no other manufacturer ever made an accessory that supplied auxiliary artificial light to illuminate the frame-lines, which makes the Nikon Rangefinder Field illuminator a very special item.

In actual use this accessory works beautifully. When mounted it adds very little weight and its low profile does not interfere with the operation of the Nikon SP. If the available light was great enough to eliminate the need for this item it could still be left on the camera, for it did not interfere with the normal illumination passing through the frosted window. If the light level would fall to a point where the frame-lines became difficult to see, the user would simply adjust the switch to the proper light level and those same frame-lines would now stand out as if they were a neon sign! An interesting point is that many years later Nikon would make a similar accessory for the Nikon F and F2 cameras that was used to provide light to illuminate the meter needle on their Photomic Meter finders. The idea for this later item is directly traceable to the Rangefinder Field Illuminator made for the Nikon SP.

No serial numbers were used for this accessory and any determination of the quantity produced is impossible to ascertain at this time. However, it was definitely not made in any large numbers. Because of its rather unique application, and the fact that it is difficult to find today, point to a small production, despite its low cost.

It is unique accessories like this that make any system interesting. Obtaining camera bodies and lenses is one thing, but finding such low production special purpose items, such as the Rangefinder Field Illuminator, is much more difficult, and it qualifies as a significant addition to any Nikon rangefinder collection.

PANORAMA HEAD: Nikon made their first Panorama Head in early 1958 and it permitted panoramic photographs up to 360 degrees to be made. It had automatic, clickstopped rotation points for the 35, 50 and 105mm lenses plus colour-coded

Close-up view of bubble level on Nikon S4 No. 6503715

Panorama Head No. 731603 and the bubble level which was inserted into the camera accessory shoe

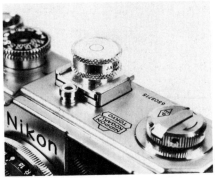

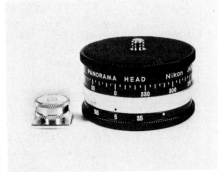

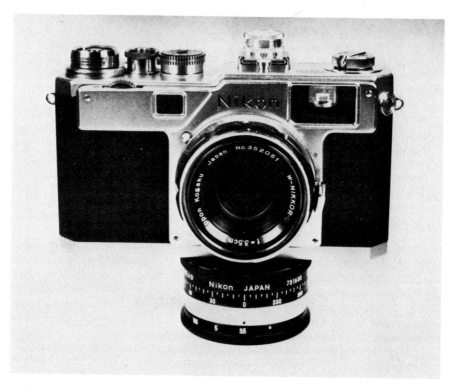

Nikon S4 with 35mm f1.8 Nikkor No. 352051 mounted on the Panorama Head with bubble level

indicators for the 28, 85 and 135mm lenses. It originally sold for $30.00, which included a leather case, and was made basically unchanged well into the Nikon F reflex era. Because the same focal length lenses were made for the Nikon F it was completely compatible with these later cameras. One way to determine the vintage of the Panorama Head is that the early version has the triangular Nippon Kogaku logo engraved on its side. This would eventually be replaced by the word 'Nikon', but this occurred well after the Nikon F was introduced. Since there is no difference between those made for the rangefinder series, and the early Nikon F cameras, anyone with the logo is proper for a rangefinder collection.

The only accessory made for the Panorama Head, besides the leather case, was a bubble level that was designed to slip into the accessory shoe on the camera. This level is unique to the rangefinders because the Nikon F used a completely different type of shoe, and they are not interchangeable. The level was an important accessory and was needed to maintain the proper positioning of the camera to guarantee correct results in the final photograph. This small accessory sold for $3.00 and many have been lost over the years, making it rather difficult to obtain today.

Serial numbers were used on the Panorama Head, but the author has not been able to compile enough examples to determine any sort of range, or production quantity, at this time.

THE NIKON '16'

This chapter is devoted to a camera that is virtually unknown! The photos used here are of one of only two prototypes that were ever made, and the whereabouts of this example are unknown today.

Some time in the late 'fifties Joseph Ehrenreich decided that Nikon should compete in the ever-growing precision subminiature camera market. He requested that Nippon Kogaku produce a prototype using the Italian Gami for inspiration, and this camera was the result. It is the only 16mm subminiature camera ever designed by Nippon Kogaku and it is a truly fascinating item. The photos used in this chapter were made from copy negatives and are, unfortunately, not of the highest quality. However, the author was not able to obtain anything superior to these for the simple reason that no one knows where this camera is today. There is speculation that the second prototype is still in the hands of the factory but no information is available. At this point a detailed description of this prototype is in order.

From the illustrations it is obvious that it followed the basic design of the Gami which is a rather large shape for a subminiature. It measured approximately 4in by 2in by 1in, but its weight is unknown. Nikon decided to use the standard Japanese frame-size which was 10×14mm on regular 16mm film, probably because so many others did and processing would be simplified. This differed from the Gami which used non-perforated film and produced a 12×17mm image. The camera incorporated a 25mm f1.4 Nikkor lens and a combined range/viewfinder, although it is not known how close it could focus. It had a spring motor drive, like the Gami, for multiple exposures, and was fitted with a metal focal plane shutter with speeds from 1/2 sec to 1/500 sec. It was designed to use the Gami type cartridges even though the film and frame-size was different.

One prototype was kept at the factory and the second was shipped directly to Joseph Ehrenreich for his evaluation. It was of extremely high quality, considering that it was hand made, and the thought that went into it would lead one to believe that Nikon had spent a great deal of time in producing it. It was a full functioning

The first-ever published photograph of one of the two prototypes for the 'Nikon 16' that were built some time in 1959!

Photo of the underside of the 'Nikon 16'. Note 25mm f1.4 Nikkor lens in a focussing mount

camera and not a mock-up, so its development was well along by the time this prototype was made. However, at about this same time the market for a precision 16mm camera was beginning to decline and what was left of it was dominated by the established Gami and Minox cameras. Ehrenreich decided that there was not a sufficient market available and all plans to produce the Nikon '16' were shelved.

One can only wonder how successful this camera could have been. It would have been Nikon's first non-35mm camera and would have brought Nikon quality and optics to the subminiature field. Its only true competitors would have been the Gami and the Minox, and what type of system would have developed around it would surely have been interesting. Nikon was a system orientated company and undoubtedly would have made many accessories available for their only 16mm camera.

All of this is now only speculation, for this very interesting camera was never produced. The author was very fortunate to obtain these photographs which constitute the very first time that any have been published anywhere in the world, and wishes to thank Mr. A.P. Poe for furnishing them.

View of rear of camera with back opened showing the focal plane shutter and the eyepiece for the coupled rangefinder!

Close-up of the Nippon Kogaku logo. No serial numbers are known at this time

SPECIAL MARKINGS

Special markings found on Nikon rangefinder equipment fall into two basic categories. The first type seen is that which denotes those items produced during the Occupation of Japan following World War II. Generally speaking everything they made during the Occupation was marked 'Made in Occupied Japan' somewhere on the item and, in most cases, quite visible. This period would cover all equipment manufactured from the release of the Nikon I, in March of 1948, up to the very early Nikon S cameras from December 1951 up through about February 1952. This would include bodies, lenses, finders, flash units, filters, lens caps and even leather cases. The only items that the author has not seen marked are lens shades, which may exist, for it seems odd that they would mark everything else and neglect the shades. The photographs in this section show the location, which did vary in some cases, of the MIOJ engraving on a cross-section of equipment produced during the Occupation.

The second basic type of special marking found on Nikon rangefinder equipment is the 'EP' engraving. This appears within a diamond and was used to identify those items that were distributed through the military 'PX' system of duty free shops. One point that must be made is that there is absolutely no difference between 'EP' marked equipment and that not so marked. Quality is identical and the 'EP' was used

The size of the lettering was eventually decreased during the later Nikon I and early Nikon M period. Camera No. 6091692 (1949). Lens is 35mm f3.5 No. 90137 and the finder is No. M901344 (1949) – (T. Konno)

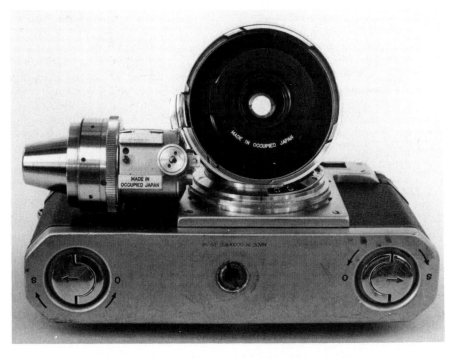

to simply differentiate that body of equipment to be sold in the 'PX' shops. Again everything that Nikon produced for these military shops was marked including cases and, finally, lens shades. The only item that the author has yet to record with the 'EP' marking is the S36 Motor Drive, which probably exists, but has yet to be seen. Even the boxes used for 'EP' equipment are marked including bodies, lenses and accessories. Included in this chapter are some photographs showing the location of the 'EP' marking on various items. All camera bodies are marked on the rewind knob going back to the Nikon S. No Nikon I or M cameras have been found as of the date of publication. The lenses are marked on the side mounted release lever and again no Occupied Japan examples have been seen. It is possible that Nikon was not using the 'EP' designation during the Occupation or that it was not required until after it ended. The use of the 'EP' did last into the reflex era for the author has seen Nikon F bodies and its lenses so marked but this usually is seen on items made before 1970.

Other markings that the collector may occasionally encounter are the following. The letter 'T' is sometimes found on the rewind knob of some bodies in the same place as the 'EP' would be engraved. This has been seen on S3 and S3M bodies, plus one recorded Nikon F, but nowhere else. It is possible that S2, SP and S4 bodies were so marked but none have been found. Also no camera has been found with both the 'EP' and 'T' engravings and no lens or accessory has been seen with the 'T' marking. As of the date of publication the author has not been able to determine the meaning of the 'T' and welcomes any information as to its purpose.

Accessory finders are often found with either the letter 'L' or 'C' engraved on their mounting shoes. This is also the location of the 'EP' marking for the finders and some have been seen with both the 'EP' and an 'L' or 'C' engraving. Obviously the 'L' is for Leica and the 'C' for Contax. Those marked 'L' appear identical to the regular finders although, because of differences in the height of the bodies, there may be slight variations in parallax correction geometry. The 'C' marked finders have a distinctly different shoe needed to properly mount on a Contax body.

Nikon made certain lenses longer than 50mm to mate with the Contax rangefinder. Although the mount and back focus of the Nikon and Contax cameras are identical, the two companies used a slightly different method of 'tracking' the image in their rangefinders. Because of this the helix of a lens intended for the Contax had a different 'pitch' than that for the Nikon. Nippon Kogaku marketed the 85mm, 105mm and 135mm lenses in special Contax mounts and so marked these lenses with a 'C' on the side of the barrel below the focussing ring. The 'C' is about 1/4 inch tall and is within quotation marks.

One last special marking that has come to the author's attention appears on Nikon M body No. 609852. A large diamond is engraved on the rewind knob and within it are some Japanese idiograms. These translate as 'CPO' which is probably some sort of military related marking, although its exact meaning is unknown. The author has seen some Canon bodies similarly marked but only with the actual letters 'CPO' and not the idiograms. More information is needed to determine the meaning of this marking and whether it appears on other Nikon equipment.

The author has searched for engraving errors on Nikon equipment for many years. To date only three have been found. Pictured here is a close-up of the frame counter on Nikon M No. 6091434. Notice that the number '30' is missing its zero and reads as '3'. Another error is in the author's collection. It is a black Nikon SP with a double serial number! This body actually has two numbers stamped into its top plate slightly

Nikon M No. 6091434 has a mis-engraved frame counter. Note that the zero in '30' is missing and reads as '3'

A very small number of Nikon M cameras have been found with the serial number mis-engraved. All early Nikons begin with '609' yet a few cameras in the range '6091800' to about '6091850' are engraved '906'! An interesting point is that the matching number on the camera backs are also engraved '906'! Example is camera No. M9061847

out of register. Because of this both numbers, on close examination, are readable and are Nos. 6210953 and 6212188. The first number has been stamped slightly deeper and is in the proper location. The second number is slightly shallower and is displaced about 1mm lower and 1mm to the right. At this time it is not known how this occurred but close examination shows that both numbers are 'factory' stamped. How this item got out of the factory is not known but it may have been sold to an employee instead of being dismantled. More information and examples of this need to be found to determine how it may have happened.

One last example of an engraving error appears only on a few Nikon M bodies. A small batch of these cameras numbered between M6091815 and M6091848 are engraved '906' instead of '609'! As mentioned earlier the '609' was a constant and denoted the month and year that the original design of the Nikon I was completed. Somehow this small batch of top plates was misengraved and found their way into the market place. To date this is the only batch discovered, although more may exist.

Comparison photo showing how the engraving was changed from MIOJ to 'Made in Japan' following the Occupation

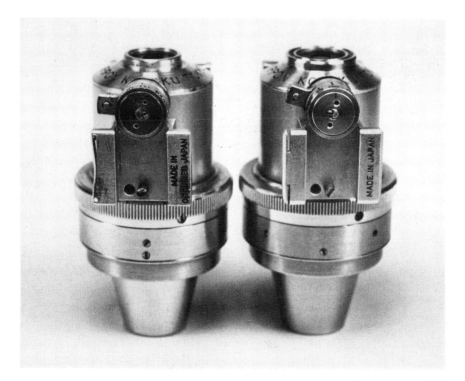

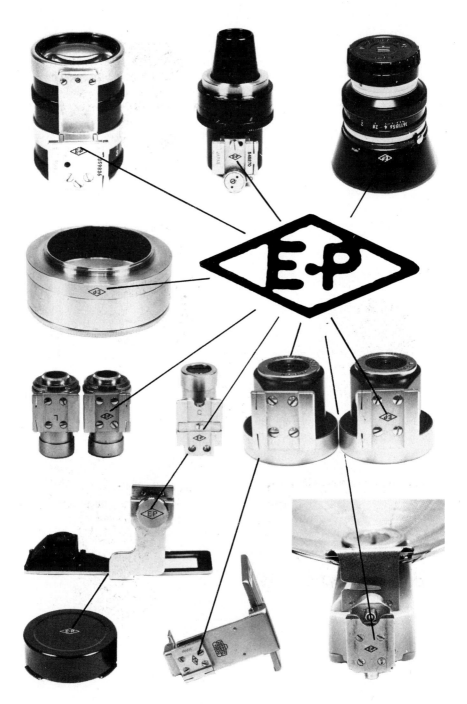

MADE IN OCCUPIED JAPAN